EVERYTHING THAT RISES

EVERYTHING THAT RISES
A BOOK OF CONVERGENCES

LAWRENCE WESCHLER

McSWEENEY'S

gift 4/69/08

MᶜSWEENEY'S BOOKS

SAN FRANCISCO

For more information about McSweeney's, visit www.mcsweeneys.net.

ISBN: 1-932416-34-X

For Robert, Toni, and Ray—
my wildly divergent siblings

Tree, always in the middle
of everything that surrounds it [...]

Tree, that (who knows?)
may be thinking there inside

—*Rainer Maria Rilke, from "Le noyer"*

Useless to think you'll park or capture it
More thoroughly. You are neither here nor there,
A hurry through which known and strange things pass
As big soft buffetings come at the car sideways
And catch the heart off guard and blow it open.

—*Seamus Heaney, from "Postscript"*

CONTENTS

 Introduction . 1

Exemplary Instances

Echoes at Ground Zero 8

The View from the Prow of the Getty 23

Cuneiform Chicago 27

Helen Levitt: Ilium off the Bowery 33

Ziggurats of Perception 37

Expressions of an Absolute 43

Gazing Out Towards 51

Magritte Standard Time 57

Women's Bodies

 Found Triptych 63

Girls in Their Turning 65

Languorous Landscapes 71

Face as Torso, Torso as Face 82

Fathers and Daughters 87

The Darling Little Being 93

 Images Without Texts 97

Political Occasions

The Graphics of Solidarity 105

The Contras and the Battle of Algiers . . . 125

How Suddenly It Can All Just End 129

Modern Times . 135

Allegories of Eastern Europe 141

Loving or Leaving Bosnia 159

Pillsbury Doughboy Messiahs 161

A Field of Blackbirds 167

Life Against Death 171

Mona Lewinsky 181

Those Wacky Htoo Twins 185

Thumb in Eye . 189

Trees, Neurons, Networks

Trees and Eyeballs 199

Branching Out Yet Further 206

Compounding Unscientific Postscript 215

Coda / Credo

We Join Spokes Together in a Wheel 229

INTRODUCTION

I don't remember exactly how I got started—come to think of it, it was probably reading John Berger one day in college, the essay on Che Guevara in *The Look of Things* where he's talking about the famous photo of Che's corpse, gruesomely splayed out like that for public display, his military captors proudly arrayed alongside; and Berger in effect says, "We all know what this photo's based on," and then proceeds to tell us: Rembrandt's *Anatomy Lesson*. And of course he's right, he's dead right: that's undoubtedly the image (hot-wired, as it were, into all of their brains) that taught all of the strutting officers how to pose in relation to their prize, and taught the photographer where to plant his camera in relation to his subjects. And I just remember thinking at the time, regarding Berger: Jesus (Jesus, of course, comprising another apt trope at that particular juncture)—Jesus, this guy doesn't read his morning newspaper the way I or anybody else I know reads the morning newspaper.

Only, in the years since, and admittedly perhaps still in thrall to Berger's way of seeing, I myself have increasingly found myself being visited by similarly uncanny moments of convergence, bizarre associations, eerie rhymes, whispered recollections—sometimes in the weirdest places. At a certain point I began keeping a folder of such visitations—usually just feathering in the images themselves, occasionally including a textual exegesis of my own. The range in tone of these convergences was considerable: some were fanciful, others polemical; some merely silly, others almost transcendental. Some tended to burrow toward some deep-hidden, long submerged causal relation; others veritably reveled in their manifest unlikelihood. Some were dated and now feel dated; others were dated and yet don't; others

have floated entirely free of any such posting. Sometimes I'd publish the results; but usually I just filed them away.

Somehow the politburo over at *McSweeney's* got wind of the file and asked if I wouldn't mind sharing some of its contents with that journal's august readers. And I figured, what the hell. One thing led to another, and that thing led to a good twenty others beyond that, and then I noticed that actually over the years I'd placed almost as many such pieces in other venues. The commisars at *McSweeney's* book-publishing division expressed interest in a giant compilation—a convergence of convergences, as it were—and here we are.

Which is to say, here we go: make what you will.

EXEMPLARY INSTANCES

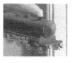

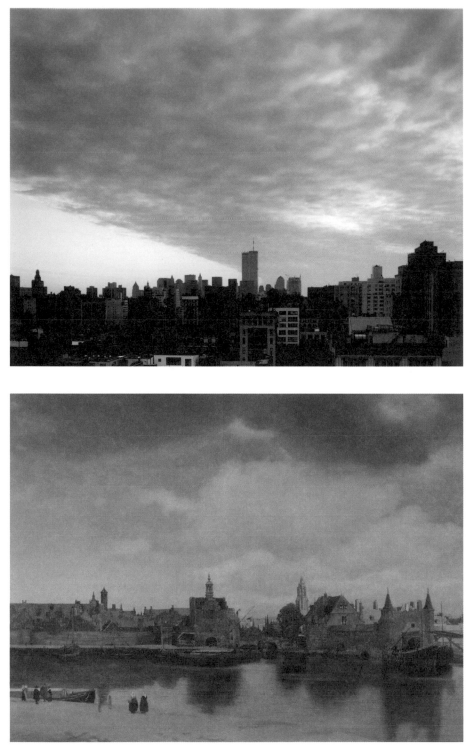

Jan Vermeer, View of Delft, *1658*

ECHOES AT GROUND ZERO

A CONVERSATION WITH JOEL MEYEROWITZ

LW: Joel, as you know, we've been looking at pictures together—and, more to the point, I've been looking at your pictures with you—for many years now, and I just wanted to show you some things I recently put together in a little scrapbook, to see whether they resonate for you at all, starting with this image of yours here, which was taken roughly when?

JM: Oh, in the mid-'80s, 1983, '84, '85…

LW: And from where?

JM: From Nineteenth Street, between Sixth and Seventh Avenues, in Chelsea, which is where I had my studio at the time. It's one of a series of such pictures called *Looking South*. I suppose I was thinking about the landscape of Lower Manhattan as a mountain range, something far away.

And the highest peaks in the mountain range, of course, were the Twin Towers.

LW: My response to those pictures, even at the time—I mean, I saw them long before the Twin Towers came down, and now I saw them again more recently, when you showed them at your daughter Ariel's gallery in the wake of the September 11 disaster—but even before that, the series in general and this one in particular reminded me of Vermeer's *View of Delft,* this painting here. Now, partly that had to do with the ratio of sky to ground, the clouds, obviously, the sense of spires. You could make an argument that the *View of Delft* is a mountain range also, in terms of distance.

JM: Exactly. I mean I've often thought that for Vermeer, in that low, flat country that Holland

5

was, the view across the river like that, at those—well, they were like skyscrapers in his time—all that verticality in the midst of all that horizontality, it must have been like gazing upon a mountain range, or the closest he ever had to the experience. And as for the similarity in the light: well, for many years when I was working on Cape Cod, doing photographs of the horizon line, the big bowl of space and sea and sky, there were days I called "Delft days." Literally, out of all those pictures, there are a half-dozen photographs that have about them the purity, clarity, and cleanliness of those northern days that you can get in Holland and Belgium and the North Sea.

LW: It's the same sea.

JM: The same sea, yes, just the other side. And now, looking at Vermeer's picture in relation to this *Looking South* picture of mine, I certainly admit to having had some—from my days as an art student and my love of art history—there certainly is an inflection of those Delft views, tiny little paintings though they were.

LW: After the disaster on September 11, of course, that whole series of yours became, in retrospect, a sort of premonitory dirge—that's certainly how it felt at the show at your daughter's gallery. But what's interesting about that, in this context, is that the *View of Delft*, although for us today it looks like an occasion of utter peace and tranquility and so forth, anybody looking at it

around the time it was made would have had an entirely different response. For it, too, is about a hole in the landscape—only after the fact, instead of, as with yours, before. Because a few years earlier, one of the most prominent buildings on the Delft skyline, slotted there in the distance between those two spires, where the puddle of light is, was the town's armory. Remember, they were only just coming out of a period of great and terrible warfare, and the armory was stocked full of explosives, which one day, a few years before Vermeer painted this picture, had accidentally ignited in a terrible, disastrous conflagration, killing all kinds of people, including Carel Fabritius, universally regarded as the greatest painter of Delft from the generation immediately prior to Vermeer's. So this cityscape, at the time Vermeer painted it, would have had a completely different resonance, much like the one that yours subsequently came to.

Anyway, that just establishes a context for some of the things I wanted to show you, because, of course, after September 11, you went down and took to photographically documenting the recovery efforts at Ground Zero for—how many weeks, months?

JM: I started photographing in mid-September, and I ended when they finally finished clearing the site and closed it in June. So, I was there the whole eight and a half months with the cleanup crew, taking 8,500 photographs.

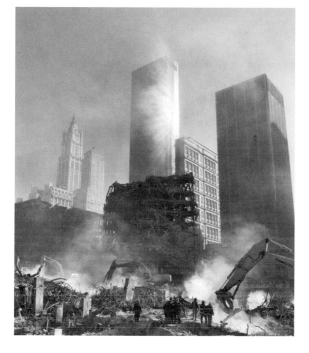

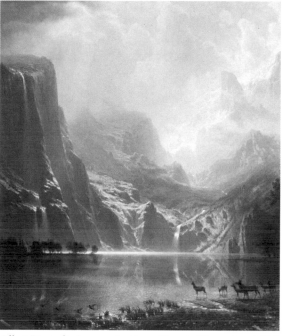

Albert Bierstadt, Among the Sierra Nevada Mountains, *1868*

LW: And a few months after that you had a show of some of those photos right near Ground Zero—just a few months ago.

JM: Yes, on the first anniversary of September 11, in 2002, we opened a show at 195 Broadway, just a block away from Ground Zero, to give visitors a sense of the effort that had gone into the work of recovery, and maybe a bit of catharsis. I created very large photographs so people could have the sense of actually standing and looking into the site rather than just at photographs of it.

LW: As we were walking through that show together one afternoon, I kept on having this whole set of associations, and I wanted to talk to you about whether those were idiosyncratic to me, or whether you perhaps shared some of them then, as you were taking the pictures in the first place, or perhaps later as you were choosing which ones to highlight, or later still, looking back on them. In effect, I want to talk to you about the degree to which images from the past create a context for ordering and approaching the chaos of the present. For example, speaking of mountain ranges, in this pairing here...

7

JM: Hunh, wow, good one, Ren. Well, yes, this is my photograph of a day when they were far enough along in the site—at this point it was probably January—such that every time they pulled something out of the pile, huge blasts of smoke and ash would come boiling out, because oxygen would go into the fires down below and they would literally explode. As the smoke dissipated and rose, it created a veil in the sky. And, at that particular moment, the sun glinting off the edge of one of the skyscrapers sent bands of light through the smoky cloud. Had there not been a cloud there, there wouldn't have been those rays—it just would have been a silvery glitter. But whatever was in the smoke allowed the rays themselves to take on a kind of visibility, as, yes, in this…

LW: This is an Albert Bierstadt. And the thing I'm wondering is, is this association mine or were you having a similar one out there on the site—that is, to this tradition of the sublime, the Alpine sublime or, in this case, the Sierra sublime?

JM: Well, I might not have been thinking specifically of Bierstadt, but I was thinking sublime, without a doubt—and for months—I was recognizing that I was in a new definition of the sublime. The awesome, horrific transformation of this place—although it wasn't nature itself—it was man acting as nature and bringing these buildings down. The collapse of these buildings

was the cataract, the chasm, the Grand Canyon—it had the same kind of awesome…

LW: Well, as in Rilke's elegy, how "Beauty is just the beginning of a terror we can only just barely endure, and we admire it so because it calmly disdains to destroy us. Every angel is terrible."

JM: Hunh, yes: terrible. Awe-inspiring.

LW: What about this matching: Piranesi and what is this?

JM: This is the Winter Garden, in the World Financial Center. A great arched space with two enormous buildings on either side. I stood there and I thought, well, not so much of Piranesi as of the Baths of Caracalla in Rome, those huge vaulted ruins, how they must have looked to people in the sixteenth and seventeenth centuries, and then later, all the ancient ruins, those great collapsed structures in the landscape. And I felt like a visitor in that romantic moment, only here it was this horror.

LW: Speaking of which, what of this? Caspar David Friedrich.

JM: Ah, well, we're old buddies, he and I. We certainly have crossed paths before.

LW: And this is your picture of…?

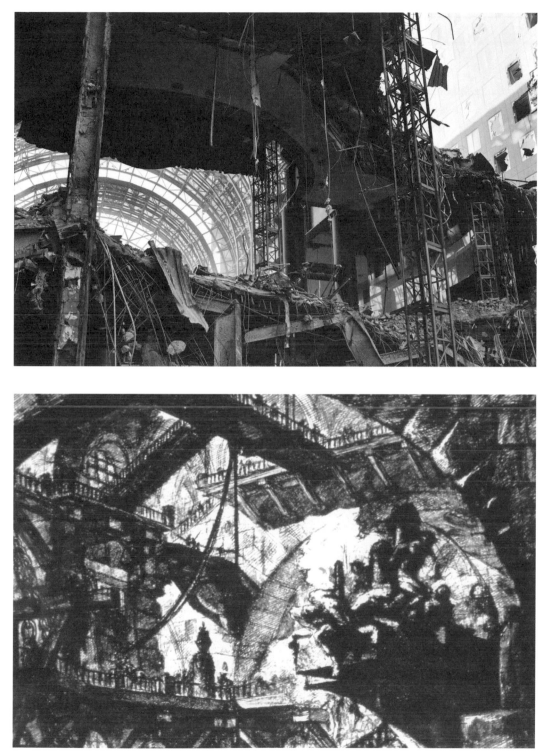

Piranesi, from Carceri d'Invenzione, *1745*

JM: This is the picture that I call *The North Wall*. It was the last remaining vestige of the North Tower and was indeed cathedral-like in its structure. But it was on one of those days when as the day waned and the light went down, the clouds suddenly turned pink. I had one of those momentary pauses where I thought, "God, I shouldn't take this photograph. It's too beautiful. Is it right to have this beauty in all this horror?" And I thought, "Well, of course. Nature's indifference will always suggest correspondences that you can't possibly imagine—you just have to accept them."

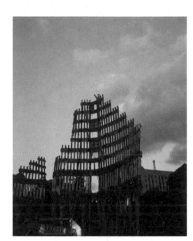

LW: Of course, there is a long tradition of Romantic imagery in the face of ruins,

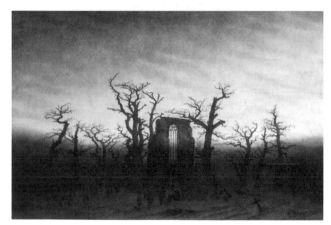

Caspar David Friedrich, Abbey in the Oak Wood, *1809*

which is all about death and beauty and so forth. You didn't invent that. And in a sense, Friedrich, for example, creates a context for the association. Look how in his image pilgrims seem to be moving through a cemetery.

JM: And of course I was in a cemetery, too. You don't see me and the men who are there, but in fact we were all standing on the graves of three thousand people.

LW: How about this?

JM: Well, yes, *The Night Watch*. And yes, I had exactly the same association. It was night and there were about fifty firemen and policemen in the bowels of the South Tower, illuminated by cold sodium-vapor lamps shining down into the site. In the center was a tungsten light that was glowing almost orange. The men had just come upon the remains of five of their comrades and they were shouting, and I came running over this incredibly dangerous pile, and as I reached the crest and looked down into this twisted steel battleground and saw these men there, I just raised my camera, made the photograph. And I just knew viscerally from the way the men were displayed—remember, I didn't control anything, I didn't move a person, I didn't even move myself: I came to the spot

Rembrandt, The Night Watch, *1642*

where I could stand and what I saw rendered itself very much like *The Night Watch*. In some way, the quality of that glowing light in the center, the assembled men, the kind of smoky background, all the hardware of the destruction of it gave me the feeling of those lances and curtains and all that heraldry. It was a gut reaction—although I couldn't call up the painting exactly, I just knew this grand assembly was a powerful image.

LW: And this?

JM: That's Charlie Vitchers and the Trades—the fifty trades foremen that ran the World Trade Center site—at their morning meeting, and Charlie Vitchers, over here on the right-hand side, is the overriding brain. He carried the entire site in his head, didn't need notes. He could tell every one of these fifty people what they were going to be doing, what their crews were going to be doing that day. And I admit that when I was in that humble double trailer with Formica walls and crappy fluorescent lighting with them sitting there, arrayed along that handmade wooden table, I didn't have exactly…

LW: This particular picture?

JM: Yeah, this—what is it?—*Banquet of the St. Hadrian Civic Guards*—in my mind. But I did have a memory of, you know, for example, Hals and his images of the elders of the various charities—the clusters of those guys with their big

ruffs on and all of their paraphernalia, the group of wise men, of burghers who were…

LW: And here, instead of the ruffs, these guys have on these strange orange vests, and this guy in particular over here to the right, he's just straight out of that era.

JM: Oh, definitely. Down there they called him Colonel Sanders. But his name is Marty Siegal and he's a forty-year veteran of the building trades, building skyscrapers and cities and things like that. I definitely had a sense that gathered here before me was the assembled wisdom of all these trades.

LW: And this pairing?

JM: Well, indeed. This is a photograph of Rescue Unit Ten, I think, or Seven—I'm not sure what the numbers were at that moment, but it's part of a firemen's rescue unit that was working down at the site, and they'd come out of the site for their break and collapsed in these chairs, of which there were thousands strewn around the site. And yes, as they sat there I too recalled those Civil War photographs and the pictures from the Crimean War, where the ranks and officers are gathered together outside a tent…

LW: With a flag… This is a long tradition going back to Brady and so forth. Did you feel that at the moment you were taking it?

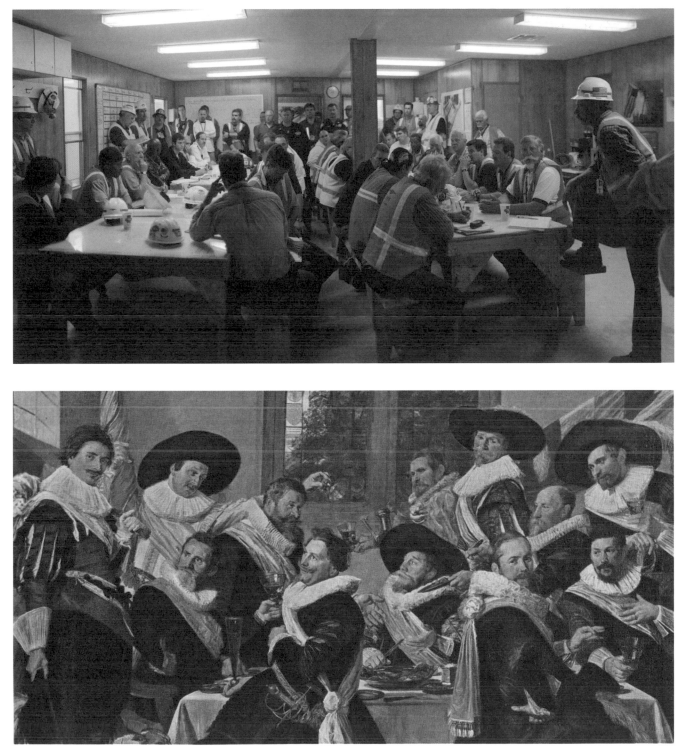

Frans Hals, Banquet of the Officers of the St. Hadrian Civic Guard company, *1627*

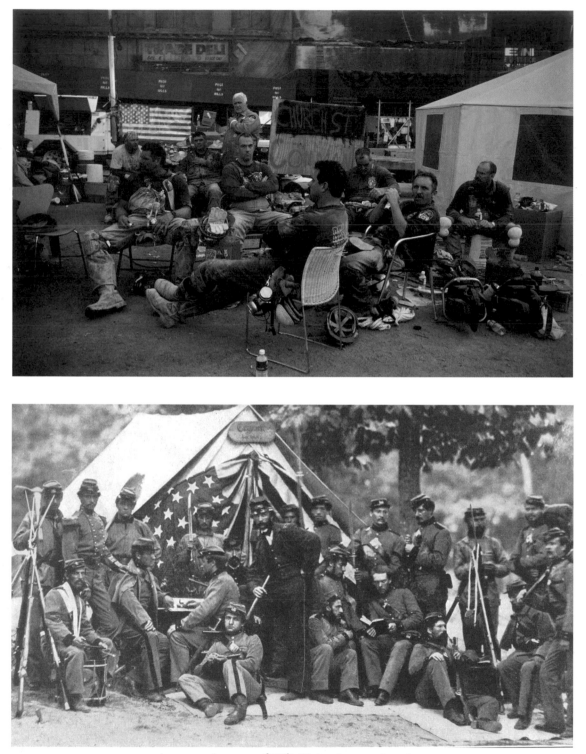

Anonymous, Amateurs of 1861 (Union Army engineers)

JM: Oh yeah, I connected with the Brady images, which probably weren't made by Brady, they were made by O'Sullivan or Jackson or any of the others, but I had the same sense of history repeating itself, people assembled after carnage or destruction or before battle, and they're dispersed in a way that is casual, from fatigue or just… And I knew, I felt myself in a continuity with the past.

LW: What's interesting to me is that history repeats itself, not only in how people arrange themselves but in how the portraitist of them stands in relation to them. In other words, the place where you choose to stand and aim your camera and so forth, the image you choose to take is a part of a history of images that forms a reservoir of such tropes in your head. You didn't attempt a close-up of, say, him—you stood at a distance, this specific distance, which is a distance that has a history.

JM: Absolutely right. There is also a distance here of respect, caution…

LW: Which was also true of the Civil War photographers, too.

JM: Yeah. But, there were also mechanical problems for the Civil War guys. They needed to be at that distance so that their slow, cumbersome equipment, glass plates, could be sharp enough all the way across so that everything was in focus and far enough back so they could get everybody in—they didn't have zoom lenses. In my own case, there was a certain hostility pervasive at the site, because firemen didn't want their pictures taken, and one had to be on one's toes to make pictures that were graceful and yet demanding enough. You can see one guy in the center here, he's basically telling me no. He actually said to me, "No," and I basically said, "Yes. It doesn't matter what you say, I'm doing this." So we had our little standoff here. But if I'd crossed the distance, the line, I could have incited his physical—at the very least his walking away. One has to feel it out in the instance. What else do you have?

LW: Well, this.

JM: Amazing. What a guy. He was a welder, commonly called a burner down there. His job was to go through the site and as each level was exposed, he would walk through with a torch and burn all the small standing steel so that men could walk through and do their search.

LW: Do you know his name?

JM: I do know his name… Paul Pursley.

LW: What is fascinating to me here is that we're playing off the Velázquez of Mars with his tool and his helmet and his mustache—I don't want to suggest or insist that you had this specific thing in your head, but you too are treating this worker as a kind of god or a personage of great nobility.

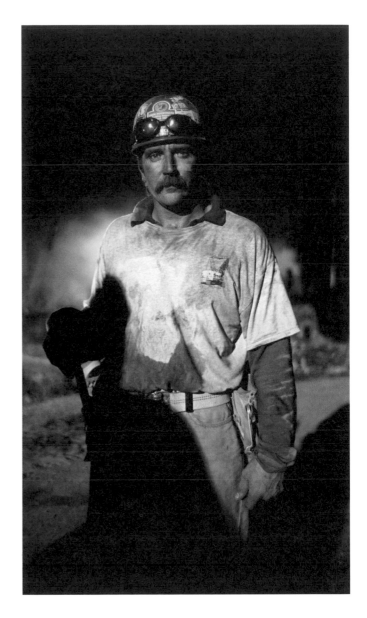

Diego Rodriguez Velázquez, Mars, *c. 1650*

JM: I was just going to say that he was noble. The reason I saw him as noble was that he came up the road bend here, and I saw him, and we had just heard a bugler playing taps, and there were eight of us standing around and we were all in tears and as he came to me I saw this little glint of a tear in his eye—you can see it in the photograph, he's slightly dewy-eyed. And as he came forward, I just felt the power of this man and his nobility, and I stepped in front of him and just made a photograph. We didn't have much of an interaction. He really didn't even pose for me, he just stopped walking. And then I asked him something and he laughed and he said, "I was just wounded today. I was burning the steel and I exploded some ammunition that was buried." He said, "A piece of bullet shell hit me in the face and I got five stitches under here." He laughed. *He laughed.* And then he just stood there and I made this picture and I realized he *is* heroic.

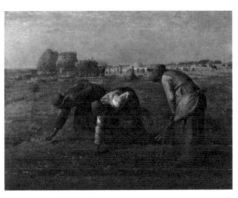

Millet, The Gleaners, *1857*

LW: One of the things that's amazing about Velázquez is how when he chooses to do a god, for perhaps one of the first times in history the god is just some mill worker. I mean, this is clearly some guy who worked as some smithy or something, who knows who he is. This is some guy who is a working-class guy, patently not a nobleman, you don't think?

JM: No, not a nobleman.

LW: And yet a god. So that's kind of interesting.

JM: A beautiful combination. As is this one. So here we have Millet's *Gleaners*, and my picture of the rakers. Without a doubt I was referencing—not the painting so much, as in trying to remake the painting, but the act. These men, for five of the eight months down there, they were either on their hands and knees with small hand tools—garden tools— or they were standing with the rakes and they were doing this incredible ancient gesture of pulling a tined instrument through the rubble, looking to turn over bones, relics, that would give some identification. They did it with such perseverance and devotion that it was like a sacred ancient gesture renewed in their

Day-Glo green-and-orange vests. It was both humble and grand and it was against this huge scale of the city behind them, so they were diminished by it. And over and over again, when I saw them reach down to pick something up, I would feel the Millet…

LW: The combination of humility and grandeur.

JM: Yeah. And the sturdiness. I mean, look at the women in the Millet, how sturdy they are. They're bent; they're like stacks of wheat. They go down there—they never have to get up. They're permanent. And these guys, their gesture, too, was permanent.

So what else have you got? Hunh. *American Gothic* and my photograph of a father and son.

LW: Not husband and wife, but father and son.

JM: Father and son. They were looking for the missing brother. They were both firemen, these guys, he was retired, and they were a part of the raking crew. I saw these men one day, there was a last column left in the site—sixty-two-ton, fifty-foot-high column—one afternoon I saw the son climbing on the father's back, the son on the father's back, climbing up the column to paste a photograph of the missing brother on this totemic column, and the old man was just there like a pier,

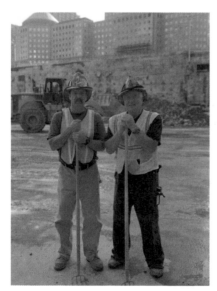

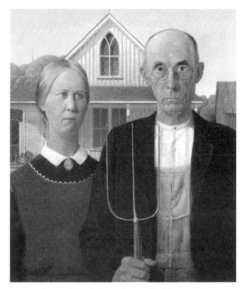

Grant Wood, American Gothic, *1930*

18

I mean a pier holding something up, and the son slithered up the father's back and braced himself and stood up onto this column, and I went over and photographed them.

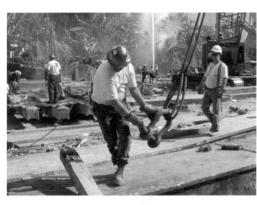

And through that act of recognition of what they were doing, we became friends. For the next two months, I would see them just about every single day—they were there seven days a week looking for the son, and finding many other bones, and the son here, down at the site, was called the Raven because he found more bones than anybody else. His nickname was the Raven. This gesture, the two of them standing so similar to *American Gothic*—I have to say, *American Gothic* didn't play in my mind, but I recognized the way they were standing—they were talking to a third guy, who was next to me, who you can't see. I just insinuated myself into the space and made the picture of the two of them. I didn't pose them at all—it was their posture. And I think you see their erect, determined stance, and the kindness with which they're standing and the readiness with which they're standing. So, one reads into their stance all of the human capacities.

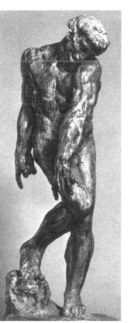

Auguste Rodin, Adam, *1880*

LW: Here's one for which you could find many matches—it feels like Rodin, maybe, or the *Discus Thrower.*

JM: It's a picture of an ironworker pulling a great cabled hook to lift some steel, and for me, actually, it evokes Rubens or Titian.

LW: And did at the time?

JM: No, at the time it was a balletic gesture of the man coming forward to the front plane of the frame, carrying this heavy thing. I tried lifting that—it's like fifty pounds or more! He's moving with it with a kind of balletic gracefulness…

LW: Ballet, by the way, itself comes out of a tradition of looking at paintings and creating them onstage. Stage pictures. So there's that whole tradition.

And finally, what of this one here? I immediately read it as a kind of deconstructivist riff on an American flag, a kind of Cubist American flag, with the redness and the blueness and the whiteness, the blue-and-white rectangle in the upper left-

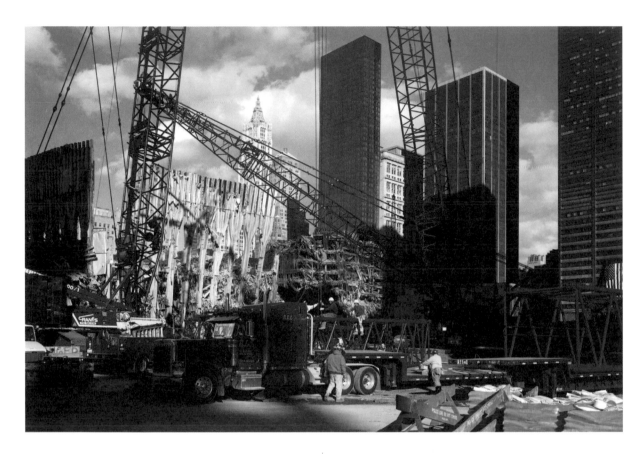

hand corner, the red stripes. Did it feel that way to you as you were taking it?

JM: Absolutely. This is October. I call it *Autumn Afternoon*, because the quality of the day was one of those pristine days where it feels good to be alive. In fact, I saw it as a red-white-and-blue day. It was a jumbled kind of flag, and I definitely felt the flag power, the call of the flag, there. Without seeing stars and stripes, but seeing the blue sky, the white clouds, the red buildings. Yeah, it was a striped, glorious moment. I have to say, taking photographs is such an instantaneous act. The recognition and acting on the recognition, depending on your equipment, is close to instantaneous. No more time than three minutes elapsed between recognizing the capacity of this image to connect and provoke me and then setting up the big camera and putting in the film. All of that was within three minutes. If

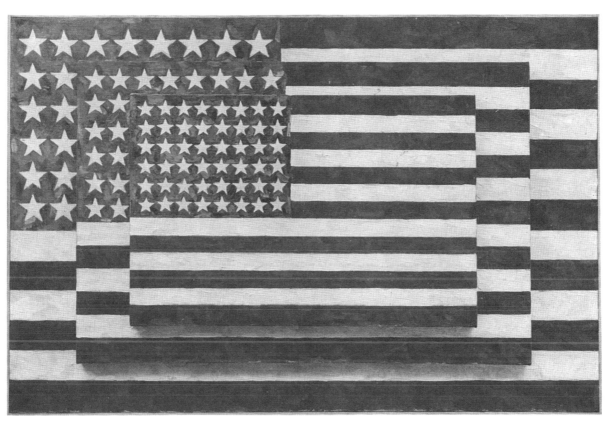

Jasper Jones, Three Flags, *1958*

it were a small camera [*snaps his fingers three times*], it would have been instantaneous. Take a breath, you take a picture. But it definitely registered flaglike.

LW: But isn't that the whole point about photography, how it's instantaneous, more or less? It's not something you set up. Can you talk about how the reservoir of things you've seen prepares you to see other things? Or at any rate prepares you to see them in particular ways. By the way, I don't think that's unique to you—I think it's true of all artists, and I'm just using this as an example, and a particularly vivid one, precisely because you were being thrown into vistas of such chaos and overwhelming horror, a place where you might otherwise have been expected to be overwhelmed by the chaos of feelings and sensa-

tions. Somehow you are gifted with this tradition that you carry with you, that you can fall back on, or that prepares you to see things. Does that make sense to you?

JM: Absolutely. None of us are free of references. And when you grow up in the world of art, things stick to you. I'm covered with imagery that has meant something to me, that has caught my attention over time, certainly they're swirling around me at all times, like the moons of Saturn. I'm not always sure I'm identifying anything, but they make a composite of me, as well as things I have seen in the real world, gestures that I may not have had time to photograph, but even they stick with me as great moments of beauty that I have missed. So when I see them again, I am awakened, because I want to be faster this time, I want to get them this time. But dealing not only with the things one misses, one is always carrying a chapbook of images around.

LW: Frank Gehry once told me that he never passes a dumpster, walking down the street, without looking in and Hoovering up the shapes—that was his word—the random shapes,

and he has this whole repository of bent and twisted shapes to draw on.

JM: And you can see from his work that he has found a vocabulary of those shapes: he likes the clashing and the asymmetries and randomness of that. For a street photographer like myself, randomness is everything, because that's one thing the world has in abundance, and I am just passing through it with my snare. My camera is a snare. I can throw this sieve out there and I can capture things in it. And risking that gesture all the time is part of the joy of seeing, because I don't have to stretch a canvas, I don't have to mix the paints, I don't have to light the studio. I walk around in the world, which is bombarding me with sensations all the time...

LW: But the point is your response is not random.

JM: No, no. The response is more and more coherent as one gets older and drags this long train of images and memories behind. You begin to see things that are identifiably yours—and yet, of course, yours in the context of a long tradition which has itself become part of you.

THE VIEW FROM THE PROW OF THE GETTY

GETTY / LOUISIANA / LANG / GODARD / MCBRIDE

So I was standing there at the prow of the Getty one particularly lovely afternoon, a while back, gazing out over an especially clear panorama, the L.A. basin stretching from the San Gabriels all the way out to the Pacific, and panning the vista, I found myself recalling Jim McBride's underrated 1983 remake of Jean-Luc Godard's 1960 film *Breathless*, and in particular the marvelous climactic scene that must have been shot right over there, in the Hollywood foothills. And it got me to thinking.

Because the thing is, though I've got mixed feelings about Richard Meier's Getty, one thing I do love about the place is the in-and-out on the second floor of the museum, how you move through a few rooms of art and then outside across light-drenched patios and colonnades, and then back in again for more art, and then more light. Indeed, when the museum's director, John Walsh,

was first showing me around the space a few weeks prior to its official opening, I paid him the ultimate compliment. I told him the in-and-out aspect of the museum reminded me of my absolute favorite museum in the world, the Louisiana Museum of Modern Art, a half-hour north of Copenhagen. He smiled and said he wasn't at all surprised, because the Louisiana was one of the places they'd taken Meier in the earliest phases of the design process. They'd shown him the glassed-in halls coursing through the leafy parklands connecting the various art-filled pavilions, and told him that that was the effect they were after.

Now, the Louisiana was designed in the late 1950s by Vilhelm Wohlert and Jørgen Bo, a pair of young Danish architects who'd been heavily influenced by their studies earlier that decade at Berkeley, where in particular they'd come under the thrall of Richard Neutra. So think about it:

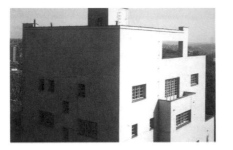

Neutra absorbed what would later be called the International Style during his studies with Adolf Loos in the early '20s in his native Austria…

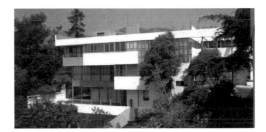

…and subsequently brought it with him to California where he gave it a thoroughly West Coast twist (all that glass and air, wood, and brick, the play of inside and outside)…

…and when, a generation later, the two Danish architects came to study at Berkeley, they became so enamored of the Neutra style that they took it back with them to Denmark, where they gave it a Scandinavian twist of their own at the Louisiana…

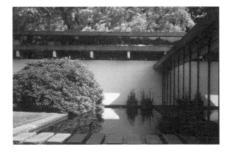

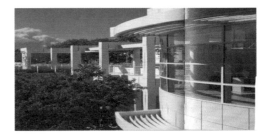

…which in turn so impressed Richard Meier a generation after that that he transplanted that rhyme back again to California, at the Getty.

Europe and America, tolling back and forth, back and forth, in a process, come to think of it, not all that dissimilar from the way, say, that…

24

Fritz Lang, for example, absorbed and reflected the Expressionist angst of 1920s Weimar German film culture (in such films as *Metropolis* and *M*)...

...and then with the rise of Hitler, he and other leading German-Jewish directors fled to Hollywood, where their expressionist temper quickly became transmuted into classic American Film Noir...

...though the term actually derives from the criticism of a new generation of late '50s French cinephiles and soon-to-be directors, such as Jean-Luc Godard, who, besotted with those quintessentially American films, soon began creating such deliriously celebratory homages as *Au bout de souffle*...

...films which in turn were among the principal influences on a whole new generation of American film students, guys like Jim McBride and his sidekick Kit Carson, who, a generation after that, concocted their own celebratory homage, situating it back in California.

Quite a view. Quite a view.

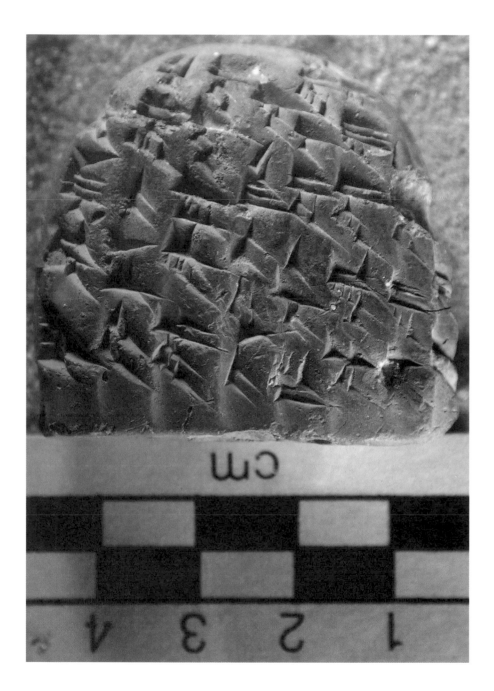

CUNEIFORM CHICAGO

STOLPER'S TABLET / LOGUE'S HOMER / BREYTENBACH'S CELL

This other time, I happened to be in Chicago for a few days and decided to pay a call on my Assyriologist friend, Dr. Matt Stolper, over at the University's Oriental Institute. I'd never actually been to his office, which as it turns out is on the third floor of the Institute's Museum (just down the block, as it happens—though on the far, far side of the History of Civilization—from Frank Lloyd Wright's low-slung modernist masterpiece, the Robie House). Matt's office proved a wide, low-slung affair in its own right, a cavernous warren of tome-lined shelves and narrow-drawered filing cabinets beneath a down-sloping ceiling. The cabinets, as Matt now proceeded to demonstrate for me, were brimming with dozens, hundreds, thousands of cuneiform-engraved clay tablets, one lying snug beside the next, each neatly catalogued on its own little cotton mat—the treasure haul from a university archeological expedition more than sixty-five years ago. Back then, in the depths of the Depression, as Matt explained to me, the University had dispatched teams of archaeologists, one of which included his own eventual teacher George Cameron, to unearth the palaces of the Achaemenid Persian kings Darius and Xerxes (legendary scourges of the Attic Hellenes, when they weren't busy managing a continental empire unmatched for size until the rise of the Romans) at Persepolis, near modern-day Shiraz, in Iran. Over half of the resultant haul has yet to be translated, and translating the individual tablets, one by one, at a grueling, meticulous pace, is essentially Matt's principal occupation.

He picked one up at random: about the size of a dry cake of Shredded Wheat, and just about as legible, at least to my untrained eye. But Matt had no problem: "This one here, for example," he said, palming the tablet and leaning it slightly so

as to rake the light just so over its chicken-scratch jumble of markings, "it's in a variant of the Elamite language, and it concerns, let's see, 'one thousand… eight hundred, thirty… -eight… and a half units of barley'—a unit: that would be about ten quarts—let's see: 'received as rations for workers, for one month,' various numbers of men and women, boys and girls—here's the total: '702 workers.' And then down here we have, hmmm, yes, 'eleven units of wine'—again, about ten quarts each—'for rations for women who have had babies, for one month,' with the women who had boys getting twice as much as the women who had girls."

Matt went on to explain how the core of that haul, sixty-five years ago, had proved to be an administrative-legal archive: "Pretty dry stuff, though not without its occasional charms." He recalled, for example, the jolt he'd experienced one day as he suddenly divined that the envoy whose activities and expenses were being documented on a particular shard before him—a certain figure named Belshunu, in Babylonian, with the title of "Governor of Across-the-River," which is to say Syria/Palestine—had to be the same Belesys, "former governor of Syria," who figured so prominently in the famous account of Cyrus-the-Younger's rebellion in Xenophon's *Anabasis*, "the greatest story ever told to students of elementary Greek," as he put it. "And to actually hold a thing like that right there in your hands," he positively beamed, "it can get to be quite thrilling."

However, even more thrilling, he went on, were those occasions when, after hours of painstaking work, he could begin to make out evidence of people, in effect, cheating on their income tax, or blackmailing their superiors at court with threatened revelations of embarrassing improprieties, or hoodwinking their associates in other sorts of ways. "Just like today," Matt marveled, "only fully twenty-five hundred years ago!"

Driving back north up the shore of Lake Michigan toward my downtown lodgings later that evening, I found myself recalling one of those magnificent sustained epic similes from Homer's *Iliad,* or, more specifically, from Christopher Logue's modern English reworking of same in his sinewy slim volume *War Music,* to wit:

> Try to recall the pause, thock, pause,
> Made by axe blades as they pace
> Each other through a valuable wood.
> Though the work takes place on the far
> Side of a valley, and the axe strokes are
> Muted by depths of warm, still standing air,
> They throb, throb, closely in your ear;
> And now and then you catch a phrase
> Exchanged between the men who work
> More than a mile away, with perfect clarity.
>
> Likewise the sound of spear on spear,
> Shield against shield, shield against spear
> Around Sarpedon's body.

Of course, part of what makes that passage so powerful (apart from Homer's typically startling trick of likening senseless mayhem to peace-filled industry) is that specific, spine-tinglingly synaesthetic line about "catching a phrase exchanged between men who work more than a mile away, with perfect clarity." The image seems to toll and toll, perfectly capturing the relation of Homer, the blind singer, to his subject, a battle that took place five hundred years earlier and hundreds of miles across the sea; and then, of that blind singer to his (seeing) audience, gathered around the fire, listening intently; and then, centuries later, Logue's relation to Homer; and later yet, our relation to Logue. And, of course, as well, my friend Matt's relation to those thousands of crumbly clay shards, the focus of his entire life's work.

Cover of Logue's translation

Speeding northward, the skyscrapers of the city gleaming up ahead, I was in turn reminded of some comments Breyten Breytenbach, the Afrikaner poet and painter, had made to me, as we sat in a Paris bistro one fine afternoon not long after his release from a seven-and-a-half-year stint in apartheid South Africa's prisons on various trumped-up charges of political subversion. He

Prison drawing by Breytenbach

and I were recording his recollections for a radio documentary, and he'd taken to reminiscing about the nights on death row in Pretoria Central Prison. (Though Breyten himself had never been condemned to death, his warders had placed him in a cell there in one of their many attempts to undermine his sanity.) Breyten recalled:

> The hanging room—the actual chamber where they executed prisoners—was, of course, the central characteristic of the place. Even though you never saw the room, you could hear it—you could hear the trapdoor opening. It would send a sort of shuddering through the entire building the mornings people were being hanged. And before that you'd hear the singing with all its different qualities. You could definitely hear when somebody sang—and there'd be singing every evening—that that person was going to die in a few days, as opposed to somebody who still had a few weeks or months. And the interesting thing, or the touching thing, when one person sang alone like that in the middle of the night and you knew he was due to be hanged in two days' time, was how you could actually hear the quality of the listening of the other people, because you knew that everybody else in that prison was awake, lying there with their ears

cocked close to the bars or the walls, listening. You could hear the listening.

Driving along, I could hear Breyten all over again, telling his story, just as I likewise recalled what it had been like subsequently to hear that story over the radio. (It had been an ur-radio moment, listening and imagining I could hear everybody else out there in the radio audience, hushed, straining to listen as well.) And now these sounds and images and silences all began to swim in my mind, and I fancied I could almost hear Logue straining to hear Homer, along with every earlier interpreter of Homer—Virgil and Pope and Chapman and Lattimore—all of them straining to hear, hushed, listening in on all the mayhem and the artifice, the suffering and the cheating: the great silent resounding vault of history, welling forth. And now I was easing off the highway, heading into downtown, and straight ahead, eerie, loomed an uncannily curious building—a modernist white marble monolith, a soaring flatiron wedge slit by a chicken-scratch grid of ultra-narrow windows—which suddenly looked to me for all the world like a giant clay cuneiform tablet.

I had no idea what it was.

The next day I asked someone, and it turned out to be the William J. Campbell United States Courthouse Annex, otherwise known as the Metropolitan Correctional Center—otherwise known as the city jail.

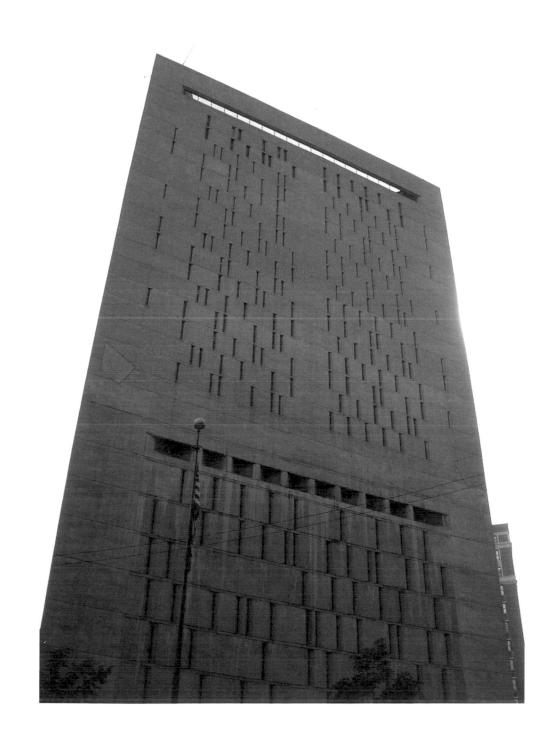

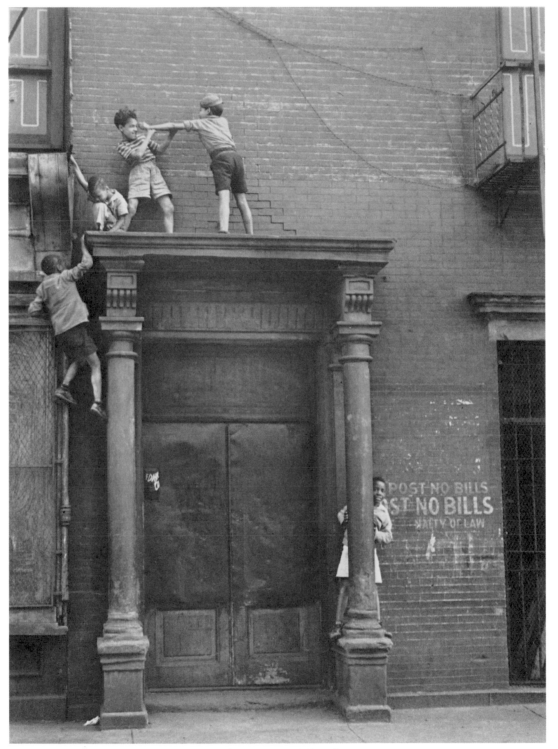

Helen Levitt, Untitled, *1942*

HELEN LEVITT: ILIUM OFF THE BOWERY

LEVITT / WORLD WAR II / THE TROJAN WAR / TAVIANI BROS.

It is around 1942 on the streets of New York City—wartime in a city itself at peace—and an artist is afoot, stalking. "The artist's task is not to alter the world as the eye sees it into a world of aesthetic reality," Helen Levitt's friend James Agee will note by way of introduction to a book of resultant images (*A Way of Seeing*) a few years later, "but to perceive the aesthetic reality within the actual world." The "ordinary world," as he puts it further on, "the irrefutably actual"— "unretouched reality [in the process of] transcending itself." Perusing the harvest of such images, Agee suggests, future readers "will realize how constantly the unimagined world is in its own terms an artist," and at the same time "how deep and deft creative intelligence must be to recognize, foresee and make permanent [that world's] best moments."

Deeply, deftly, Helen Levitt goes stalking.

From Colin Westerbrook and Joel Meyerowitz's history of street photography, *Bystander*, we learn that one of the methods by which she accomplished such uncanny capture was through the use of a *winkelsucher*, a right-angle viewfinder of the sort Ben Shahn was given to deploying around the same time, an attachment which "allowed the street photographer to sight along the camera body while standing sideways to his subject, who consequently fails to realize that he *is* the subject." With the adults, surely, she must have been using some such periscopic device— how else to account for the meltingly unselfconscious self-presentation of so many of her subjects?—though with the children, not necessarily. They are already lost to the world, lost in their own worlds: playing at war, they are not children playing at war; they are warriors, vital, zest-filled immortal heroes, enthused (from *entheos*,

god-introjected), absorbed into all wars for all time. "The games of children have sudden nuances," Levitt herself noted a few years later in an application for a MOMA fellowship, "that reveal the deep repressions of the unyoung." Captured at an angle, her images themselves reflect the world at an angle, provoking more primordial associations.

The effect is reinforced, in the specific image I am remembering just now, by the Doric columns flanking the porch up which the enthused boys are clambering for battle. The columns help ricochet our associations to wartime Europe, to be sure, but beyond that, as well. We are at Ilium off the Bowery, the Trojan ramparts along the Lower East Side. (Only one boy, over to the side, having just spotted us, has momentarily resurfaced to the present, but his gaze seems to come welling back from far, far away.)

This is the flip side of the effect Homer himself often deployed in those extended similes when, for example, he likens the bountiful carnage of battle outside Troy to the golden harvest of peacetime wheat back home. And gazing on this particular image of Levitt's once again, I am suddenly reminded of an equally startling and unforgettable, if more recent, juxtaposition: the scene in Paolo and Vittorio Taviani's cinematic wartime memoir, *The Night of the Shooting Stars,* when (just around the same time as the kids in Levitt's photo, as I suddenly realize), Italian villagers, on the eve of the liberation by the Americans, spill out of their Tuscan hilltop homes and into the surrounding wheatfields, where they presently fall into a civil war, simultaneously vicious and ludicrous—Fascists versus the Resistance—which in turn suddenly transmogrifies into the Trojan War itself, with armor-clad chest-plumed heroes hurling spears at one another. The association is so uncanny that I go to rent the movie where, it turns out (in a detail I'd forgotten) the sudden Trojan War motif comes momentarily welling up from the dumbfounded vantage of a little girl out there in the field, a marveling six-year-old witness, herself the germ (no doubt) of some future artist.

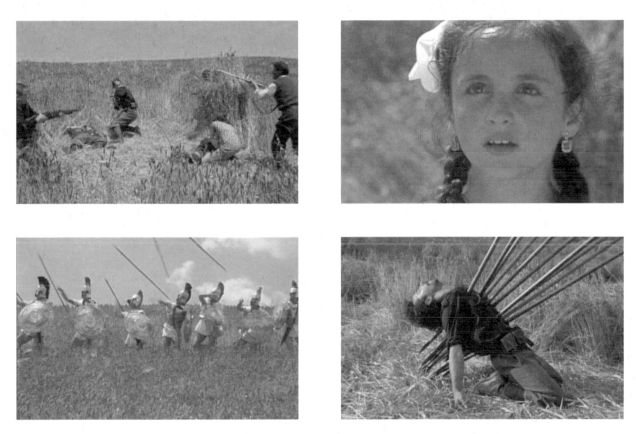

Stills from The Night of Shooting Stars

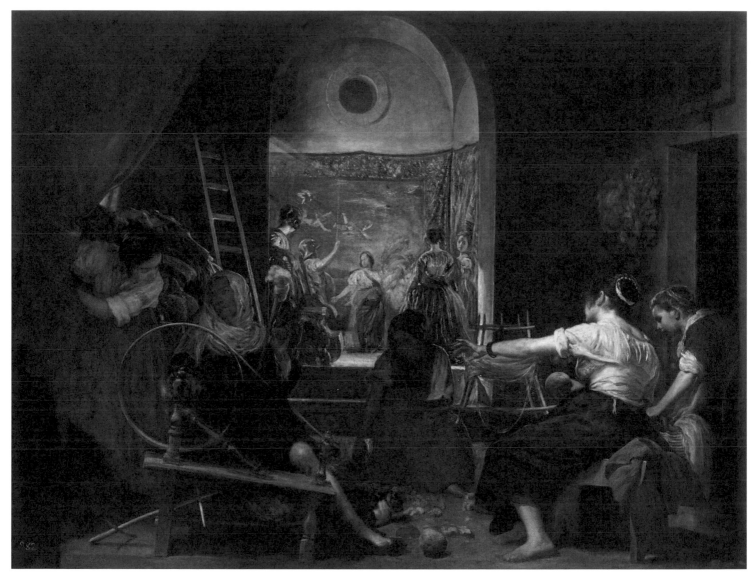

Velázquez, The Spinners, or The Fable of Arachne, *c. 1655*

ZIGGURATS OF PERCEPTION

Arachne / Velázquez / Titian / Jaar

To hear Ovid tell it, at the outset of Book VI of his *Metamorphoses* (and here I am following Ted Hughes's straightforwardly plainspoken rendition), "Arachne was humbly born. Her father / Laboured as a dyer / Of Phocean purple. Her mother / Had been humbly born. But Arachne / Was a prodigy. All Lydia marveled at her." Arthur Golding's marvelous version of 1567 is more ornate: "This Damsel was not famous for the place / In which she dwelt, nor for hir stocke, but for hir Arte [....] But though this Maide were meanly borne, and dwelt but in a shed... yet her trade hir fame abrode did spred / Even all the Lydian cities through." Indeed, so sumptuous were the tapestries she wrought that there were those who claimed she had to have gleaned her craft from the great goddess Minerva herself—a claim that Arachne, for her part, dismissed out of hand: her brilliance was all her own, the head-strong girl insisted, and was if anything greater than that of the celebrated goddess, so what could the latter have possibly taught her? Minerva (or Athena, as she was of course known to the Greeks) was hardly amused by such intemperate boasting and presently appeared before the young maiden, disguised as an old hag, to urge greater piety upon her. The proud young girl spat out her contempt at such timorous advice, going so far as to challenge the goddess herself, should she happen to be listening, to a direct contest, so as to settle the question once and for all. At which point, of course, the old crone instantly transmogrified into the mighty goddess, veritably doubling in size—and the race was on.

As subject for her tapestry, Minerva chose to portray the primordial events surrounding the founding of her own magnificent city, Athens,

and naturally she did so to dazzling effect. But Arachne's efforts were no less astonishing: as her theme, she chose the abject love the gods so often come to harbor for mere mortals, braiding a garland of specific instances (Leda, Danae, and so forth) around the central image of the infamous abduction of the lovely young maiden Europa by a lust-addled Jove, momentarily disguised as a bull.

Upon the contest's conclusion, Minerva spent many minutes pawing over Arachne's creation, trying to isolate the slightest flaw and naturally failing to do so, for the piece was indeed manifest perfection. In a compounding rage, the goddess now took to ripping Arachne's tapestry to shreds and presently to beating the girl as well. "Arachne / Staggered away," in Hughes's rendition, "groaning with indignation. / She refused to live // With the injustice. Making a noose / And fitting it round her neck / She jumped into the air, jerked at the rope's end, / And dangled, and spun." Calming at long last, the fierce goddess subsided into a kind of pity, granting the poor girl renewed life, there at the end of her thread, though transformed forever after into a web-weaving spider.

Why the Spanish King Philip IV's foremost court painter Diego de Velázquez should have been drawn to this myth in particular as the subject for one of his last, and greatest, paintings (composed, most likely, around 1655, almost simultaneously with that other great masterpiece of his late maturity, *Las Meninas*) is likely to remain an abiding mystery, especially given his highly unorthodox treatment of the theme. For one thing, in Velázquez's rendition, the action of the myth is arrested well short of its climax (at the moment when Arachne is first displaying her completed tapestry), and, at that, is relegated to the background of the painted canvas, literally to a back room: the foreground (and a good two-thirds of the canvas's acreage) is given over to a haunting evocation of the sort of proletarian labor—humble women carding and spinning and winding threads of wool—which would necessarily have preceded and thereby grounded the momentous developments transpiring in that backroom. (The painting, sometimes referred to as *The Fable of Arachne*, has just as often, and perhaps more accurately, been catalogued under the name *The Spinners*.) Of course if, squinting our eyes, we momentarily conceive of the three principal threadworkers at the center of that foreground grouping as stand-ins for the Three Fates, spinning and measuring and then snipping the courses of human life, we might imagine them, too, as integral to the myth unfolding behind them, for then all the more literally would they be holding Arachne's fate in their hands.

But of course the canvas is overdetermined, the exquisitely nuanced product of a genius working at the peak of his powers, over any number of weeks and months, during which time he could have built into his canvas any number of continuously shifting and countervailing inter-

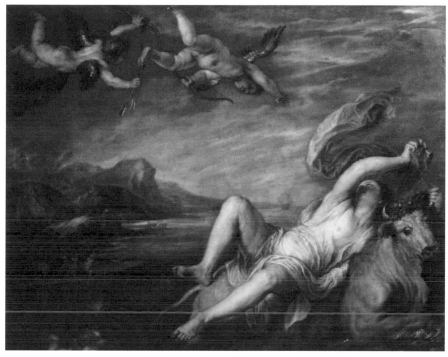

Titian, The Rape of Europa, *1559*

pretations. Surely key to one of those clusters of possible meaning is the nature of Arachne's tapestry, draped at the rear of the back room and opening out, as it were, onto a whole third layer of imagery. And not just any imagery, for Arachne's labors turn out to echo (anticipate? replicate?), quite specifically, the version of Europa's abduction which the great Venetian master Titian, in 1559—almost precisely a century before Velázquez's efforts (and almost simultaneously, for that matter, with those of Ovid's

Elizabethan translator Golding)—had rendered under commission to that magnificent predecessor of Velázquez's own patron, Philip II of Spain. That canvas, in turn, by Velázquez's own time, had grown to be considered one of the greatest treasures in the Spanish Imperial collection. As many critics have subsequently noted, there's thus an element of brazen cheek in Velázquez's insertion of the earlier panel into his own rendition of Arachne's tale, as if he were positing himself in direct competition with the great demigod

Titian: for look, he seemed to be asserting, he could even top the vaunted master—for example, by rendering motion itself in the spinning of the wheel, a truly uncanny illusion well beyond the earlier painter's powers.

Myself, I've always been struck by a different aspect of the painting's possible meanings—for lack of a better shorthand, shall we say, the class connotations the canvas so conspicuously raises, the way the painting seems to insist on foregrounding the question of the precise relation between the working poor and idle aristocrats lording over them. Of course, no one is suggesting that Velázquez was any sort of proto-Marxist, although there is considerable evidence to the effect that during those years in particular, the painter had become ensnared in an anxious and ugly class drama of his own. Jonathan Brown, in his 1986 monograph *Velázquez: Painter and Courtier,* has unearthed a fascinating tale regarding the ways in which, during his later years, the relatively humbly born Velázquez, through his abject service to the king, was angling to elevate his own status at court and specifically to gain admission to the prestigious knightly Order of Santiago. Despite the king's sponsorship, however, and for that matter further letters of support from the papal nuncio, Velázquez's applications went repeatedly rejected, for the Order's rules specifically proscribed "those who themselves, or whose parents or grandparents, have practiced any [such] manual or base occupations [as] silversmith or painter, if

he paints for a living, embroiderer, stonecutter, mason, innkeeper, or scribe." Brown notes how "this regulation speaks tellingly about the social status of painting in seventeenth-century Spain," and goes on to suggest the ways in which, in this context, Velázquez's picture might be read as a defiant assertion of the worth of painting itself (Titian's efforts, and by analogy, his own)—placing them on a virtual par with the labors of the gods themselves, the contemporary nobility's own narrowly blinkered prejudices notwithstanding.

Which is fine, as far as it goes, but it seems to me that Brown's observation could be taken considerably further. There is a conspicuous layering of protagonists in this image: modestly attired working women engaged in a manifestly noble labor in the foreground; sumptuously garbed noblewomen (especially the two on the right) idling away their time in the middle field; and then, in the far distance, a modestly attired Europa, beloved of the gods. (If anything, the protagonist in Velázquez's canvas who most resembles Titian's Europa, both in terms of clothing and placement in the picture, is the seated, white-bloused threadworker, second from the right in the foreground, arguably the painting's most prominent and lovingly rendered figure: consider, as well, in this context, the way her own casually naked foot echoes that of Titian's heroine.)

And now imagine the context in which Velázquez's painting would have been seen at the

court of Philip IV, the sorts of people who would have been standing in front of it, doubtless dressed, if anything, like the idle noblewomen of the painting's second layer. A veritable ziggurat of perception opens before our eyes: noblewomen idly gazing upon working women slaving away so that noblewomen can idly gaze upon the image of a peasant woman being carried off by the gods.

El Castillo, Chichen Itza, Yucatan

A ziggurat, for that matter, like nothing so much as the Aztec or Mayan pyramids that had famously characterized those mighty indigenous civilizations that a few centuries earlier had collapsed before the onslaught of the Spanish conquest of the New World. Or rather, maybe, more precisely, a deep-burrowing mine—the silver mine, say, in Potosi,

high in the Bolivian Andes, inside the bowels of which thousands of enslaved Indians had perished while excavating the very wealth upon which the lavish court life in Madrid was to be grounded for generations to come.

Or maybe even an open pit mine, an inverted ziggurat, like the

Alfredo Jaar, 1985 (this and above)

one, in our own time, that the Chilean-American art-photographer Alfredo Jaar came upon in the summer of 1985: forty thousand men, avid for gold, having left their families and communities behind, to burrow, Sisyphus-like—a veritable hive of Sisyphi—into the irregular formations of the Serra Pelada in the northeastern Amazonian rainforest of Brazil.

Returning to New York with a trove of such images, and confronted by the dilemma of how to present them in the sort of uptown gallery setting that nowadays stands in for the royal courts of yore, Jaar hit upon the inspired notion of slotting close-ups of the faces of the exhausted miners into elaborately ornate gold-leaf frames, replicating for a moment, the very same vertiginous ziggurat of perceptions first broached by Velázquez back in the middle of the seventeenth century.

The great Weimar theorist and critic Walter Benjamin once noted how "the historical materialist views [cultural treasures] with detachment. For without exception the cultural treasures he sur-

41

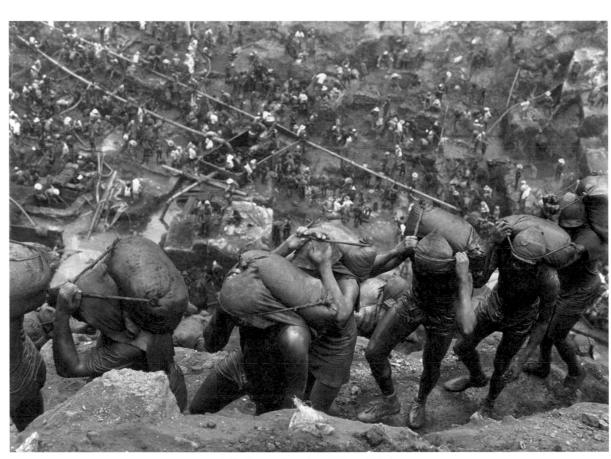

Alfredo Jaar, from the series Serra Pelada

veys have an origin which he cannot contemplate without horror… There is no document of civilization which is not at the same time a document of barbarism. And just as such a document is not free of barbarism, barbarism taints also the manner in which it is transmitted from one owner to another." This is the famous passage that culminates as he urges the student of culture always "to brush history against the grain."

EXPRESSIONS OF AN ABSOLUTE

POLLOCK / GALAXIES / ROTHKO / MOON

"Narrowing and raising it to the expression of an absolute," (we are with Clement Greenberg, rhapsodizing on the uncanny quality of the present—or presence—in Jackson Pollock's famous drip paintings of the late '40s and early '50s) "…an absolute in which all relativities or contradictions would be either resolved or beside the point." Or Patrick Tyler, around the same time, noting how in these paintings, "Something which cannot be part of the universe is made to represent the universe in its totality of being." Or more recently, with T.J. Clark, in the marvelous essay on Pollock in his *Farewell to an Idea: Episodes from a History of Modernism*: "Maybe the dream was of extraterrestiality," and elsewhere, "with lines hurtling across the picture surface as if across a paper-thin firmament, shooting stars, comets," or again, "an endless plunging (like Lucifer) through the heavens… [the paintings'] throws reach[ing] out toward weightlessness… lacy, nebulous," the paintings themselves evincing "an unapologetic emptiness, like a glimpse into deep space."

I am, of course, hardly the first to have sensed the galactic quality in the great Pollocks of that period (who with eyes to see hasn't sensed it?)—a quality closely tied to their ravishing opticality, the sense, somehow, that they are purely, sheerly optical, impervious to synaesthetic associations (to taste or smell or sound) of any kind—explosions, precisely, without sound, as might occur, as do occur, endlessly in the endlessness of deep outer space. Prosaically, lunk-literal-mindedly, I've wondered to what extent Pollock was being subliminally influenced by the color images of telescopic deep space suddenly proliferating in all the popularizing magazines and books and movies of the period. And, too, I've wondered

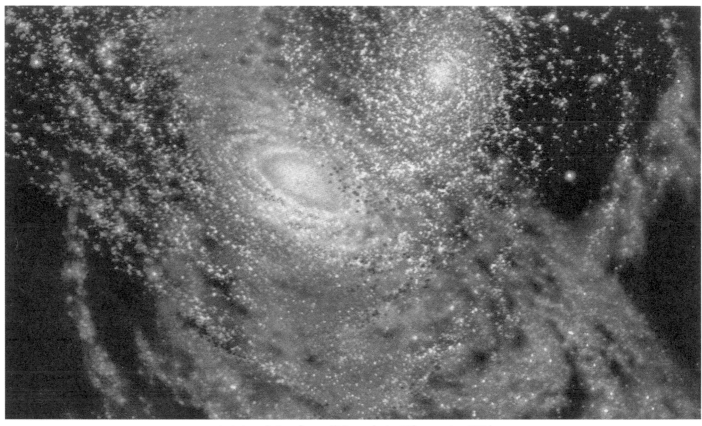

Artist's rendering of two colliding galaxies, Life *magazine, 1954*

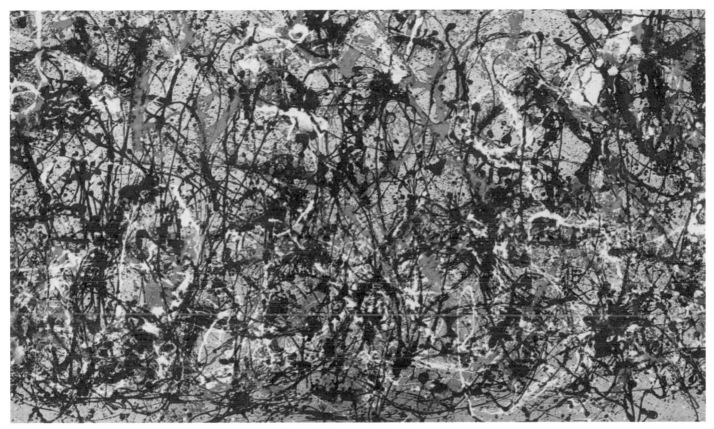

Jackson Pollock, Autumn Rhythm, *1952*

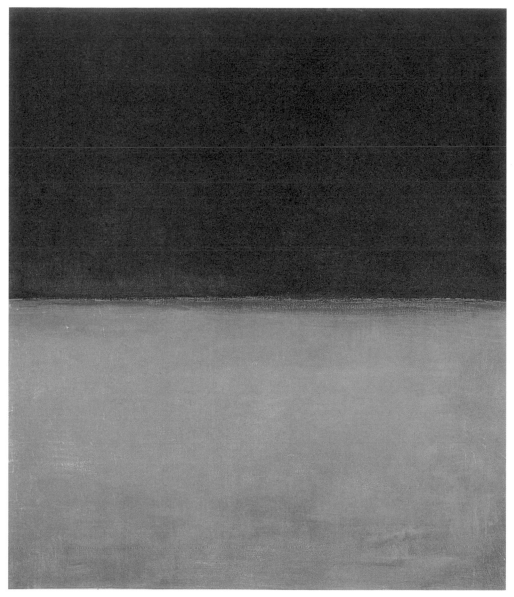

Mark Rothko, Untitled, *1969*

about the human scale—the place of the human in the unfolding drama. Standing before such paintings, I can get to feeling positively infinitesimal (less than minuscule, a merest speck, utterly, in Greenberg's phrase, "beside the point"); or, alternatively, as my eyes sweep the canvas and my mind identifies, momentarily, with the glory of the painting's making, I can get to feeling almost godlike. One is reminded of the various self-dramatizing films made of Pollock around the time he was making those paintings—a Colossus striding purposefully from side to side, pausing, stabbing, hurling the universe itself into existence. As if Michelangelo's Sistine Adam, summoned to life by the finger tap of God, had risen up and was now himself returning the favor, majestically conjuring an entire cosmos into being. Fiat lux, indeed.

With Rothko, of course, it was always different. Not Genesis so much as Exodus. "The people who weep before my paintings are having the same religious experience I had when I painted them," he said. "And if you are moved by the color relationships, then you miss the point." Then he committed suicide.

Doesn't just about everyone experience that same shudder of vertigo standing before one of those great paintings of Rothko's high maturity—the canvas poised neatly between self-possession and self-divulgence: it draws you out and gives Nothing back. Its presence, like that of a black hole, is of such density that you might lose your Self there. Mute totemic authority: like what it must have been like to stand before the Burning Bush. For those Rothkos do not make a statement; rather, they raise a demand, or more precisely maybe, a question. The kind of questions, though, that the kabbalists raised, the kind larger than the sum of their possible answers—nothing can exhaust them. There is a moment in looking at those paintings when we stop looking at them and they start looking at us—at, and if we are not careful, if there is not enough of us there, straight through us. We can't help ourselves: these Rothkos keep bleeding out of aesthetical categories and into ethical ones. Not, is it beautiful? But rather, how should one lead one's life?

I was thinking about all this again the other day, as I wandered through the painter's recent retrospective, Rilke's lines before an archaic torso of Apollo thrumming through my head, as they often do whenever I find myself suddenly coming to myself, standing before such a Rothko, the painting breaking out of all its contours / like a star: for there is no place / that does not see you: You must change your life.

I moved on: the rooms were arrayed in chronological order, so that the colors were gradually stratifying, growing more bulbous; now they were becoming ethereal; already they were coalescing, darkening, shivering toward their stark finale, night horizons, death...

And then suddenly I happened to notice the

date on that last painting: 1969. Night horizons, indeed, but like no night on earth. Rather, of course—the pitch-black upper half of the painting; the shimmering, flimmering, ghost-white expanse of the bottom half—like nothing so much as night (or rather day) on the Moon. The very image, come to think of it, that was being broadcast repeatedly, plastered everywhere, that amazing summer of the moon landing. (I remember marveling, at the time, about how the moon would be a place where you knew it was day because the ground was shining.)

I don't want to make too much of this: of course I'm not suggesting that Rothko lifted his final imagery from the morning papers. But I do find myself pondering: A Giant Leap for Mankind? Godlike, unprecedented, Man had vaulted forth into the heavens, a mammoth enterprise, a stunning achievement: a man on the moon. And yet on the moon, there was nothing there (what-in-God's-name-else had we been expecting?). A vast interminable emptiness: a howling, airless silence. A vacuum of meaning: absolute solitude. And I do find myself wondering how Rothko himself was experiencing the images flickering across the TV, the photos bannered across the morning paper, that (for him) terrible summer.

POSTSCRIPT
Auden, for his part, was not impressed: "Worth going to see?" he mused, in his August 1969 poem "Moon Landing," "I can well believe it. / Worth seeing? Mneh! I once rode through a desert / and was not charmed: give me a watered / lively garden, remote from the blatherers // about the New, the von Brauns and their ilk, where / on August mornings I can count the morning / glories, where to die has meaning, and no engine can shift my perspective. // Unsmudged, thank God, my moon still queens the Heavens / as She ebbs and fulls, a Presence to glop at [...] and the old warnings still have power to scare me: Hybris comes to / an ugly finish, Irreverence / is a greater oaf than superstition."

Whereupon he concludes: "Our apparatniks will continue making / the usual squalid mess they call History: / all we can pray for is that artists, / chefs and saints may still appear to blithe it."

The Moon, Untitled, *1969*

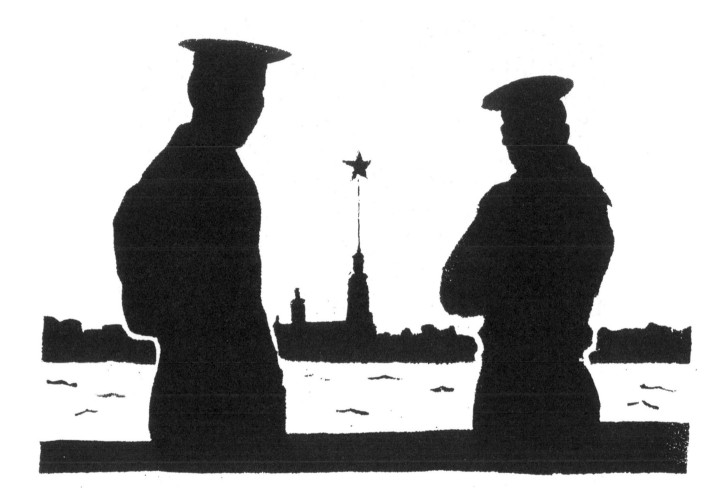

SPOJRZENIE W PRZESZŁOŚĆ

KRET

GAZING OUT TOWARD

Kret / Eisenstein / Friedrich / Diebenkorn

The year is 1989, the walls are Polish, over forty years into their communist dilapidation, the drab flaking flanks of those crumbling gray apartment blocks surrounding Warsaw, Lodz, Wroclaw, and Lublin—and suddenly, everywhere, it seems, they are blossoming over with sprayed, stenciled bits of graffiti.

The particular image I am recalling just now was the work of an astonishingly talented young vandal who was going by the name Kret ("Mole")—consider the sheer mastery of line and scissor blade involved in the rendering of those palpably inhabited sprayed silhouettes. Kret's image revisited the bracing Eisensteinian

Still from Battleship Potemkin

Bolshevik iconography of the 1920s: those virile Potemkin sailors, solidly planted, gazing confidently out into the utopian communist future. Only Kret was completely upending Eisenstein's intent through the deployment of his own sly caption, which read, A GAZE INTO THE PAST.

Such that we were confronted with a marvelous sort of time mirror through which we in the present were being invited to look over the past's shoulder, through a glass darkly, at that past's future, in all its counterfeit luster, which is to say at our own decrepit, dystopian present-day selves.[1]

Standing there, gazing, we couldn't help but

1. Or, as in the lines of T.K. Whipple that Larry McMurtry uses by way of epigraph to his own novel, *Lonesome Dove:* "Our forefathers had civilization inside themselves, the wild outside. We live in the civilization they created, but within us the wilderness still lingers. What they dreamed, we live, and what they lived, we dream."

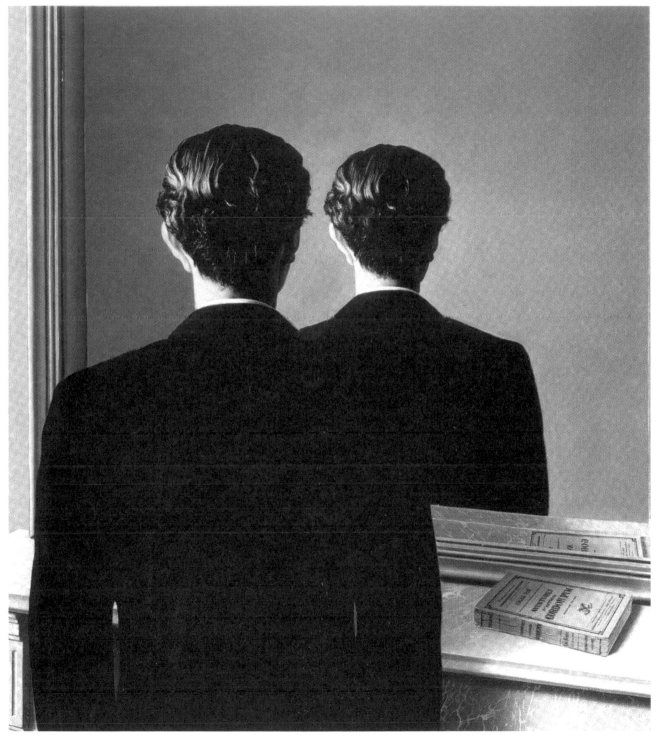

Magritte, La reproduction interdite, *1937*

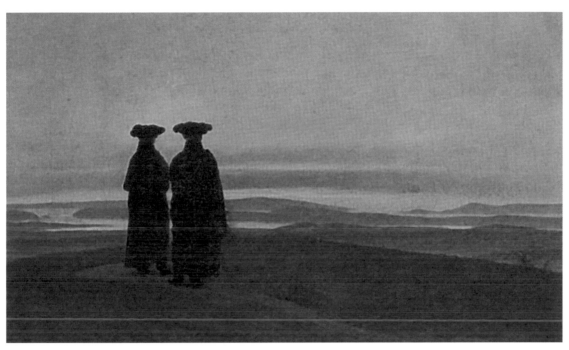

Caspar David Friedrich, Evening Landscape with Two Figures, *1830*

assume the sailors' very posture: that same slouch, arms folded or stuffed into pockets, bodies momentarily stilled. Or was it rather (the wry punk anarchist's caption notwithstanding) that at that particular historic juncture, we no less delusionally than they were finding ourselves gazing forward into our own (this time capitalist) utopian future?

Funny the way mirrors (time or otherwise, canvas or crystal) are constantly doubling and redoubling possible significations in a vertiginous regress.

Though not even a mirror exactly, in Kret's case, for his sailors' backs are to us (like the backturned reflection of the backturned bourgeois cypher, our stand-in, in Magritte's seminal *La reproduction interdite*). We both see them and see with and through them. Their eyes become ours in a sort of gathered focus—or rather, a sort of ingathered and then outpoured vantage. (Not unlike, come to think of it, the pinhole corneal lens of the human eye's pupil—see p. 204—the outer light rays converging on and through that corneal hole and then spreading back out again

toward the retinal wall on the far side.)

Think in this context of other such images, say, Caspar David Friedrich's 1830 *Evening Landscape with Two Figures* from the Hermitage (in Eisenstein's Petrograd: wonder if that's where he got the idea). We both see the two figures and see through them, toward the sublime smear of a vista spreading out toward the horizon beyond. The sublime, however, is precisely not an appearance; rather, it's an experience. We too experience it, as it were, through them, but only (through an alchemy of concentrated outwardness) by seeing past them. As they fall away, it rises, Rothko-like: cover the figures in such images of Friedrich's with your palm and what you have left are indeed Rothkos avant la lettre. The sublime as nature momentarily abstracted or transmuted into a sort of heightened experience of nature.

Abstraction and figuration. Richard Diebenkorn was forever moving back and forth between the two, seemingly always out of fashion (figurative in the '50s and early '60s when everybody else, seemingly, had gone abstract; abstract in the later '60s when everybody else was going figurative), though in fact he was continually folding the one into the other, discovering the taproots of each in its apparent opposite. Such was most notably the case in the remarkable sequence of figure paintings he composed in the early '60s as he was phasing out of his figurative spell and into the haunting Ocean Park series of abstractions which were to consume most of his next couple decades. Often in those days he would give us solitary women, staring out and deeper into the image: the composition of the paintings as a whole (the diagonals, the swaths and blocks of slathered color) anticipated the Ocean Park abstractions of a few years later, but those windows or balconies or patioscapes or vistas into which the women were staring were (Friedrich-like) already pure abstraction. Klines, perhaps, rather than Rothkos. Albino Klines.

Abstraction: to be lost in thought, lost to thought, transported out of oneself. But out of oneself toward what?

Richard Diebenkorn, Untitled, *1960*

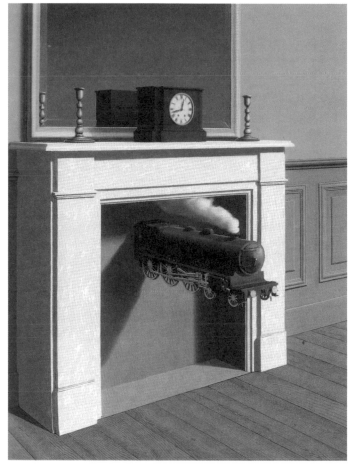

Rene Magritte, Time Transfixed, *1938*

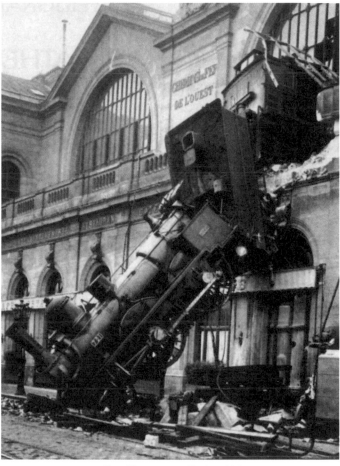

Gare Montparnasse, Paris, 1895

MAGRITTE STANDARD TIME

MAGRITTE / EINSTEIN / SIMMEL

In olden days, time was true. Noon occurred in every village at the very moment that the sun reached its zenith over the courthouse steeple. Trains—in particular, transcontinental rail travel—changed all that. In the era before time zones, passengers on coast-to-coast trips might well have had to jimmy their watches dozens of times, adjusting to the separate temporal reality of each locality through which they traveled. (Schedules were similarly scrambled; New York City's noon was Buffalo's 11:40.) For years, people puzzled over these mysteries and muddled through the confusion—what did it mean, for instance, to say that two events happened at the same time in two different locations?—until, in 1884, an international conference finally resolved the problem by decreeing a unified system of standardized time zones.

Is it any wonder that a genius, born in 1879 and growing up in a world grappling with these issues, would go on to formulate a theory of relativity which deployed trains as one of the principal motifs in its exploration of simultaneity? ("Lightning has struck the rails on our railway embankment at two places A and B far distant from each other…") And is it any wonder that, a generation later, a leading Surrealist painter would have recourse to the same train motif in his 1938 painting *Time Transfixed* (*La durée poignardée*)?

But what of *this* coincidence: René Magritte was born in 1898 in Lessines, Belgium. The train pictured in the photograph on the right overshot the Gare Montparnasse, in Paris, on October 22, 1895. Surely no relation. Except that it was Magritte himself who gave us to understand that everything is relative and everything is simultaneous.

Always has been. Always will be.

* * *

The foregoing first saw print as a sort of send-off to the Magritte retrospective that was then about to leave town, headed for Houston, with the reference to the five-year-old Einstein offered up by way of speculative flourish, a clever afterthought. Little did I know.

It turns out that this business of the young Einstein's immersion in questions of train time and clock accuracy was central to his entire development, and that of his theory. I doubt I am particularly unique in long having imagined Einstein's day job at the Swiss patent office as something akin to Kafka's, around the same time, in the railway (!) insurance bureaucracy over in Prague: mindless drudge work, something to help pay the bills while the real work of genius transpired late at night and around the margins. It turns out, though, that the central focus of Einstein's work there at the patent office in Bern around the golden year of 1905–06 (perhaps not surprisingly so, Switzerland after all being famous for being the world's center for clockmaking) were applications having to do with devices capable of ever more accurate timekeeping. Indeed, as the Harvard historian Peter Galison, who had the wit to actually go look up some of those patents, recently showed in his thoroughly engrossing new book, *Einstein's Clocks, Poincáre's Maps,* that question of the need for ever more minute degrees of accuracy was *the* technical challenge of the moment, the specific

challenge in question being how to establish simultaneity across great distances (not only for the sake of train schedules and scientific experiments, but also, for example, so as to facilitate precision in mapmaking, this also being the climax of the great age of those far-flung colonial boundary-establishing surveys)—and what with his job at the patent office, the young Einstein may have been the world authority on cutting-edge practice and thinking in these regards. He would have been thinking about simultaneity all day long: and at night he just kept right on thinking.

Incidentally, Einstein was hardly alone at that moment in trying to puzzle out the paradoxes of absolute movement and total stasis. A few years earlier, in an entirely different field, another German-speaking Jew, the philosopher Georg Simmel, had been wrestling with parallel issues. In the conclusion to his magisterial *Philosophy of Money,* published in 1900 (the same year as Freud's seminal *Interpretation of Dreams*), Simmel had marveled at the fact that "There is no more striking symbol of the completely dynamic character of the world than money. The meaning of money lies in the fact that it will be given away. When money stands still, it is no longer money according to its specific value and significance. The effect that it occasionally exerts in a state of repose arises out of anticipation of its further motion. Money is nothing but the vehicle for a movement in which everything else that is not in motion is completely extinguished." But if in one

Einstein, before and after

of its aspects Simmel saw pure motion in money, in another he located an absolute stillness. "As a tangible item, money is the most ephemeral thing in the external practical world; yet its content is the most stable since it stands as the point of indifference and balance between all other phenomena in the world…"

But that's another story, I suppose—unless, of course, you're trying to determine the true value, say, of a painting of a miniature locomotive emerging full bore from out of a fireplace. The answer, naturally, is that it depends. It's all relative.

WOMEN'S BODIES

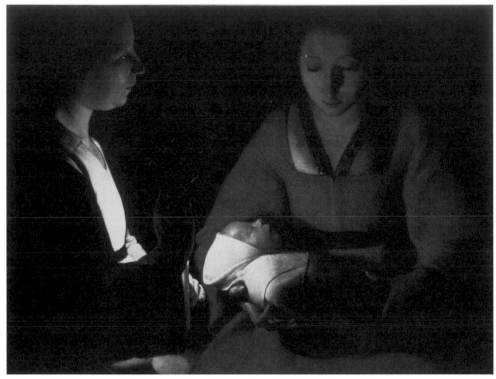

Georges de La Tour, The Newborn Child *(detail), c. 1645*

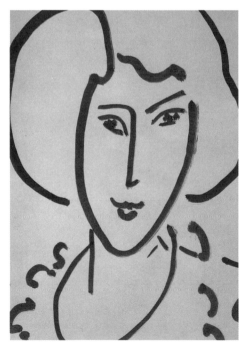

Henri Matisse, Study of a Woman (Sirene), *1950*

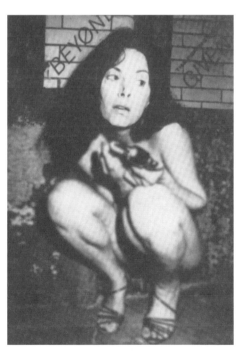

Hannah Wilke, Self Portrait, *1978*

FOUND TRIPTYCH

DE LA TOUR / MATISSE / WILKE

If you happened to be a writer who, like me, occasionally covers the art scene, you, too, would probably grow inured to having your daily mail larded (or should I say, festooned?) with cards and notices promoting the various upcoming openings and exhibitions. Sometimes, though, the juxtapositions can get a little strange. A while back, for instance, my mail happened to include three such announcements which I opened in random order, as replicated to the left, notices proclaiming, in turn, a Georges de La Tour retrospective at the National Gallery of Art in Washington, D.C.; a Matisse drawing survey at C&M Arts on 78th Street in New York; and a reprise of performance videos and self-portraits by the late Hannah Wilke, at the Ronald Feldman Gallery in Soho.

The happenstance triptych, fanned out there on the desk before me, grew more and more uncanny. I mean, de La Tour's 1645 Madonna and Matisse's model Sirene from 1950 were somehow almost the same woman—that same long nose, at any rate, those same delicately mottled lips. But then Matisse's Sirene wasn't all that different from Wilke's 1978 self-image either. The startlingly theatrical left-side chiaroscuro lighting of the de La Tour mother, cradling her baby, was mirrored in the similarly dramatic right-side illumination of Wilke, cradling her pistol (so much so that one would have sworn that Wilke herself must have had de La Tour somewhere in the back of her mind).

As I continued to gaze upon the random splay, my mind started being flooded with all sorts of associations—thoughts, for instance, about the passage from the early modern through the high modern to the postmodern, or from the sacred to the profane, from well-nestled security

through raw vulnerability—insights into the differences in how men see women and how women see themselves (or rather, maybe, how women see themselves being seen by men). All sorts of things. And I was going to write them all out right here right now, but then I thought (in the immortal words of my fellow occasional art-dabbler, Ian Frazier): naaaah.

GIRLS IN THEIR TURNING

RICHTER / VERMEER / VELÁZQUEZ

In 1988, the German master Gerhard Richter drew on a photograph he'd taken of his daughter Betty ten years earlier as the source for a painting which was to become one of the most vivid iconic images of the late century—a wistful complement to Eisenstein's sailors (created, as it happens, a mere year before Kret's stencil—see page 50). (It currently hangs in the St. Louis Art Museum, and for its sake alone, the place is worth a considerable detour.)

Betty does seem to be gazing back rather than into any sort of misty future. In 1978, at the time of the original photo, Betty had been eleven; in the painting (otherwise completely faithful to its source), she's indeed more like twenty-one. In 1988, Richter was just coming off a sequence of harrowing monochromatic gray paintings, the "18 October 1977" series, a searching depiction of the grim fate of the Baader-Meinhof terrorist group. With Betty (another late-'80s vantage on a late-'70s subject), it was as if, through luscious color, Richter were being called back, were calling himself back, to life.

And yet the image is saturated in a sort of melancholy, a pang of yearning, time caught in its passing and already past saving, a different kind of experience of the sublime.

I am reminded (I'm sure Richter, too, had the image in mind and that it's he who is the one reminding me[1]) of another fleeting father-daughter vantage, or so, anyway, they used to say: Vermeer's *Head of a Young Girl*. Who knows whether the girl with a pearl was actually the painter's daughter (he had fourteen children). The

1. "Giorgione might have made that sky," exults Gulley Jimson, the perennially exuberant painter protagonist in Joyce Cary's *The Horse's Mouth*. "And probably he did. He made me see it."

Gerhard Richter, Betty, *1988*

Gerhard Richter, Confrontation 1, *1988*

Jan Vermeer, Head of a Girl (Wearing Pearl Earring), *1665–1666*

longtime conceit does lend the eternally fresh image a certain added poignancy.

But what is it about *that* painting anyway? The finest elucidation of that riddle I've ever encountered is in Edward Snow's magnificent prelude to his *Study of Vermeer:* twenty-two pages on that one painting, and almost every sentence a startling new insight. Has she just turned toward us, Snow asks by way of entry into the image, or is she just about to turn away? Through a close reading of the painting, Snow argues that certain of its aspects suggest the former answer (cover her face with your thumb and note how everything else in the image conspires to suggest a profile), while others—the fall of the turban from the back of her head toward the front of her forward-facing shoulder—evoke a countervailing torsion. In fact, suggests Snow, the answer is both: she has just turned toward us and already she is turning away. Hence the pang (the pearl, a sort of displaced tear).

Richter's Betty, for her part, was looking at us just a moment ago: her attention has only just now been drawn elsewhere. But where? The sense of moment, at any rate, is as immediate and transfixing as Vermeer's.

Compare the knot of Betty's hair, ingathered on itself, with the odd turban sworl atop Vermeer's girl. Snow is especially good on that turban:

> The turban, like so many of the inanimate objects in Vermeer's paintings, gathers up invisible, half-sensed elements that resonate at the human center—in this case, the viscerally felt grief and desire, capture and release. Its knotted portion is wound in tight repetitions—as if to define, contain, defend, hold tightly to the pearl-like integrity of the head. The pendant, however, lies outside the compulsion to conserve and/or repeat: it falls, once and for all, out into the element of gravity— yet remains attached to the knot from which it issues. And the polarity between the two parts of the turban is itself unstable; there is a stiffness about the pendant that undermines the release and self-abandon of its fall, whereas the knot folds itself softly in upon itself with lotuslike contentment.

Capture and release. A punctum. An inheld breath. The ingathering, the self-possession of consciousness itself. All of these seem similarly limned in Richter's treatment of Betty's hair, which likewise recalls a parallel treatment—a similar sense of ingathered moment—in another picture to which I feel certain Richter is consciously alluding: Velázquez's Rokeby Venus. She, of course, is gazing both imperiously away and then (by way of the mirror) right back at us, calmly taking our measure, the very epitome of near-regal self-possession. The point is that once again, here in the Velázquez, that baited sense of moment, of consciousness conscious of itself—hers, our own— is evoked by that hair wound tight.

Back to Betty, though. For what is she looking at? That brownish gray amorphous expanse?

Turns out (note the band of white wall at the bottom right-hand corner), it's a painting, one of her father's, one of a series of mammoth gray mirror paintings (enamel under glass—smooth, sheer, and highly reflective) that he had been contriving around the same time and that now hang along-side the Betty painting at the St. Louis museum. As in both the Vermeer and the Velázquez, turning away she is turning toward, as in turn are we through her.

Intersubjectivity: gazing back, outward, at the site of our own innermost being.

Diego Rodriguez Velázquez, Venus and Cupid (Rokeby Venus), *c. 1650*

70

LANGUOROUS LANDSCAPES

GEYER / VELÁZQUEZ / MAN RAY / CHAGALL / L.A. CLOUD

So I was visiting my friends Pepe and Dionora in Santiago, Chile, a while back—they're great art lovers and their apartment nests a collection of marvelous books—and Pepe was escorting me through this one particularly sumptuous volume given over to the life and works of the Venezuelan folk master Juan Félix Sánchez (weaver, potter, sculptor, builder-by-hand of rock-hewn highland churches); and presently, turning the page, we happened into a magisterial spread by the photographer Sigfrido Geyer, evoking the undulating hill approach to Sánchez's hardscrabble lair—and, quite unself-consciously, I found myself gasping: "Velázquez's Venus."

Pepe looked over at me quizzically, noncomprehending.

"The Rokeby Venus," I clarified, self-evidently.

I got up and grabbed a Velázquez catalog from a nearby shelf and turned to the image in question—and Pepe started laughing, whether at or with me I wasn't quite sure.

"The long, languid spread of her body makes the first and most lasting impression." It was the inimitable Edward Snow, I suppose, in a superb little essay he squirreled away a long time ago in an out-of-the-way, short-lived journal (*University Publishing,* Issue 3, Winter 1978), who first set me to thinking along these lines: of the Rokeby Venus, that is, in addition to everything else, as a sort of extended landscape. "She unfolds and

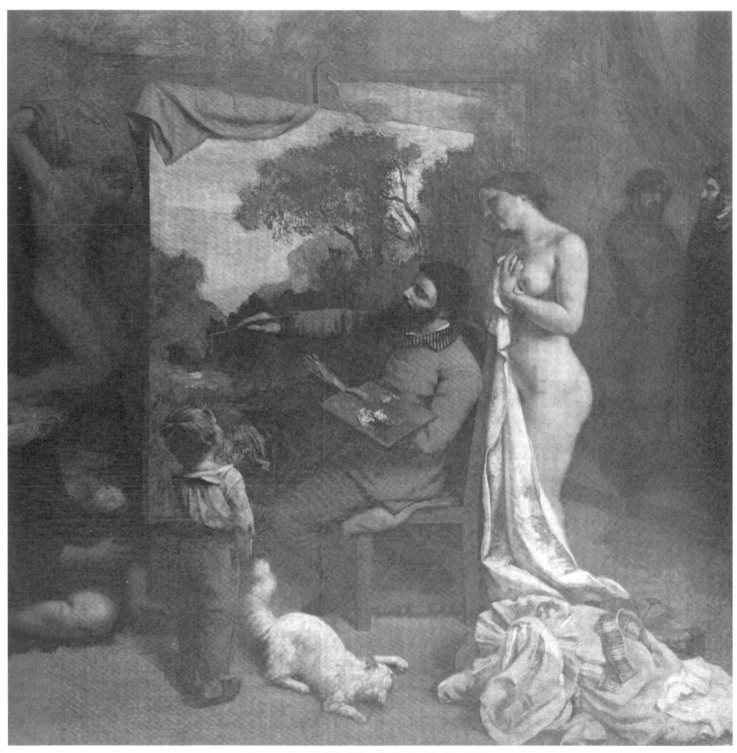

Gustave Courbet, The Painter's Studio *(detail), 1855*

extends before the eyes like the manifestation of a vast inner horizon. (The reflection in the mirror rests beyond her like a setting sun.)"

In Geyer's instance, it was the cloud bank over the haunch of hill, rather than any putative sunset, that more precisely echoed the tuft of white fabric just beyond Velázquez's goddess. But still…

Not that I'm the only one subject to these sorts of landscape-bodyscape slippages. Far from it. Edward Weston, for example, seemed to be falling into them all the time. One of Courbet's most astonishing paintings, *The Origin of the World*, his evocation of a languorously reclining nude, swathed in bedsheets with legs spread wide, the image cropped in tight so as to divulge only the expanse from breasts to midthigh, conspicuously echoes several of his lush river- (or rather gorge-) scapes, such as *The Source of the Loue* (a grotto) and *Le puits noir* (The Black Well); and indeed, the central grouping in perhaps his most famous allegory, *The Painter's Studio*, portrays a naked model, presumably on a break, bedsheets clasped to her chest as she stands gazing, in rapt absorption, over the artist's shoulder at his latest creation, another lush riverscape for which one can't help wonder-

Diane Cook, Back Basin, Yellowstone, *1992*

ing whether she herself wasn't the model. (Michael Fried has a nice discussion of all this in his book *Courbet's Realism*.) The other day, meanwhile, the photographers Len Jenshel and Diane Cook were recalling for me a time when they had occasion to be showing the poet W.S. Merwin a sheaf of their then-recent vantages of Yellowstone shrouded in snow, riffling from one photo to the next, when the poet suddenly stayed their hand before a particularly suggestive image, virtually whistling, "Boy, would I like her number."

Later that night in Santiago, jetlagged, insomniac, I was padding about Pepe and Dionora's living room and pulled the Sánchez volume off the shelf once again. I turned to the "Rokeby spread," as I'd taken to thinking of it, only this time the associations were altogether different. Something about the barely suggested diagonal swath that cut clean across the valley floor—what was it? a cowpath, perhaps?—and now I was instead experiencing the image not so much as a lollygagging, backturned nude but, rather (what with the two undulating hills above the path and the supple cleft separating the two of them), as a vast, front-facing set of lips. Luscious lips spread clean across the sky… For, of course, now my associations were all to Man Ray's celebrated

Man Ray, A l'Heure de l'Observatoire: les Amoureux, *1933*

1933 canvas, *A l'Heure de l'Observatoire: les Amoureux.*

Pepe's well-stocked shelves soon yielded up a Man Ray catalog as well, and the match was indeed uncanny. Even more uncanny, though—for now I'd pulled down the Velázquez volume one more time—was how thoroughly the Man Ray aligned with the Rokeby. Cupid's bow, indeed.

The Man Ray catalog explained how the American expatriate artist, haunted by the recent rupture of his affair with the ravishing Lee Miller, had taken to launching out on long walks across the Montparnasse and the Luxembourg Gardens, with their distant view of Louis XIV's twin-domed observatory ("its two domes like breasts dimly indicated on the horizon" is how Man Ray subsequently parsed matters in his autobiography, *Self-Portrait*). That observatory for many years had constituted France's Greenwich—the prime meridian well into the twentieth century for French cartographers, who insisted on having Longitude Zero slice through Paris rather than Greenwich. Hence the seemingly endless present-ness of *l'Heure de l'Observatoire,* the time of mourning, when the departed lover's lips hover streaked across the sky.

The lips sprawl across the sky, lounging across the bed of the horizon line—like Velázquez's Venus—and indeed, for the months Man Ray was working on it and for several years thereafter, he hung the wide canvas over his own bed.

But look again at the Velázquez: for isn't it rather that the goddess herself extends like an upper lip over the lower lip of the black satin sash spread just beneath her—the two joined, as it were, in an enigmatic if barely subliminal smile. A smile that in turn levitates over the white of the bed itself, below which lies another dark expanse, just as in the Man Ray composition.

Surely, at any rate, the Velázquez must have been teasing at the rim of Man Ray's own creative consciousness as, heartbroken, transported beyond heartbreak, he labored over his rendition. (Look, for instance, at the way the goddess's extended elbow, at the far right of the Rokeby, swells beyond the support of the black satin sash—and now look at the funny business going on in the Man Ray, with the far right of the upper lip.)

Man Ray would subsequently observe in his autobiography how "the lips, because of their scale, no doubt suggested two closely joined bodies." And, elsewhere, he'd further gloss: "Your mouth itself becomes two bodies separated by a long, undulating horizon. Like the earth and the sky, like you and me."

The lips (in French, *les levres*) are thus themselves the lovers (*les amoureux*)—the levitating lovers!—of the painting's title. A French-American pun, worthy of that love-lorn American in Paris. But a seventeenth-twentieth-century pun as well: two bodies separated by a long, undulating horizon. Like you and me, like Velázquez and Man Ray?

* * *

Sometimes I wonder about these convergences of mine. ("Uh-oh," my daughter is given to saying once she senses me getting going, "Daddy's having another one of his loose-synapsed moments.") Maybe I'm reading a bit too much into all of this.

I'm reminded of the old story about the guy who goes to a shrink, desperate for relief. "Doc, Doc, you've got to help me, I can't take it anymore. My problem is—" At which point the doctor interrupts him: "No, no, don't tell me. I'll give you a little test here and I'll be able to tell you what your problem is." He pulls out a sheaf of placards from his desk drawer and shows the patient the first—which portrays a simple pair of straight, parallel vertical lines—asking him, "What's this?" "Oh my God," says the guy, "it's two people, a man and a woman, and they're necking, and yecch, it's disgusting." Hmm, thinks the shrink as he scribbles a note on his clipboard. "And this?" (Another two lines, this time horizontal.) "Ach, Jesus!" exclaims the patient. "It's the same two and now they're in bed, they're having physical relations, intercourse, and, aye, it's completely revolting." Hmmm, thinks the shrink as he jots himself another note. "And this?" (Another two lines, this time crossed.) "Oh my Lord, dear God," stammers the patient, barely able to continue. "It's the same couple and this time, I can't even say it, they're... they're—" "Sir," interrupts the

shrink, "we don't even have to go any further, I can already tell you what your problem is: You, sir, have a pathologically dirty mind."

"I've got a dirty mind?" the patient explodes. "*You're* the one showing me the dirty pictures!"

So, as I say, sometimes I think I may be getting a little ahead of myself, but the world does keep showing me these pictures.

And, indeed, a few months after my return from Santiago, I happened upon an image in a Man Ray wall calendar, a photograph Man Ray himself had taken of that painting of his, spread over his bed, and draped across the bed... well, see for yourself.

Man Ray photo of Man Ray painting over Man Ray bed

And then, a few months after that, while browsing through a Marc Chagall catalog, I came upon a reproduction of his *Nu au-dessus de Vitebsk,* surely another Rokeby-intoxicated work, this time the back-turned nude herself floating in the sky over the artist's nostalgically evoked home shtetl. Velázquez-influenced? No doubt. But look at where it was painted—that same city, Paris—and when it was painted: that same year, 1933! And look at the synagogue, which occupies almost the same swath of horizon as the observatory in Man Ray's painting. Was it something in the water? Had either artist seen the other's? I don't know, but I can't help wondering.

Of course, with the Chagall, especially as we view the painting today, the temporal vectors are entirely reversed. The Man Ray, as we have seen, gazes back upon the expiring sigh of his relationship with Lee Miller. But, again, look at the date: 1933. Chagall's masterpiece uncannily foreshadows a near future when the remains of naked massacred women would indeed be wafting smokily over emptied, plundered villages.

As it happens, my grandfather, the Weimar modernist composer Ernst Toch, was also in Paris in 1933: the first stop on his flight, along with his wife and the young daughter who would presently become my mother, out of newly Nazified Berlin, through Paris and London and New York, and eventually on to Southern California. Just like Man Ray, who by the late '30s would find himself ensconced in an apartment just off Hollywood and Vine, in the lee of the Griffith Park Observatory, up there in the Hills just beyond the HOLLYWOOD sign.

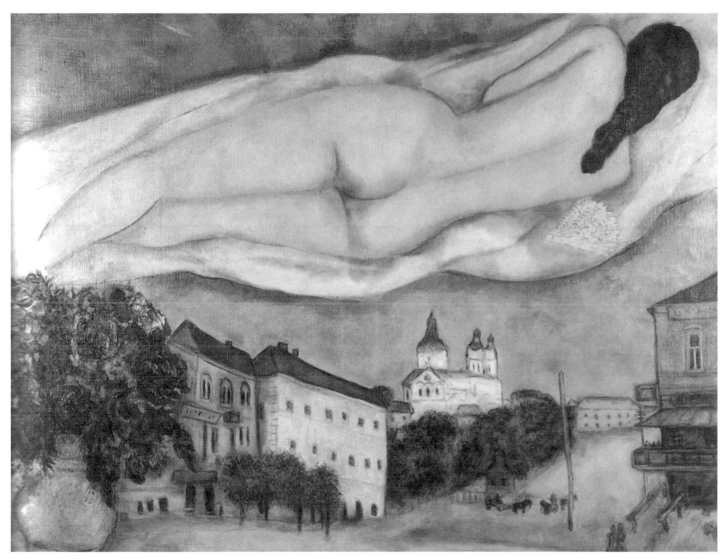

Marc Chagall, Nu au-dessus de Vitebsk, *1933*

I mention all this because my grandfather's fortunate escape accounts, in part, for why I was born and grew up in Los Angeles (for the longest time I'd assumed the observatory in Man Ray's painting was in fact the Griffith Park of my field-trip youth), hopeless acolyte of the light there—at no moment perhaps as fervently, though, as on that afternoon, in November 1976, when a great-dreamy-somnambulant blimp of a cloud went floating, pink and languorous, bulbous and surreal, across the sky of Golden Hour, like nothing so much as… well, by now of course you know.

Anybody who was in town that day and happened to look up remembers that cloud. Lloyd Ziff, the art director of *New West* at the time, had the wit to telephone photographers all over town that afternoon, urging them to get out and record the visitation. Several did so, and he subsequently compiled a delicious poster: the cloud as framed by palm fronds and reflected along sleek-finned automobile hoods; as seen floating benignly, here over the airport and there atop a gas station; and then there, in the middle of his resultant grid, my favorite, the cloud hovering as backdrop to a portrait of the all-time quintessentially perfect California Girl, who, of course, is smiling.

As I say, the world does just keep throwing these images at me.

I recently had occasion to interview Rafal Olbinski, the celebrated Polish émigré graphic artist, for an introduction to a book he was putting together focusing on the imagery of women that has come to dominate his creative life, especially his many startling posters for the New York City Opera, over the past decade and a half.

Prior to that, his work back in Poland and then during his first years in America, following the imposition of martial law in his homeland—jazz and film posters and magazine covers, for the most part—had rung changes, as it were, on a tight set of motifs: hands, trees, clouds, birds, hourglasses, ladders, windjammers, faces (see, for example, the remarkable image he created for the release of Wajda's Solidarity era film, *Man of Iron,* reproduced up ahead on p. 120), but no women.

Not that women had ever been far from his mind. Indeed, he recalled how in the dark old days of deep drab (and relatively puritanical) Polish communism, in the early sixties, as he was just emerging from his teens, a vocation for art had first welled up in him through his exposure to

the astonishing erotic drawings of Bruno Schulz, the incomparable magic-realist fabulist of the shtetl of Drohobycz, in pre-Holocaust Eastern Poland (killed by a Nazi stormtrooper in 1942). Schulz's feverish drawings of cowering men in avid thrall to archly imperious women, he suggests, played much the same role in his life that *Playboy* centerfolds, completely unavailable there in Warsaw, he imagines must have been playing in the life of his American contemporaries. Only more so, because they were just so damn good. "So, come to think of it," Olbinski recalled for me, "probably, Schulz was my first creative father. That was my first idea to be a painter: I wanted to paint and draw like Bruno Schulz!"

Several decades and a transplanted continent later, in the fall of 1988, Jerzy Kosinski invited his friend Olbinski to design the poster for a festival in celebration of the still relatively unknown Schulz that he was putting together for PEN in New York, and Olbinski jumped at the chance.

And look what emerged: among other things one of the thoroughly accomplished émigré artist's first attempts at a nude. And a shtetl nude at that—almost, come to think of it, a Chagall.

A secret nude, couched in the lips of the secret martyred master.

"It was," says a marveling Olbinski, for whom this was to be the first of a succession of ever more vivid and lively renditions of the nude, "as if Schulz were whispering me his permission."

The New York Times Magazine

NOVEMBER 14, 1999

It's So You

What clothes reveal, and mask, about identity.

Multiple-Personality Dressing
By Amy M. Spindler

The High-School Code of Cool
By Adrian Nicole LeBlanc and Bob Morris

Epiphany at 40
By Judith Shulevitz

Fool the Experts: Are You What You Wear?

Wearing a Dead Person's Clothes
By Lynn Hirschberg

Why Homoeroticism Sells
By Herbert Muschamp

Made Over by a Personal Shopper
By Daphne Merkin

Made Over by a Girlfriend
By Thomas Beller

The New York Times Magazine, *November 14, 1998*

FACE AS TORSO

Rene Magritte, Le Viol, 1934

TORSO AS FACE, FACE AS TORSO

TIMES MAGAZINE / MAGRITTE / D. MORRIS / RILKE

Or, for instance, this. What are we to make of this?

The former, the startling and quite memorable cover of a *New York Times Magazine* from about seven years back, designed by the late Claude Martel (featuring a photo of the model Shalom Harlow by Andrew Eccles) and ostensibly intended to introduce a special issue on "What Clothes Reveal and Mask about Identity"—though clearly charged with associations far more primordial, indeed an image almost salacious in its clotheslessness, in its curious (yet inescapable) suggestion, that is, of an entirely naked female body. And an unabashedly knowing body at that, one, in turn, that has us (with our cereal-filled spoons arrested halfway to our opened mouths) completely nailed in its gaze.

Though an image not entirely original for all that. Surely Mr. Martel must have had Mr. Magritte rattling around somewhere, at least in the back of his mind. (I mean, even down to the rhyme in the siren's sex-tousled hair.)

Magritte perpetrated his astonishing painting in 1934, just a year after Man Ray's celebrated lips-hovering-in-the-sky image, *The Lovers,* or *The Hour of the Observatory,* and shortly after he himself had made his so-called "Elective Affinities" breakthrough. Prior to that, Magritte's surrealist juxtapositions had tended toward the confoundingly, if oddly evocatively, arbitrary (a woman with her head swathed by a cloth standing beside a table on which sit a tuba and a valise, for example, or one man's head pronouncing the word-bubbled phrase "The piano," while another's replies, anything but self-evidently, "The violet"). But then (likewise in 1933), Magritte had hit upon the image of an oval birdcage with, inside it, filling it almost to the brim, a huge solitary egg. Magritte thereafter positively reveled in these sorts of "secret affinities" between objects. The process of conceiving such affinities, Magritte said, was difficult (and here I am following the account of Dawn Aves in the catalog to the Tate's marvelous 2001 "Surrealism: Desire Unbounded"

show), but the solution, once found, was self-evident, with all the certainty of a fact and the impenetrability of the finest conundrum. And it was in the thrall of this new method that, the following year, he contrived the striking image we are considering today, which he entitled, unsettlingly, *Le Viol*. Meaning, on the one hand, "The Viola," thereby inversely aligning his painting with the Picasso/Braque tradition of portraying musical instruments (guitars, violins, cellos, etc.) as metaphorical stand-ins for the female body. But, more directly, meaning "The Rape." In attempting to explicate the latter, Ades notes how "the neck is elongated beyond the demands of erotic sinuosity to become an ironically maternal phallus" (we speak, of course, of the head of a penis), going on to observe how, in this context, "the head of hair becomes pubic in texture, penetrated by rather than crowning the face/body." Which, come to think of it, it sure does seem to be doing.

But I want to return to the central discovery of the painting, that inspired recognition which the Magritte shares with that *Times* cover photo-collage, the insight that a woman's torso, in the arrangement of its features, somehow does recapitulate the splay of features in a face—and in fact that, as such, it stares at us, it holds us in *its* gaze. I am reminded of the delightfully loopy theory advanced years ago by the zoologist Desmond Morris in his wildly controversial blockbuster of a book, *The Naked Ape* (1967), his notion that the size and shape and allure of the human female chest hearkens back to the moment when our primate ancestors first began to move about upright. Prior to that, Morris theorizes, among our ancestor's ancestors—as was and remains the case with all other primates—the males had approached and copulated with their females from the rear, the female buttocks in turn constituting a primary token of sexual display and arousal. Once humans began to walk about upright and approach each other (sexually, as otherwise) face-to-face, however, Morris suggests that the seductive work of the buttocks would have needed to be transferred to the front of the female body, a feat accomplished through the genius of natural selection by the progressive expansion and rounding of human female breasts beyond anything previously (or, for that matter, currently) seen anywhere else in the animal kingdom.

Well, I don't know about that—about breasts as buttocks, I mean (and I sure as hell don't know about how such tendrils of perverse speculation get lodged and stay lodged in my own poor hyperventilating brain; what in God's name is going on in there?)—but as for breasts as eyes and bodies as faces, it seems to me that Magritte and latterly Mr. Martel of the *Times* are onto something. Our gaze—and I would suspect anybody's gaze, male or female—gets drawn to and held by the female body (or, alternatively, finds itself compelled to turn away in abashed embarrassment) precisely because of the bald directness of the way that body is staring back.

And maybe not just female bodies.

Didn't Rilke, after all, launch the second volume of his *New Poems,* in 1908, with that invocation of an "Archaic Torso of Apollo," in which he noted (in Edward Snow's superb translation) how

> We never knew his head and all the light
> that ripened in his fabled eyes. But
> his torso still glows like a candelabra,
> in which his gazing, turned down low,
>
> holds fast and shines. Otherwise the surge
> of the breast could not blind you, nor a smile
> run through the slight twist of the loins
> toward that center where procreation thrived.

And otherwise, as Rilke notes, "this stone would stand deformed and curt" and, a few lines later,

> …not burst forth from all its contours
> like a star: for there is no place
> that does not see you.

This, of course, being the poem that ends (and, as I suddenly just remembered, being the poem with which Philip Roth ended his own startlingly unsettling surrealist 1972 romp, *The Breast*)

> You must change your life.

To which all I can add (with reference to myself, anyway) is, I'll say.

FATHERS AND DAUGHTERS

TINA BARNEY PORTRAITS

About three years ago, on an art walk through Soho, in a gallery off Broadway, I happened upon a large-scale color-saturated photograph that stopped me cold: Tina Barney's double portrait of what were clearly a father and his late-teenaged daughter, staring head-on into the camera. It stopped me cold, and immediately I started to warm to it. As it happened, this was the photo that was featured on the show's announcement postcard, so I was able to take that version of it home with me: I pushpinned it to the wall facing my desk and have, in the months and years since, had frequent occasion to lose myself into it.

Back in college, years ago, I'd had a girlfriend who looked remarkably like the girl in Barney's picture—and who'd look at me in a remarkably similar manner: self-assured, ironical, a drowsy-lidded gaze freighted with entendres and double entendres. Occasionally we'd go up to visit her parents in San Francisco. I could be wrong, but something about the light and the furnishings makes me sure the bedroom in Barney's photo is also in San Francisco.[1] Anyway, my girlfriend's parents were of a certain class—comfortable haute-bourgeois, which is to say a situation slightly higher than my own family's—and every once in a while, she and her father would get themselves lined up, facing me, just like the pair in the photo: she'd be giving me that ironically freighted look, and her father, in turn, who looked remarkably like the guy in the photo, would also be giving me a look just like his: wary, somewhere between begrudged and resigned.

1. After this piece ran in *McSweeney's*, a punctilious reader wrote in to assure me that the picture couldn't possibly have been taken in San Francisco: the girl is smoking a cigarette. And my reader was right. I subsequently learned that it was taken in New York.

87

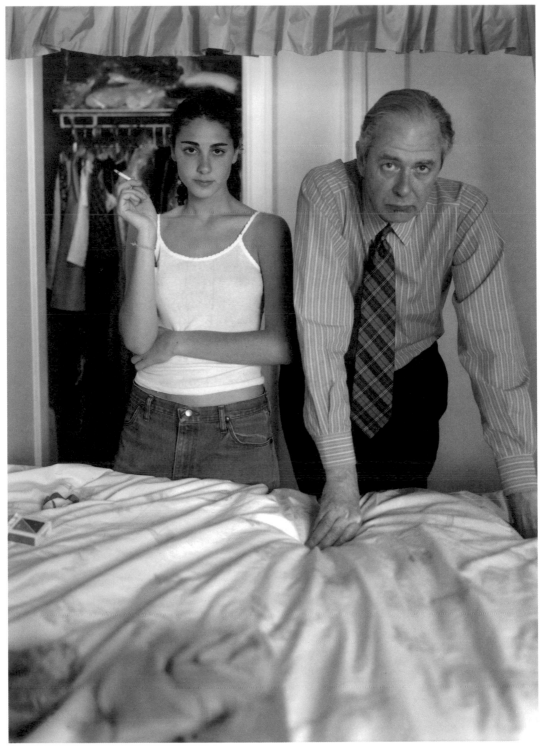

Tina Barney, Marina and Peter, *1997*

Between the two of them, they had me nailed.

And years later, as, daydreamingly, I continued gazing back into the father and daughter in Barney's double portrait over my desk, they still had me nailed: I was back in college, it was as if I hadn't grown a day, I was still that slightly gawky and yet increasingly assured kid, right on the cusp, eternally on the cusp.

Do any of us ever grow up?

Anyway, as I say, that photo has been staring at me from across my desk for years now, slowly becoming festooned over with other cards and photos and announcements, but still pertinent, still sweetly charged, still capable of drawing me in in the midst of my otherwise busy days.

Days full of this and that, my writing work, my own family responsibilities, and this past year, increasingly, caring for Herb, the dear old man across the street, a ninety-eight-year-old geezer who until just recently had been wry and spry and sharp and funny and astonishingly nimble, an ongoing inspiration to everyone in the neighborhood, including me and my wife and our little daughter. Late some nights—say, three in the morning—our entire block would be dark save for two lights: me in my office, writing away at my desk; and Herb across the street in his front parlor, hunched over, his glasses pushed up onto his bald pate, gazing down, intently reading by the light of a single bulb. I knew that some months hence, when whatever

piece I happened to be working on got published, Herb would read it and have me over to kibitz about it: he'd be my best reader, and I was writing for him.

Though, it had to be said, over the last several months, Herb had suddenly started declining precipitously, and actually—it was tough to face but clearly true—he no longer sat there at night in the front parlor in that puddle of light, reading away. He was largely confined to his bed, which had been moved down into his living room because he could no longer make it up the stairs. A dear, spirited Trinidadian woman named Marjorie had moved into the house to care for him full-time. Herb was on his last legs. He no longer wanted to live: in considerable chronic pain and discomfort, all he wanted anymore was to be let to die.

Very early one morning a while back, around four—it happened to be my birthday—I was startled awake by the phone. It was Marjorie, calling to tell me that Herb had just "breathed his last" and asking if I could come over to sit with her, she really didn't want to be alone with the body. My wife happened to be away, traveling, so after I got dressed, I went into my then-thirteen-year-old daughter's room to wake her and tell her what had happened. Sara took it pretty hard: she'd adored Herb, too. I told her where I'd be, how she should go back to sleep but if she wanted she could just look out her window and she'd be able to see me there across the street. I'd keep checking, I said, in any case.

And the morning proceeded like that: sitting by Herb's side, making the necessary calls, commiserating with Marjorie, occasionally peering through the window across the street to check on Sara (she was standing there, framed in her bedroom window, somber, intent, unmoving the entire time). Eventually the sun rose, the police arrived, then the coroners, and I headed back across the street to get Sara ready for school.

Sara came downstairs to greet me: she'd obviously been thinking. "Daddy," she said thoughtfully, "do you realize that Herb died on the very day that you became half his age? And that, for that matter, even though today is the thirteenth and I myself happen to be thirteen, in two days it will be seven days until I become exactly two-sevenths your age. Which is weird because at that point I will be two-times-seven and you are seven-squared and Herb was two-times-seven-squared, which of course also means that I will have become one seventh of Herb's age. And what's really weird, if you think about it"—clearly she'd been dwelling on all this, up there in the window her mind had been racing—"half of seven is 3.5 and you are going to be 3.5 times as old as me, or phrased differently, 35 years older than me."

I looked at her for a few long seconds and finally said, "Sara, get a life."

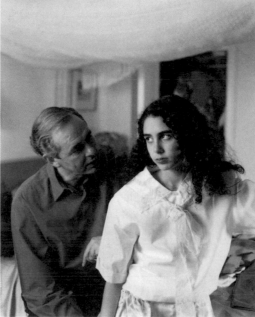

Tina Barney, Marina and Peter, *1990*

That evening I was back at my desk, working, when I happened to gaze up at the Barney photo. It had undergone a sudden transformation. Wait a second, I found myself thinking, I'm not the one the father and the girl are looking at—I'm the father! That's me, or almost: that's what I'm fast becoming. It was a startling, almost vertiginous shift in vantage.

A few weeks later, during a trip to Chicago, I wondering into another gallery that happened to be staging a Tina Barney retrospective. I got to talking with the gallery owner, described the picture over my desk, and she averred as to how, yes, of course, she knew it, and in fact she happened to have a couple earlier pictures from the same series.

"The same series?" I asked.

Oh yes, she said, leading me into her storage

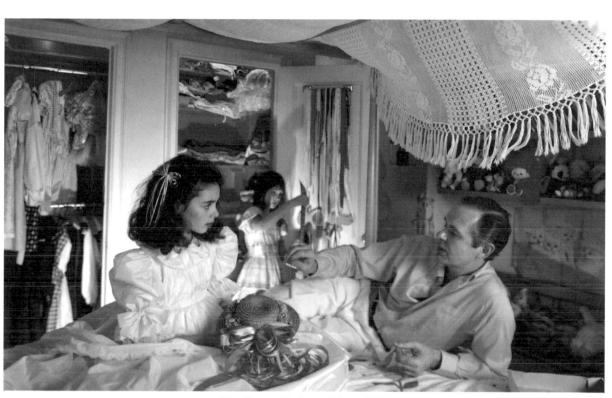

Tina Barney, Marina and Peter, *1987*

vault and rifling among the framed images. Barney photographed the same father and daughter at least three times. Once when the girl was maybe ten or so—this one here (and indeed, there they were, draped on the same bed: the girl roughly the age my own daughter had been the day I first happened on the later image at that Soho gallery)—and then another time, about three years after that, when the girl was thirteen or fourteen: that one… there. And indeed, there they were again, the same bedroom, the girl exactly my daughter's age: with exactly her haughty put-upon self-assurance ("Daaa-aaadie"). The gallery owner then pulled out a Barney book and turned to the last image in the series, the one over my desk. And yes, there they were again, same father, same girl.

Ten years: God, he had aged.

MAYBE ALL THIS

by WISLAWA SZYMBORSKA

Maybe all this
is happening in some lab?
Under one lamp by day
and billions by night?

Maybe we're experimental generations?
Poured from one vial to the next,
shaken in test tubes,
not scrutinized by eyes alone,
each of us separately
plucked up by tweezers in the end?

Or maybe it's more like this:
No interference?
The changes occur on their own
according to plan?
The graph's needle slowly etches
its predictable zigzags?

Maybe thus far we aren't of much interest?
The control monitors aren't usually plugged in?
Only for wars, preferably large ones,
for the odd ascent above our clump of Earth,
for major migrations from point A to B?

Maybe just the opposite:
They've got a taste for trivia up there?
Look! on the big screen a little girl
is sewing a button on her sleeve.
The radar shrieks,
the staff comes at a run.
What a darling little being
with its tiny heart beating inside it!
How sweet, its solemn
threading of the needle!
Someone cries enraptured;
Get the Boss,
tell him he's got to see this for himself!

Translated by Stanislaw Baranczak
and Clare Cavanagh

THE DARLING LITTLE BEING

SZYMBORSKA / VERMEER

"In my dream," Wislawa Szymborska had written in a slightly earlier poem ("In Praise of Dreams," 1986), "I paint like Vermeer of Delft." And in this poem she paints like him as well. Surely, at any rate, the image splayed across the cosmic screen in the last stanza of "Maybe All This" (1993), the picture Szymborska's words have in mind, must be something very like Vermeer's *Lacemaker*. How marvelously, at any rate, the poem helps elucidate the painting, and vice versa.

Start, perhaps, with the painting (created in Delft, around 1669, just a bit more than a decade after Velázquez's *Arachne*—see p. 36): how everything in it is slightly out of focus, either too close or too far, except for the very thing the girl her-

The lacemaker's hands

self is focusing upon, the two strands of thread pulled taut in her hands, the locus of all her labors. This painting is all about concentration: gradually, spiralingly, we come to concentrate on the very thing the girl herself is concentrating on (everything else receding to the periphery of our awareness), like nothing so much as a painter lavishing his entire attention on his subject (or else, perhaps, like what happens as we ourselves subsequently pause, dumbstruck, before his canvas in the midst of our museum walk).

Are we perhaps exaggerating here? Look more closely at the threads themselves, how they arrange themselves into a crisp, tight V, couched in the M-like cast of shade and light playing upon

the hand and fingers behind them. The girl, god-like, momentarily focuses all her attention onto VM, the very author of her existence.

And hence back to the poem. For the girl threading her needle, "the darling little being with its tiny beating heart inside," is of course none other than the poet herself, intent over her page, laboring toward the perfected line (or else, subsequently perhaps, we, her readers, hunched over her completed poem). Though, as creator of the poem, Szymborska is of course simultaneously the Boss (as do we, too, the poem's readers, momentarily get to be, re-creating, recapitulating her epiphanic insight, seeing it clean for ourselves).

Indeed, Szymborska gets it just right; how in the perfected work of art (be it a poem or a painting), across that endlessly extended split second of concentrated attention, artist and audience alike partake of a doubled awareness: the expansive vantage (lucidly equipoised) of God, the concentrated experience (meltingly empathic) of his most humble subject.

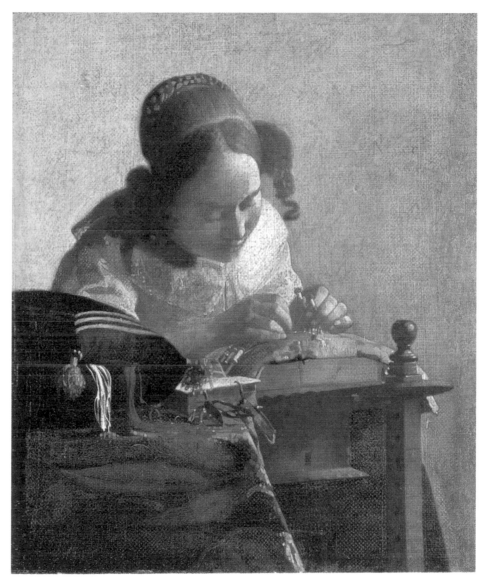

Vermeer, The Lacemaker, *1669*

IMAGES WITHOUT TEXT

Billboards in Venice, 2000

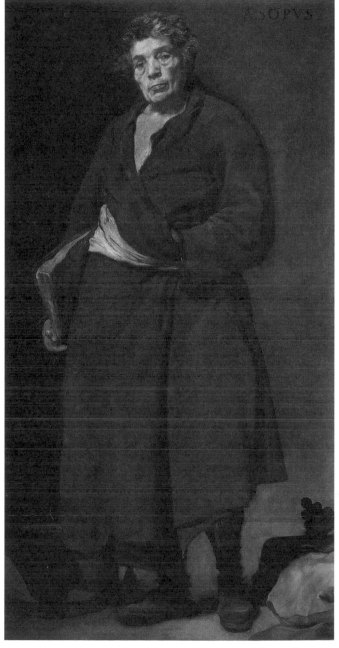

Velázquez, Aesop, 1639-40

*Photo by Jeffrey Barbee on page one of the May 11, 2005 New York Times,
illustrating a story on the fate of Malawian AIDS widows*

Cover of 1998 book, featuring a 1976 photo by Josef Koudelka

Brochure cover for an art show that same season

Matisse, Antibes, Paysage vu de l'interieur d'une automobile, *1925*

Vija Celmins, Freeway, *1966*

Full-page ad, prominently featured in The Economist *and elsewhere, the week before 9/11*

Time, *September 14, 2001*

POLITICAL OCCASIONS

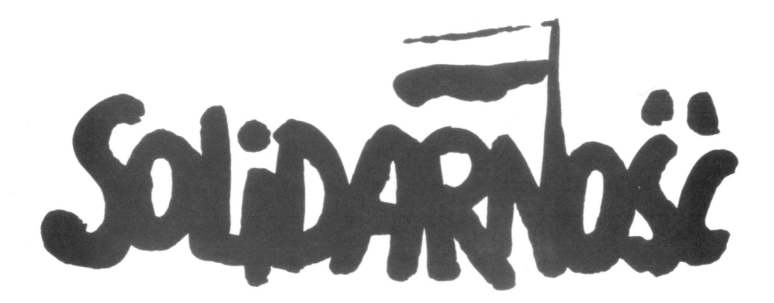

THE GRAPHICS OF SOLIDARITY

POLAND

1983

Start with the logo. It came surging forward like a crowd: the S hurrying the straggling O along, the A and the R striding confidently, the dot over the I and the accents over the second S and C reading like heads craning forward to where the C was pointing, the N holding its rippling banner proudly aloft—the red and white flag of Poland. The word itself—SOLIDARNOSC ("solidarity")—tapped into a reservoir of communal memories, memories of more than a century of worker activism on behalf of a socialist ideal which had been betrayed by thirty-five years of inept, corrupt state-bureaucratic practice. The word reclaimed that ideal, and the flag pegged it as specifically Polish.

The Solidarity logo was designed by J. and K. Janiszewski, two marginally employed graphic artists living in Gdansk, during the second week of the August 1980 strike at their hometown's mammoth Lenin Shipyards. Within a month it had become the ubiquitous emblem of a national worker's movement. In this particular case we do have some knowledge of the graphic's origins. With many of Solidarity's posters, no such documentation exists. Some of Solidarity's most powerful images, for that matter, are no longer available in any form. In the heat of confrontation, Solidarity didn't have much time or interest in archival documentation. Paper and ink were scarce: what little could be foraged was quickly used and the resultant posters immediately slapped onto public walls, where they

belonged. Weather, and in some cases official sabotage, took their toll before anybody realized that no record had been kept. The next day's crisis—the next day's occasion—was in any case already at hand.

Like its logo, the Solidarity movement came barreling out of a history of struggle in a land where the simple mention of a year invariably summoned up a store of common impressions. One of Solidarity's most succinct graphic images consisted of a graph—the chart of a heartbeat, perhaps, or a seismograph—a red line coursing horizontally across a white page, throbbing occasionally to jagged verticals, above which were marked the dates 1944, 1956, 1968, 1970, and 1976—a litany of failed national rebellions. As the line approached the present, the verticals become increasingly steep and frequent, and on the other side of 1980, the line opened onto the single word: SOLIDARNOSC.

One of the reasons Solidarity's graphic artists were able to generate such powerful posters is that they could draw upon the matrix of succinct images with rich, common associations that Polish history had deeded them. Take, for example, the phrase "Warsaw 1944." That formula, on a poster that first appeared in August 1981, might initially have seemed to celebrate the liberation of the city from Nazi occupation by the Soviet Army—and the Poles were perfectly content to let the Russians think as much. Every Pole, however, knew that "Warsaw 1944" in fact alluded to the Rebellion, the valiant, tragic attempt of the Polish Home Army, the country's indigenous nationalist Resistance, to liberate the capital in advance of the Soviet arrival. The Soviet army, for its part, stopped dead in its tracks on the other side of the Vistula once the Rebellion began in August 1944 and let the Nazis liquidate the nationalists for them before they finally came in to liberate the city's ruins. The symbol of the Home Army, from 1939 to well beyond 1944, was *℔*. The graffito was scrawled on walls throughout Poland during the Nazi occupation and in the first several months of the Soviet counter-occupation. PW stood for *Polska Walczaca*: "Poland is still fighting"—fighting both the Nazis and the Soviets. But the image

itself summoned an even deeper association, for it suggested Poland anchored—the anchor being a longtime token of Polish Catholicism. We are speaking of a country where, across a tortured history, Catholicism and nationalism had blended into a synchronous passion.

The theme of the anchor symbol went on to achieve a particularly rich development during the decade immediately prior to Solidarity's 1980 upsurge. In December (*Grudzien*) 1970, a work stoppage at the Gdansk shipyard was quashed in a sudden massacre: thousands were injured and hundreds killed as Polish soldiers fired on Polish workers. The memory of that traumatic event was officially repressed—virtually ignored in contemporary journals, glossed over in history texts—but it was sustained throughout Poland, as most such memories were, through word of mouth, tattered photos passed from hand to hand, and the cumulative force of the slightest gestures. For example, when writing the year "1970," Poles would transubstanti-

ate the "7" into a "†"; this practice even came to pervade government documents reviewing the period. At the Gdansk cemetery, where actual mention of the circumstances of the strikers' deaths was forbidden, mourners would mark the

grave of a slain worker by hanging a small anchor from the feet of the headstone's traditional crucifix. The anchor provided a startling mirror image of the tiny crucified Jesus, but it also suggested that this was the grave of a shipbuilder—a welder of anchors—who had died a Christian martyr.

When the workers took up the strike again, in August 1980, one of their first demands was that a fitting memorial to their martyred 1970 colleagues be erected just outside the shipyard, at the very site where the first workers had been shot as they surged out of the gates. The government, its back to the wall, acceded to the demand, and within just three months (as if to mock the government's accusations of low productivity, and in order to be ready for a commemoration of the tenth anniversary of the carnage) the shipworkers themselves raised an extraordinary monument: three gleaming steel crosses, rising 140 feet above the plaza, attached at the arms back-to-back in a triangular configuration, and atop each cross, splayed in anguished crucifixion—an anchor. In the bases of the three crosses, amidst the tangle of steel shards which led up into the sleek vertical beams, the workers had slotted friezes commemorating the triumph of their August rebel-

lion. They even included bas-reliefs of themselves building the monument.

For the Poles, if 1970 had been the Crucifixion, then 1980 was the Resurrection and the Life.[1]

The Polish flag is red and white, and the red stands for blood: the blood of patriotic martyrs and the blood of Christ, which, for Poles, is the same blood.

In 1956, the de-Stalinizing thaw within the Soviet Union was fast reaching floodtide at the country's periphery. On June 28, in Poznan, a proletarian stronghold in west-central Poland, workers from the infamous Cegielski locomotive factory (site of many nineteenth-century confrontations) set down their tools in protest over wages, food supplies, and working conditions, and marched on the town's central Stalin Square. The Polish army was called out, and by the time the violence had subsided, hundreds of workers had been injured and seventy killed. There happened to be an international trade fair in the city

1. A similar expression of the same allegorical drama occurred up the coast, in Gdansk's twin harbor city of Gdynia, where the shipyard workers likewise demanded the right to erect a monument of their own, and in their case chose an image reminiscent of the thousands of paintings and sculptures of Christ's limp, lifeless body being lifted off the cross. The body in question, in this instance, turns out to be that crucified "7" from the date 1970—the other numerals are seen to be supporting it in its martyrdom—and the body appears to have been felled by a giant bear claw's swipe, an allusion, in turn, to the perfidy of the Soviet Bear.

at the time, so there were many photographers taking countless pictures, some of which soon took on an underground, hand-to-hand existence.

Of all these images, one in particular seemed most to sear itself into the Polish national subconscious. When you mention Poznan to Poles today, they will tell you about the crowd of workers led by the young woman in a white dress who was carrying a Polish flag back into the town square. The white of the flag was stained red: it had just been dipped in the blood of a fallen worker.

What is interesting about this memory is that everyone tells you that it is the woman who was bearing the flagpole, whereas in fact when you look at the photograph—which now, in the wake of Solidarity, existed in omnipresent, openly displayed profusion throughout Poland—it was clear that the woman had been carrying nothing at all, and that a worker behind her was the one holding the flag. This once again suggests the way in which people are prepared for images—in which images are prepared for people—by the context of prior images. For there is indeed an image—by this time almost an archetype—of a woman leading a crowd over a barricade while holding a flag aloft. She is *Liberty Leading the People*, as depicted by Eugène Delacroix in 1830. (The composition of the two pictures—the lower-left-to-upper-right diagonal of the advancing crowd which in turn is advancing from left to right—is remarkably similar.) I am convinced that this particular photograph, rather than any of the innumerable others taken that day, was the image that Poles came to remember because, in a strange sort of way, they already knew it by heart.

Solidarity's graphic artists could in turn rely on the communal memory of that photographic image in composing their own iconography. The poster that Solidarity published in June 1981 on the thirty-fifth anniversary of the Poznan massacre,

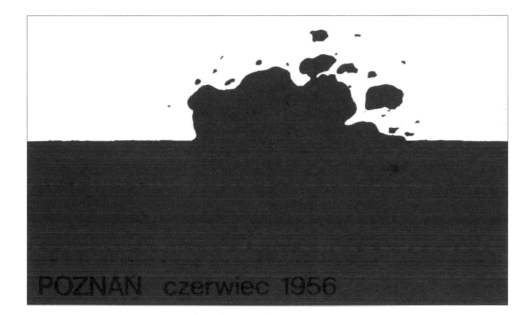

POZNAN czerwiec 1956

perhaps one of the most effective broadsides they ever produced, consisted simply of the legend "Poznan June 1956" superimposed over a bloodstained Polish flag. Actually, the flag was not really stained. Rather, the red of the lower half of the flag had become an abstract form bleeding into the white of the upper half.

Just as the woman leading the crowd and carrying the bloodstained flag became the image of Poznan 1956 for most Poles, so Gdansk 1970 was largely remembered in terms of a single riveting photograph. Such photographs as do exist of Gdansk 1970 were taken by amateurs on the run, with crude equipment, under desperate conditions. Most were poorly exposed, poorly developed, and poorly preserved. In 1980,

Solidarity offices throughout the country began to receive such photographs (as well as shots of the events of 1956, 1968, and 1976), usually as anonymous offerings; during the spring of 1981, Solidarity launched a traveling show of documentary snapshots. I happened to see the show in its Warsaw incarnation. The photographs were interesting but looked commonplace to me: we in the West have become inured to the visual vocabulary of social violence—police phalanxes, stampeding crowds, crumpled bodies—and these photographs looked just like Chicago or Berkeley or Paris. What I couldn't get over, however, was the way the Poles were looking at these images. In a country of lines, this exhibit seemed to draw the longest lines. People stood

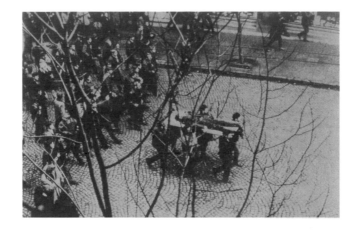

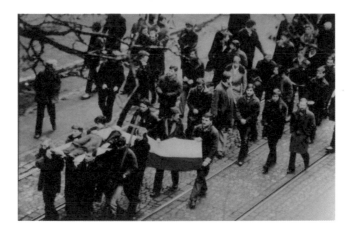

waiting two and three hours to get in; once in, they lavished minute after minute of focused attention on each picture, notwithstanding the pressure of the lines waiting behind them. It was as if they had never seen anything like this—and they hadn't. Or rather, perhaps they had, but never like that, in public. Standing there, staring, they were absorbing both the information in the photographs and the sheer fact that they were standing there at all.

The single most intense image, judging from the conversations I had with countless Poles during the weeks that followed, was a photograph of another advancing crowd.[2] This one, seen from above (as in Russian avant-garde photographs of the 1920s—Alexander Rodchenko's, for example), was marching through the cobblestone streets of Gdansk 1970; at its forefront it bore not a flag, but a wooden doorframe, and atop the doorframe, a corpse.

Virtually everyone who described that photograph to me said the corpse was spread-eagled, its arms stretched to the sides as if in crucifixion. In fact, in the photograph, the arms merely extend down the sides of the corpse's torso. But

once again, the Poles had been prepared for this image. When Andrzej Wajda, the premier Polish film director, set to work on his latest film, *Man of Iron*, an epic commemoration of the events that led up to the August 1980 strike, he of course included the December 1970 massacre. And perhaps the key image in the sequence of the film was a virtually literal quotation from that photograph, shot once again from above (although, for some reason, from the other side of the street).

When the poster makers set to work designing the announcement for *Man of Iron*, they came up with several solutions. One of the most effective consisted of a spread-eagled, bloodstained shirt. Splayed across the white poster, it looks for all the world like the Shroud of Turin. Red on white, it was of course nothing other than another rendition of the Polish flag.

Why were the posters of Solidarity, and Poland generally, so forceful and so vital? What gave them such authority? Was it just that Polish graphic artists had this context of common

2. Actually, there was one other image one kept hearing about, that of a woman by the cobblestoned street curb leaning over the sprawled body of another dead worker. What's curious here is how receptivity to that particular image may have been prepared by

an event just a few months earlier, on May 4, 1970, and an ocean away, when American national guardsman had fired on students protesting the Vietnam War at Kent State University in Ohio, an incident which generated a whole series of political posters based on its own iconic image. And of course, receptivity in the case of both these images doubtless owes something to their rhyme with the classic pietà image.

images to draw upon? Did much of the wallop of the extraordinary poster for *Robotnicy '80*, Andrzej Chodakowski's and Andrzej Zajaczkowski's remarkable documentary on the August 1980 negotiations, for example, derive from its association with the previous year's poster for Janusz Kijowski's feature film *Kung Fu*? (Think about that second poster: it is dated 1979. Polish filmmakers and graphic artists, like many others, could see this revolution coming a mile away. Indeed, their persistently dynamic graphic work all through the '70s might be said to have helped keep alive the subliminal energy which burst into action during the early 1980s. When Solidarity erupted into being, the filmmakers and graphic artists enthusiastically joined in.)

Is it possible to discuss the strength of these posters in purely aesthetic terms? I don't know, I'm not sure, but I'd like to think that the authority of political art, finally, exists at best in proportion to the authority of the politics it advances. In order to work, political images have to command authority, but they can only realize the authority and authenticity of the political context out of which they arise. They cannot endow empty politics with vitality; and empty politics

will drain them of their own vitality. Strong politics allow for strong images, and vice versa. And the politics of Solidarity were strong indeed: we are speaking of a movement whose membership, as its first anniversary poster reminds us, had grown in one year from less than a hundred to "10,000,000 SOLID." And not ten million crazed hysterics or massed zombies; ten million highly disciplined members who, for months on end, had proven capable of challenging the authorities while at the same time tempering their challenge so as not to provoke an endgame.

Solidarity's graphic artists therefore had two things going for them: a legacy of common images (flag, cross, fist, blood, crowd, face[3]) and a politics with authority. Graphic artists working in the United States during the same period had neither, or at least not in the same terms, and their efforts therefore tended to be fairly anemic.

Consider a contemporaneous American effort, one of the most widely distributed posters advertising the AFL-CIO's September 19, 1981, Solidarity Day protest march in Washington, D.C., nine months into the Reagan administration. Start by comparing the faces in this image with those in the *Robotnicy '80* poster.

It is not the relative aesthetic merits of the two posters that I am trying to consider, but rather the situation within which each was produced, and specifically the desperate limitations of the American situation for political artists. To begin with, there was the event itself. This was a rally being held by a huge labor confederation which barely one month earlier had stood idly by, paralyzed, as the president of the United States gutted one of its member unions (12,000 air traffic controllers were fired on August 5, and the AFL-CIO did precisely nothing). Is it perhaps the humiliation of that episode that we see behind some of the brittle imitations of sternness on the faces of these workers? This organization was projecting virtually no authoritative politics on its own—the banners in this poster's background were blank. Indeed, the best it could do was to cannibalize someone else's politics: *Solidarity Day?* Who was kidding whom? This rally drew about 250,000 people.

The same day in New York City's Central Park, a Simon and Garfunkel Reunion Concert drew more than twice that number.

"When you don't know where you're going, any path will take you there," or so claimed the old Talmudic masters. Maybe any color will get you there, too. For the AFL-CIO poster, the artist chose green (*green.?!*) for the printing on the otherwise black-and-white poster. About the only thing you could say for green in this context was that it was conspicuously not red, white, or blue. Compare, for example, Solidarity's May Day 1981 poster, which deployed the same kind of image: a crowd of grimly determined workers faced head on. Solidarity's crowd *was* their flag.

In fact, Solidarity's artists were even capable of deploying the *American* flag for their purposes, as in another, somewhat more makeshift flyer, from that very same May Day, celebrating, as it did, "Chicago, 1 V 1886." Now, while few

3. I mean, take a look at this pin, which one began seeing on lapels everywhere, reproduced at approximately its actual size! And note the rhyming reference, already here, to Eisenstein's defiant workers from back during the Bolshevik revolution, though now that worker is seen to be being vilified as an "antisocialist element" and a "hooligan," two of the Polish Communist regime's favorite put-downs of Solidairty activists, which he, on the other hand, proudly wears as a badge of honor. As we have seen, that same Eisensteinian worker would recur, a few years later, when Solidarity resurged once again on the far side of martial law. See p. 50-51 (from the "Gazing Outward" Exemplary Instance).

1MAJA ŚWIĘTO SOLIDARNOŚCI ROBOTNICZEJ

Americans today would be able to grasp the allusion, any Pole (steeped as they'd all been in a good, strong, socialist education) would be able to tell you that the date referred to the Haymarket Rally and subsequent police riots and massacre, the incident in honor of which every subsequent May Day around the world would thereafter be celebrated in commemoration. (The Solidarity artists recognized a fellow precedent—

regime thugs firing on defenseless workers—and their communist overlords couldn't very well object, since they were the ones who had so tirelessly belabored the incident as part of their indoctrinations.)

In retrospect, the American progressive movement during the '60s made perhaps one of its gravest mistakes when it took to burning the national flag. It's true, the government almost forced

them into it, cornered them into that kind of national self-loathing. (Who knows? It may even have been undercover government agents, acting as provocateurs, doing some of the burning.) But today you can see the difference. In Poland, progressives can deploy the national flag as their own. In the United States, progressives have lost that birthright. A revolutionary flag has been appropriated by the society's most reactionary elements.

And yet, even though it forsook the flag, the American antiwar movement of the '60s did briefly generate a few common icons: the circular peace sign, for instance, which at antinuke rallies today still has a certain, albeit nostalgic, life to it. If most of these images have been destroyed, it's partly because there was a virtually systematic effort to destroy them—often simply by coopting them. Take, for example, the two-fingered *V*, which for a time in the sixties betokened and united a whole subculture. You could be driving down the road anywhere and somebody'd flash you that *V*, their middle and index fingers spread, and you'd know they were against the war in Vietnam and probably

Breathe free.

3M

against a lot of other things you were against as well. It was a particularly nifty peace sign because it had been stolen from Winston Churchill, in whose hand it had symbolized military victory. Richard Nixon then stole it right back: I've always been convinced that he did so knowingly.[4]

In America nowadays, products—not politics—are granted strong images. Consider, in this context, a striking ad which began appearing in several American newsmagazines around this same period, featuring the close-up image of the face of a gagged Lady Liberty. Note that this was no call to arms around, say, issues of free speech, or alternatively threats posed by increasing air pollution. No, this was an ad for that particular brand of facemask, manufactured, as it happens, by the good folks over at 3M. Americans do not even share a sense of a common past. In Poland, it's not just years that summon a common response—it's dates on the yearly calendar: May 1 (May Day); May 3 (the promulgation of Poland's first constitution,

4. In Poland, Churchill's V-for-Victory had a different destiny. Taken up by the Home Army during the war, it was suppressed (for that very reason) during communist times. With the imposition of martial law in December 1981, Poles (who knew from wartime and occupation and what that was all about) resurrected the spread-fingered V-sign, at one point leading one exasperated general, facing a crowd of such defiantly raised hands, to sputter, by no means inaccurately, "What the hell are they doing? *There's no such letter in the Polish alphabet!*"

1791); June 28 (Poznan 1956); August 1 (the launching of the Warsaw Rebellion, 1944); August 15 (a Polish national army turns back an invading Soviet force, 1920); August 31 (victory in Gdansk, 1980); September 1 (the Nazis invade Poland, 1939); November 11 (the end of World War I and the reemergence of a Polish state that had been missing from the map of Europe for more than a century). Each of these days is honored, is an occasion for celebration or mourning, for poster-making. (Consider, to offer but one more example, the spectacular poster some of Solidarity's artists came up with to honor November 11, 1981—a simple flick of the date, rendering 1981 as epochal a year for Poland as 1918—and, it is implied, for the very same reasons.) In America, we couldn't even sustain November 11 as Armistice Day, an occasion for honoring the dead of World War I; one war later, we diffused it into Veteran's Day (honoring all veterans, liv-

ing and dead, from all our wars); and a couple of wars after that, it was no longer even November 11 but rather the nearest Monday or Friday, an empty excuse for all the potential profits of a three-day weekend. Is it any wonder that American political artists have so few authoritative images to go on?[5]

If Solidarity's graphic artists could draw on the vitality of their political situation, they were also finally constrained by the limitations of that situation. Or perhaps, phrased more precisely, it is through the evidence of their work that some of those limitations become most apparent. During the late summer and fall of 1981, a political context that had seemed wide-open began to close in precipitously. The economic factors which had spawned the political renewal in the first place now began to foreclose its possibilities: against a backdrop of increasingly desperate shortages and the relentless onset of

5. Not to beat a dead horse, but take a look at this poster, from around the same time in the early '80s, for a conference of academic Marxists. Although rampantly deconstructionist, it's hardly bracing in its call for any sort of revolution, if that is what it is intending to call for.

Having said that, American graphic artists were occasionally able to pull off a sort of jujitsu appropriation of conventional advertising imagery for their own purposes. For example, consider this Berkeley 1970 appropriation of a Coca-Cola bottle to convey a powerful anti–Vietnam War message. The funny thing about Coca-Cola is that its advertising imagery was so universal that it could be appropriated by graphic artists on either side of the Iron Curtain—as, for example, by these post-Soviet pranksters, who found new significance in the ubiquitous Coca-Cola-red.

winter, Solidarity's solidarity began to fray. Intensity was giving way to extremity.

"The old is dying, and yet the new cannot be born," wrote Antonio Gramsei, the great Italian political theorist, from deep in the bowels of the prison to which Mussolini had remanded him during the early '20s. "In this interregnum, a variety of morbid symptoms appear."

And Solidarity's graphic artists now began to reflect and portray the morbid contradictions inherent in their situation. Thus, for example, in August 1981, two new posters appeared within a few weeks of each other. One advertised Solidarity's first annual national convention, to be held in Gdansk in early September: it portrayed a well-fed one-year-old in Solidarity T-shirt and red and white shorts (Polish flag diapers!) launching into his first confident steps. Meanwhile, the other, a more primitive poster, assessed the "First Effects of the Communist Party's Ninth Congress" (concluded in Warsaw that July): "Slashed Food Rations." That poster's central image was a skull over a crossed fork and knife. (The luxurious silverware, which it implied

Communist party members could regularly deploy, was arrayed in a conspicuous parody of a hammer and sickle.) This poster was particularly prominent in the vitrines of the virtually empty grocery stores—the skull's vacant eye sockets staring back at the weary faces in the endless lines. In Poland, where more than ten percent of the population was under the age of four, there loomed a desperate shortage of milk, and the first poster's optimistic chubbiness notwithstanding, Solidarity's experts estimated that more than seventy thousand babies were now suffering from malnutrition severe enough to cause permanent damage.

During the two-month period of decentralization and secret balloting (July–August) that culminated in the selection of the 850 delegates for the Solidarity congress (a process in which all ten million members of a year-old organization were canvassed, an extraordinary achievement in itself), one of the most prominent posters simply proclaimed "YOU decide." Two bold arrows converged on the word YOU, framing it, emphasizing it, and nearly crushing it. The imperative of the poster

was almost too intense. (Compare, incidentally, the near simultaneous television ads in which New Yorkers were being frantically implored by a crazed pitchman leaning out of the forehead of a papier mache Statue of Liberty to choose between McDonald's Big Macs and its Chicken McNuggets—"New York, you decide!")

The visual organization of that Polish poster was echoed in two other posters commonly displayed during that summer, two posters which in turn suggested diametrically opposite interpretations of Poland's then-current situation. The first was another of the announcements for Wajda's film *Man of Iron*. This one presented the head of a large, powerful worker around whose eyes an oversized metal industrial nut had been wedged: as the worker strained his facial muscles, the nut appeared to be in the process of splitting apart. (This image of liberation in turn alluded to a type of propaganda imagery prominent during the '50s which had been the subject of Wajda's earlier film, *Man of Marble*, to which *Man of Iron* constituted a sort of sequel. During that period, particularly prolific laborers were canonized as "worker heroes": their portraits were blown up and hung as huge banners from public buildings. The protagonist of *Man of Marble* had been such a hero: the *Man*

of Iron poster offered a conspicuously ironic revision of his canonization.)

Self-liberation gave way to self-annihilation, however, in the second poster, an advertisement for Agnieszka Holland's film *Goraczka* (Fever). Again the central image was of a man's head blindfolded, this time not by some cracking metal nut but rather by ropes wedging two burning sticks of dynamite to his temples. Holland's film derived from Andrzej Strug's classic Polish novel *The Story of a Bomb* and related the fate of a motley band of terrorists during the 1905–06 Polish nationalist insurrection against the country's Russian occupation. The authorities allowed the film to be made because its terrorist heroes were socialists and the Russian targets of their plot were, after all, representatives of the Tsar. The Polish audiences, however, reveled in the film's references to police spies, corrupt Polish collaborators, and valiant young patriots; still, they couldn't help but have been sobered by its tragically farcical conclusion: every plot was botched. During the two years of its existence, the bomb destroyed only those who tried to use it. When the last character finally did succeed in hurling it into a roomful of police collaborators, the bomb turned out to have been a dud. The would-be targets scrambled, and nothing hap-

pened. The would-be assassin, who had cratered into feverish Dostoyevskian incoherence, was simply taken out and hung.

As winter closed in over Poland, Solidarity's filmmakers and graphic artists were continuing to produce inspirational images. During the night of December 12–13, 1981, however, the Polish Army seized power, though from whom—the Communist Party, or Solidarity, or the vacuum that had grown up between them—was not at first entirely clear.

The date was chosen, in part, so as to head off the massive Solidarity rallies scheduled for three days thereafter, on December 16, to commemorate the eleventh anniversary of the 1970 massacres, and to celebrate the first anniversary of the solemn dedication of the Gdansk and Gdynia monuments to the victims of those massacres. The Polish postal service had even been set to issue commemorative stamps celebrating the latter anniversary; and even though post offices throughout the country had been shut down as part of the martial law seizure of power, sympathetic gremlins had managed to sneak into the offices on the day in question, steal some of those now superannuated stamps, score them with the proper "December 16, 1981" cancellation, and secrete the objects out of the building, where they now became some of the most prized anti-regime insignias.

Among the first priorities in the seizure were the primitive, semiclandestine printing plants which had been producing the extraordinary posters of the previous fifteen months. This by no means signaled the end of Solidarity's graphic production, however. Solidarity's strategists had spent months anticipating this eventuality, preparing secret caches of paper and ink. And within days, fresh graphic broadsides began to appear, often drawing directly on the potent vocabulary of images and dates that those artists had spent the previous sixteen months burnishing.

Thus, for example, in the alcove of one Warsaw church, it was simply as if a new chalked-in body, labeled "1981," had been tossed down onto the grim crime scene that was the rest of Polish history—with, through the window, a reproduction of the Black Madonna, eternal mother of the Polish nation, gazing on in benign concern.

Wending back even further, one poster from that moment referenced an image as famous in Polish history as that of Washington crossing the Delaware is in American: that of a Polish noble-

JAK DŁUGO JESZCZE ?
13.XII.81 – 13.III.82

man who had hurled himself in front of the door of an assemblyroom where other Polish nobles were in the midst of gathering, back in the late 1700s, to vote the Polish state out of existence altogether, at the time of the last partitions. He had famously torn his shirt open to offer up his naked chest in defiance—only, now, look: on second glance, it turned out he had been wearing a Solidarity T-shirt all along!

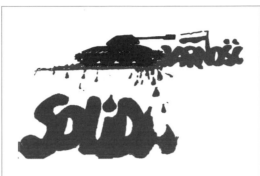

Similarly, flyers began appearing with all sorts of recastings of the Solidarnosc logo. In one, the massed crowd of letters was now portayed loitering grimly behind the barbed wire of a concentration camp (thereby summoning all *those* associations). Note how the same graphic, with all its associations to a surging crowd at an earlier time, could just as easily now read, Rorschach-like, as a surly, expectant throng (the *A*, for example, leaning against the *R*), everybody waiting to see what was going to happen next. In another image, a tank was barreling down upon just such a crowd, mowing down the first several letters, but look:

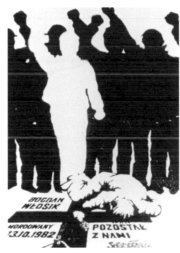

there they were, already reforming, only larger! And in yet another image, commemorating the fate of seven of the coal miners at the Wujec mine in Silesia who'd been gunned down when regime troopers early on overwhelmed their occupation protest strike, the crowd itself, through its very solidarity, seemed defiantly to be retaining the impress of the slaughtered martyrs. All over the country, a new piece of graffiti began to appear scrawled over the tenement walls: that same *P* from the Home Army days, only now with a new twist.

Back in its glory days, Solidarity theorists had cast the movement as an expression of the *subjectivity* of the Polish nation, by which they meant its capacity to act as a subject of history, rather than merely its object. That characterization, which cleverly drew on both Marxist and Catholic social philosophies, summoned up a transformation so profound as to be grammatical: people who'd been content to suffer as the objects of other people's sentences were now intent on becoming the subjects of

their own. In that sense, martial law could be seen as a counter-offensive, an attempt to take people who'd begun acting like subjects and, through concerted repression, to turn them back into good little objects, stones to be slotted back into the wall. And the persistent underground resistance of Solidarity and its graphic artists, in turn, could be seen as a refusal to accept such a fate.

How things would turn out remained to be seen. But another of Gramsci's aphorisms—"Pessimism of the mind, optimism of the will"— seemed best to sum up the current passion of Poland's artists and its people. For, in the characterization of another piece of graffiti one began seeing everywhere that wretched winter, the Polish saga was definitely *CDN*, standing for *Ciag Dalszy Nastapi*: to be continued.

THE CONTRAS AND THE BATTLE OF ALGIERS

LUCIDITY / RESPONSIBILITY

1986

Observing the recent Congressional debates over the funding of the Nicaraguan Contras in their campaign to bring down the Sandinistas in Managua, I've been haunted by memories of a scene in Gillo Pontecorvo's 1965 film *The Battle of Algiers*. The film was a stirring piece of agit-prop, a gritty, cinéma-vérité-style re-creation of the urban terrorist campaign that preceded Algeria's liberation from French colonial domination in the early '60s. Pontecorvo made no attempt to mask his allegiances in the film—his sympathies were unmistakably engaged on the side of the guerrillas—and yet he evinced a remarkably steady kind of lucidity. Particularly in the scene that keeps haunting me. By that point in the story, the Algiers Casbah had been

more or less cordoned off by French military police, and residents were having to pass through elaborate security checks to enter and leave. The guerrillas therefore began using women, who would presumably arouse less suspicion, to deliver their bombs to the civilian colonial targets on the far side of the cordon. In the sequence I'm remembering, the camera followed one such woman as she picked up her bomb, stowed inside a basket, and carried it through the narrow streets of the Casbah, across the checkpoint (undetected), down into the broad, leafy avenues of the cosmopolitan part of town, and into a café packed with breezy, insouciant French colonials. She set down her basket by her feet, under a bar stool, nudged it under the bar counter, and then, in accordance

with her instructions, dallied for a few moments, so as not to provoke notice.

And here's where Pontecorvo's lucidity entered, because during the next minute the camera adopted her point of view. It would have been easy to populate those seconds with her perceptions of flirting, cocky soldiers or rich, spoiled colonial teenagers out on a lark. Instead, Pontecorvo has his woman's gaze come to rest on a manifestly innocent toddler, lapping at an ice

cream cone. She continues watching that child and some other people, for a few seconds more, then gets up and ambles away, out into the street and down the avenue; some moments pass (the camera returns to the café for one last look at the child, his cone now finished), and then there is a tremendous explosion.

That scene was in turn echoed, a few years later, in 1976, roughly halfway between Pontecorvo's film and the current Congressional

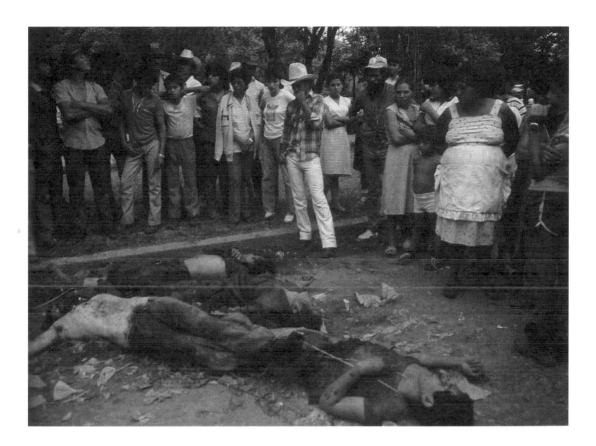

debates, in a remarkable poem by the Polish poet Wislawa Szymborska, entitled "The Terrorist, He's Watching." Szymborska likewise adopts the terrorist's point of view, in this case after he's dropped his package off in the bar and as he stands across the street, waiting for the bomb to go off at 13:20. "The distance," Szymborska notes, "keeps him out of danger, and what a view—just like the movies." In Baranczak and Cavanaugh's sinewy translation, he observes how: "A woman in a yellow jacket, she's going in. / A man in dark glasses, he's coming out. / Teenagers in jeans, they're talking. / Thirteen seventeen and four seconds. / The short one, he's lucky, he's getting on a scooter, but the tall one, he's going in." At one point a girl with a green ribbon approaches the bar, but just then a bus pulls in front of her. "Thirteen eighteen. / The girl's gone. / Was she that dumb, did she go in or not, / we'll see when they carry them out."

At thirteen nineteen, a fat bald guy leaves the bar, but "Wait a second, looks like he's looking for something in his pockets and / at thirteen twenty minus ten seconds / he goes back in for his crummy gloves."

> Thirteen twenty exactly.
> This waiting, it's taking forever.
> Any second now.
> No, not yet.
> Yes, now.
> The bomb, it explodes.

Pontecorvo, for his part, back in his 1965 film, seems to be saying, "Yes, such tactics are perhaps sometimes necessary, but, my God, the cost! The terrible cost, and the awesome responsibility!" He didn't allow his agitprop characters any easy evasions.

And it's that refusal to evade responsibility which has haunted me these past few weeks as the Senate considered once again, and probably not for the last time, the question of military aid for the Nicaraguan Contras. The proponents and the opponents of extending a hundred million dollars in such aid seem to be inhabiting different universes, so divergent are their interpretations of what is going on down there and what this vote implies. That in itself is eerie, and gives one pause. But what has really been bothering me is the sense of distance, of sublime remove, on the part of the proponents of the assistance. It would be one thing if they were saying, "My God, what a sorry pass things have come to that today we have to vote to expand a war that will inevitably result in hundreds of deaths and the mutilation of hundreds of innocent bystanders—men, women, children. It's terrible, and yet we have to do it, for such-and-such a higher cause. We do it with heavy hearts and with our eyes wide open. Still, do it we must."

However, they have said nothing of the kind. Through copious recourse to euphemisms of the "pressure for negotiation" and "nurturing the movement toward democracy" variety, they have managed to empty their positions of all its actual consequences. Their vote will have terrible consequences in the real world. The legislators have simply contrived, if only for the time being (and hardly for the first or, one fears, last time), to evade all responsibility for them.

HOW SUDDENLY IT CAN ALL JUST END

VARIATIONS ON A THEME

THE CHALLENGER DISASTER / THE FAIL-SAFE NUCLEAR REGIME (1986)

If there ever is a nuclear war, chances are it will go remarkably like the shuttle disaster. That's one reason the imagery of that disaster continues to hold such fascination for us, why we studied the video images every night on the evening news—new images, seemingly, each night from some fresh perspective, revealing some new angle. We realize, if only subliminally, that we are being afforded a premonition.

Mankind as a whole today sits perilously strapped to a doomsday machine of our own devising: the globe itself has become like a giant booster hurtling through space, enormous explosive potential held barely in check, atop which we sit huddled, secured to our fragile life-sup-

port systems. Like the seven shuttle astronauts, we've been assured that the machine contains safeguards two and three deep, checks and counterchecks and checks on counterchecks, that nothing can possibly go wrong. ("The space shuttle Challenger's solid fuel booster rockets were not equipped with sensors," the *New York Times* reported within days of the catastrophe, "because designers thought the boosters 'were not susceptible to failure.'") And indeed, things have been "going right" for so long that we've become inured; we've grown to take success—or at any rate, the impossibility of failure—for granted.

And then something happens. It begins with

Explosion of the Challenger, 1986

A mushroom cloud from Operation Upshot-Knothole at the Nevada Test Site, March 24, 1953

a pinprick leak over to the side—along the rocket's South African rim, say, or over by its Iran-Iraq seal, its Israeli joint, its Polish latch. In retrospect, we can now see the leak may have developed owing to a fluky set of extraneous climactic conditions—it was too cold the night before, the price of oil or gold was dropping, or rising debt pressures were straining established orders, a particular minority was refusing any longer to countenance its continued oppression. The leak rapidly grew in intensity: the hiss became a spout became a geyser, an assassination or a food price increase provoked a riot that provoked a mobilization, a preemptive raid, a counter-raid.

The entire structure began to shudder violently—as the crisis burgeoned, leaders and computers strained mightily to cope with a situation increasingly out of control, one that had never before been encountered in any of the exhaustive predictive models. The vibrations were becoming too extreme, a latch perhaps shook loose, one booster veered toward the casing of another—the superpowers went on red alert, they removed the safety latches from the weapons in their respective arsenals, just in case.

And then… it's already over. The climactic spasm, when it happens, happens so suddenly and annihilates so completely that we can't even see it happening. We slow down the videotape, slow it down some more, and there's not a single moment, a single frame, when the explosion is just beginning. There are sparks, little flashes racing up and down the belly of the booster, but one moment the rocket is still there, entire, and next it's utterly vaporized. There's no in-between. Just as it was never supposed to happen.

The analogy breaks down. The shuttle disaster did happen; the nuclear holocaust hasn't yet. Consciousness survives the horror of the shuttle disaster, tries to make sense of it, to assign it meaning, to fashion analogies, to derive lessons. There would be no consciousness on the far side of a nuclear holocaust; or if there were any, it would be so damaged as to be incapable of making sense of anything—there would be no meaning, no analogies, no lessons.

TETRIS / GORBACHEV (MARCH 1990)

If you've spent some time around ten-year-olds lately, as I myself had occasion to the other day, you may have come upon a particularly elegant (and exasperating) item called Tetris, a computer game in which a variety of angular shapes made up of four squares—squares in a row, for example, or aligned as a chess knight's move, or staggered in a zigzag configuration—gradually drop from the ceiling of what looks like an empty silo. As the shapes float downward, the player is able to manipulate them—to move one to the right or the left, for example, or

rotate the knight's-move shape on its axis so that it lands on its back (three squares wide) instead of its head (two squares wide)—and the object of the game is to have the shapes fall in such a way, one beside the next, that they fill the bottom of the silo without leaving a blank. If you fail to accomplish this (and the irregularity of the shapes makes it more difficult than you might imagine), a new layer of shapes begins to form on top of the first. Once you do fill a row, it disappears—poof!—and you are awarded points; everything else settles down a notch, previously covered air pockets open up again, and it becomes momentarily possible to fill them in with the shapes that are continuing to float down. Invariably, though, you muff a chance here, a chance there, and the incomplete rows start piling up. Soon the silo is a quarter, a half, more than half full. And here things begin to get scary, because what you don't want is to let the rows get close to the top: as soon as even a single square gets jammed against the ceiling, the entire silo automatically fills up and the game is over.

Tetris was designed by a Soviet programmer named Alexey Pazhitnoc and is the first Soviet computer game to enter the United States market. It's not hard to guess where Mr. Pazhitnov came up with his idea. This past week marked the fifth year of Mikhail Gorbachev's tenure as the head of the Soviet Union, and in retrospect his entire term might be likened to an epic game of Tetris. The shapes—the challenges—keep floating down: Chernobyl, arms-control deadlocks, failed grain harvests, the Armenian earthquake, the Afghan evacuation, general economic prostration, striking workers in Gdansk's harbor, Lithuanian separatists, Georgian separatists, hard-line Communists to one side and radical democrats to the other, Russian nationalists, striking Siberian miners, Armenians and Azerbaijanis at each other's throats, East Germans pouring across the West German border, throngs in Wenceslas Square, riots in Timisoara, election reversals in Nicaragua, uprisings in Tadzhikistan. And, like a Tetris wizard, Gorbachev keeps trying to master them all: to manipulate and rotate them (having the Latvians attempt to negotiate a ceasefire

between the Azerbaijanis and the Armenians, for example, or exploiting the sudden windfall afforded by the fact that the Soviets no longer have to subsidize Managua by using it to ward off some other short-term calamity)—to clear this row and then the next, never letting the pile get too near the ceiling.

Last week, the editors of the *Bulletin of the Atomic Scientists* reevaluated the placement of the minute hand on the little clock whose face they have featured on their cover for the past four decades—the clock that is designed to suggest just how close humanity has come to midnight, or nuclear Armageddon. In the past it has come as close as two minutes to midnight (that was in 1953, after the first test of the hydrogen bomb), but now they have set it back four minutes, to ten minutes to midnight, the farthest away it has been in almost two decades. That feels about right. The world does seem a safer place these days, the ultimate threat much more remote, and, indeed, the clock itself seems an antiquated image, a quaint piece of nostalgia from a wall of the Atomic Café. (Of course, in a world that still contains more than fifty thousand nuclear weapons, roughly half of them under the control of a power that appears to be rapidly coming apart at the seams, that remoteness may be a delusion.)

Perhaps the atomic scientists should consider replacing their clock with a little picture of a Tetris board. On any given day, just how full is Gorbachev's silo? A quarter? Half? Two-thirds? Is he managing to retire rows—is the pile going down? Or are they stacking up on him? In this context, one of the most interesting features of Tetris is what happens as the silo starts to fill. In the early going, it's easy to retire rows, and it can take a long time for the silo to fill a quarter of the way, a little less but still a long time for it to fill halfway. But once the pile reaches roughly the two-thirds mark, the game usually ends within just a few more moves. The shapes are still floating down ever so gently, but now they have less and less space to traverse before they reach the top of the pile, and you have less and less time in which to manipulate them, and also less and less room. For example,

in rotating a knight's-move shape you may inadvertently wedge it between the top of the pile and the ceiling, and then the game is over. So there's a real urgency to the question of how high Gorbachev's pile has become. If his game were suddenly to end—especially with those thousands of nuclear weapons still in place—who knows what time it would be then?

POSTSCRIPT

A few months after this was piece was published, there was indeed a coup attempt against Gorbachev by a cabal of hardliners. The coup failed, but Gorbachev's authority was fatally compromised and he was out of office by the end of the year. As of this writing in 2005, there are still almost 20,000 live nuclear warheads in Russian and American arsenals.

MODERN TIMES

GULF WAR / SF EARTHQUAKE / AWACS / LEXIS-NEXIS

January 1991

The morning after the launching of Desert Storm—the long-threatened invasion of Iraq in the wake of Iraq's occupation of Kuwait—a group of us at my office were talking about this awesome new thing that has entered the world, these awesome new things: this unprecedented kind of warfare with its truly precision, pinpoint aerial bombing; this unprecedented kind of coverage where, thanks to the various satellite technologies and the twenty-four-hour news networks, you get to see and hear the results of that bombing instantaneously, as it's happening. Modern, we said, high-tech, uncanny, eerie, futuristic. And yet, of course, at another level, there's nothing new here. On the ground, the carnage of war, the gore, the frantically desperate attempts at rescue, the bitterly expiring hopes—they're all the same as they've ever been.

One of my friends there at the office that day commented on the way he'd been haunted all morning by the memory of an article he'd read last year—he couldn't remember where—about the San Francisco earthquake back in October 1989. About this young couple who'd been buried alive together in a small room in their collapsed apartment, their bones crushed in debris up to their waists, the two of them huddled together in this narrow air pocket. And of how the rescuers finally got to them—but at that very moment the wreckage caught fire; they were able to free up the husband, but he was forced to leave his wife behind and she perished in the flames.

We were all silent for a moment—CNN in the background was crosscutting between the latest Pentagon briefing and live coverage of a speech by the Turkish prime minister in Ankara.

"Wait a second," my friend said. "I remember: it was in the *Whole Earth Review*. In fact, I bet we can even access it over Nexus." Our office is tied into one of those computerized databases which offers continuously updated access to the complete back-contents of hundreds of newspapers and periodicals. My friend set himself down before the system's console, revved up the machine, punched in a few key words—*earthquake* and *fire* and *rescue* and *couple*—and instantaneously that very article appeared on the screen. He punched a few more buttons and the console's neighboring printer revved up and began spewing out a copy. The whole process didn't take more than a few moments.

The account, by Stewart Brand, was every bit as compelling as our colleague had remembered it. It turned out that Brand himself had happened to be visiting the neighborhood at the moment the earthquake struck and that he'd played an impromptu part in the volunteer rescue attempts: he'd been one of those on the outside, scrambling through the wreckage. "Of course, it wasn't as direct and purposeful as this brief account makes it seem," he records. "A real rescue is dreamy and hesitant, full of false starts and conflicting ideas, at times diffuse. It is a self-organizing process, neither quick nor tidy." Much later, weeks after the disaster, he'd gone back and interviewed several of the principals from that evening's incident, including Bill Ray, the husband, who was still recovering at a hospital. In his article, Brand interwove their stories, and his account climaxed as the firemen were being driven back by the flames:

> "I told Janet," [this is Ray talking] "I told her 'I'm going to get free, and we're both going to get free.' I assumed that I was binding her and that if I could get loose, then she could get loose. You just start pulling with everything you've got. You reach up and you pull on the lathe and the plaster, and it's breaking off in your hand…. Janet was screaming because it was a lot of pain and her arms were trapped, and a picture frame of glass was cutting her.
>
> "Then I got free, but she still wasn't. I tried to pull her out. Smoke was coming in. You could hear the flames cracking and popping. She couldn't pull herself loose, and I couldn't get to her."
>
> What they said to each other then, Bill Ray prefers to keep private. "Then I left," [Ray recalls] "I crawled out that hole…."

And so forth. That terrible lacuna—the private moment, what they possibly could have said to each other—has haunted me, too, ever since I read it. And, of course, I've been imagining the hundreds of variations of that scene being played out half a globe away; the fact that accidental strikes on civilian targets are purportedly being kept to a minimum doesn't comfort me in the

Crew members at an AWACS console aboard a NATO E-3A aircraft

The intersection of Beach and Divisadero, San Francisco, after the Loma Prieta earthquake of October 17, 1989

Baghdad, during the first Gulf War, 1991

least. I envision seventeen-year-old boys scrambling desperately to rescue their buddies, having to abandon the attempt in the face of further bombardments, and the image is in no way softened by the allegedly mitigating circumstance that the boys in question may be wearing uniforms.

But, strangely, the image that really haunts me, and the one I just can't shake, is that of my colleague in the eerie glow of his Nexis console, calmly punching that set of keys, activating the machine—the machine silently humming away, surveying the veritable continents of information before it, instantaneously targeting its quarry, yanking it out of the endless field and delivering it up to us whole. The surgical precision of the whole process. For a moment that morning, my colleague seemed to me like one of those amazing young officers strapped to his battle station aboard the AWACS control planes circling high above Saudi Arabia—coolly surveying his console, punching in the coordinates, splaying out the information, directing the entire battle.

CNN, Nexis, AWACS—they're all of a piece. And the carnage on the ground is something entirely else, almost infinitely removed.

Vaclav Havel, addressing the revolution, wearing the jacket in question, Prague, 1989.

ALLEGORIES OF EASTERN EUROPE

KAPUSCINSKI / SACKS

Spring 1990

For many years during the middle of this century, the truth in Central and Eastern Europe often, if not usually, came veiled in allegory. The tradition of collusion between writers and readers, between playwrights and playgoers, between filmmakers and film-viewers, ran from *The Master and Margarita* through *Closely Watched Trains*. Sometimes audiences discovered—insisted on discovering—the immediately relevant allusions planted in texts centuries old: the Polish drama of 1968 began with wildly inappropriate (or alternatively, wickedly astute) audience responses to a stage production of Adam Mickiewicz's *Forefather's Eve* (1823). Other times, authors cleverly cast their trenchant critiques of the contemporary scene in their own countries by purporting to examine events transpiring in lands (only seemingly) far distant.

Thus, for example, far and away the best diagnosis of the situation in Poland in 1978—which is to say, one of the last years of Edward Gierek's fabulously corrupt and incompetent regime—was Ryszard Kapuscinski's *The Emperor,* an enthralling account of the precipitate downfall of Haile Selassie in Ethiopia five years earlier. And everybody in Poland took it as such. Actually, the book worked on several levels at once, not the least of which was as pure reporting on those earlier events in Addis Ababa. Kapuscinski had long been one of Poland's foremost foreign correspondents; he had personally witnessed more than twenty-five

revolutions and civil wars throughout the Third World, from each of which he'd filed daily dispatches as the Polish Press Agency's journeyman correspondent on the scene. But in several cases, as in this one, back in Warsaw several years later, he'd had occasion to revisit the subjects of his earlier reportages and to compose rhapsodic elegies on themes he might only have glanced on at the time.

The Emperor is in fact a crepuscular work. "In the evenings," Kapuscinski begins, "I listened to those who had known the Emperor's court." The evenings, that is, as opposed to the daytimes, when he was busy scrambling to track the quickly unfolding story of Selassie's debacle and the upsurge of a Marxist insurgency within the ranks of the Emperor's own military, the one presently to be headed by Colonel Mengistu Haile Mariam—tracking that story and filing his dispatches in time for each late-afternoon's deadline. But in the evenings he'd track down the Emperor's former courtiers, pathetic wretches who were now holed up in caves and hovels, desperately hiding from the Terror already rampant in the streets outside. And he'd get them to recall their days in the Emperor's resplendent court—the elaborate rituals, the pervasive intrigues, everyone's obstinate refusal to acknowledge either the desperate poverty just beyond the palace walls or the inevitability of their own onrushing doom.

At another level, Kapuscinski's text works as a general allegory—a piercing dissection of the dynamics and contradictions inherent in any and every courtly situation (political, corporate, cultural, academic, institutional)—how authority itself first comes to be engendered but then inevitably congeals, begins to break up, and finally evaporates entirely. As such, *The Emperor* reads like the nightmare endlessly haunting Machiavelli's *Prince*. At still another level, it reads as literature, plain and simple, an inspired fiction over and beyond its almost incidental facticity, and as such Kapuscinski slots himself nearly on the shelf, right there between Franz Kafka and Gabriel García Márquez, where he belongs.

But it was, as I say, at this more intermediate level, as a *specific* allegory to the then-immediately contemporary situation in Poland, that the book was so zealously prized by most Poles when it first appeared in 1978. The correspondences between the two situations were indeed uncanny. Or rather (for in fact the two situations could hardly have appeared less similar on any objective sort of scale), Kapuscinski had worried out a series of uncanny correspondences, underscoring these again and again with almost conspicuous delight. Gierek himself had risen to power in 1970 after his predecessor Gomulka had ordered a huge increase in food prices only days before Christmas (Gierek had been a member of the Politburo which had initially signed off on the move). Industrial workers in the three northern coastal complexes at Szczecin, Gdynia, and Gdansk had thereupon boiled out of their shipyards and factories in tumultuous protests which

were quickly crushed with ruthless abandon by state security forces. Gomulka himself soon fell, and one of Gierek's first initiatives as his replacement was to suspend the price increases. "That is why His Providential Majesty," one of the Selassie's former courtiers at one point explains to Kapuscinski, "seeing the Empire wobbling, first sent the strike force to Gojam to take the peasants' heads off, then, confronting the incomprehensible resistance put up by the rebels, ordered the new taxes repealed and scolded the ministry for its overzealousness."

Another of Kapuscinski's informants recalls how "His Majesty sensed the spirit of the times, and shortly after the bloody rebellion he ordered complete development. Having done so, he had no choice but to set out on an odyssey from capital to capital, seeking aid, credits, and investment: our Empire was barefoot, skinny, with all its ribs showing. His Majesty demonstrated his superiority over the students by showing that one can develop without reforming. And how, I hear you asking, is that possible? Well, it is. If you use foreign capital to build the factories, you don't need to reform." This was, of course, precisely Gierek's gambit as well: rather than embark on any serious reform of the communist system in Poland, in just a few short years he managed to accumulate more than twenty billion dollars in debts to Western governments and banks. Initially the country surged, as well it might have been expected to, all that cool hard cash giving the economy a good stiff rush.

But for lack of any serious reforms accompanying the development, Poland presently experienced a spectacular proliferation of corruption. "Enrich yourselves!" was Gierek's flamboyant motto, and he certainly did, spotting himself no less than ten villas around the country. But so did his minions throughout the nomenklatura, and with a vengeance. "He liked the people of the court to multiply their belongings," one of Selassie's minions confides to Kapuscinski. "He liked their accounts to grow and their purses to swell. I don't remember His Magnanimous Highness's ever demoting someone and pressing his head to the cobblestones because of corruption. Let him enjoy his corruption as long as he shows his loyalty!"

But in 1978, Poland's initial boom had ruptured, the economy was hemorrhaging, and meanwhile the ghosts of 1970 were unassuaged. (One of the ways Poles were required to show their loyalty to Gierek was by never mentioning the bloodbath in the north which had given birth to his regime in the first place; for all intents and purposes, the massacres had never occurred. The survivors of those killed during those horrible days were even forbidden to include the dates of their deaths on their tombstones.) "Father," Kapuscinski has one young man address his resplendent courtier-father just a few months before the final coup, "this is the beginning of the end for all of you. We cannot live like this any longer. This death up north and the lies of the court have covered us with shame. The coun-

try is drowning in corruption, people are dying of hunger, ignorance, and barbarity everywhere. We feel ashamed of this country."

Nobody in Poland in 1978 needed to be told what that passage was all about. And in case there was any doubt as to how Kapuscinski himself intended it to be read, just a few pages earlier he'd coyly quoted a former courtier of Selassie's to the effect that "His Highness worked on the assumption that even the most loyal press cannot be given in abundance... *For even what is written loyally can be read disloyally.*" (italics mine)

Of course, Kapuscinski's text put Gierek and his censors in an excruciatingly uncomfortable position. They knew precisely how disloyally this text was intended to be read, and yet what could they do? To begin with, on the surface anyway, it was an account of the downfall of a reprehensible pawn of capitalist-imperialism and his replacement by a disciplined squadron of Marxist military men, close allies of Poland at that. Far from banning such a tale, one ought almost to be celebrating it. Beyond that, to ban it would have been to *admit* the similarities and thereby to endorse the subterfuge's entire premise.

So they just had to sit tight and smile and bear it. The Poles of course relished the evident discomfitures of the authorities almost as much as they savored the text itself (imagining their discomfiture was in fact one of the supreme pleasures involved in reading the text). But the thing they loved most about reading *The Emperor* was its delicious implicit prophecy: how such

regimes were doomed to fail. The book was incontrovertibly an elegy to the Polish present, and that adamantly confident tone (the sense of historic inevitability that pervaded the text) couldn't help but prove, in Poland's bleak late '70s, especially tonic.

Two years later, with the upsurge of Solidarity, seven separate stage adaptations of Kapuscinski's text would erupt on stages all over Poland. All that Polish theatergoers wanted to immerse themselves in, it momentarily seemed, were exotic tales of imperial doom on the Horn of Africa.

For some months now I have been wondering who was going to produce the first great allegorical treatment of the amazing transformation currently convulsing Eastern Europe and the Soviet Union. In a way, of course, the question is fundamentally misdirected, for it is precisely one of the most thrilling aspects of that transformation that in those lands allegories are no longer required. Journalists and novelists and playwrights need no longer couch their meanings while jousting with censors; for the first time they are able to report directly on the world around them without fear of sanction. This revolution in attitude is perhaps nowhere as evident as in Kapuscinski's own production: the great and wily chronicler of Eastern European realities as seen through a succession of Third World prisms is currently traveling throughout the

144

Soviet Union itself, preparing a chronicle of that empire *as it is*, which is to say, as just one more Third World country.

And yet, as the months have passed, I've likewise become increasingly convinced that the great allegory of the current period already exists, and has existed for more than fifteen years. Furthermore, in the simultaneous power and clarity of both its witness and its prophecy, the book in question suddenly seems to me indispensable for anyone trying to understand current developments in the rapidly disintegrating Eastern Bloc. It was not written by a resident of either Eastern Europe or the Soviet Union, and yet it seems to me inevitable that once it's translated into the succession of Eastern European languages (as it inevitably will be), it too will become the basis for dozens of spontaneous stage adaptations. No one will need to be told how to read it—people will recognize themselves and their situations immediately. And that is all the more remarkable in that the book's author, far from being an exceptionally cunning political analyst, is one of the least overtly political authors I know. I am speaking of Oliver Sacks and his 1973 masterpiece, *Awakenings*.

Actually, as a writer Sacks is in many ways comparable to Kapuscinski. Both simultaneously engage in two entirely different sorts of writerly production: whereas Kapuscinski files his daily dispatches only to return to the same themes years later for more expansive rhapsodic treatments, Sacks produces standard clinical notes on a daily basis as part of his regular practice—that of a consulting neurologist specializing in cases of chronic, often devastating neurological debility, usually in poorhouses and various state institutions—only years later to return to the same subjects, distilling and transmuting their histories into his celebrated "clinical tales." A 1987 collection of such tales, *The Man Who Mistook His Wife for a Hat,* became a phenomenal international bestseller. But *Awakenings* is Sacks's masterpiece, the ur-chronicle from which all his other work derives. And, as with Kapuscinski, it took Sacks almost a half-decade following the actual events described in his chronicle—which occurred for the most part in the summer of 1969—before he was able to see them clear. Similarly, as well, the book he then produced works on several different levels simultaneously— as straightforward reportage, as general allegory, as literature of the highest order, but also, as I am now beginning to see, as chillingly apt specific allegory as well.

Of course, as far as this last case goes, Sacks, unlike Kapuscinski, did not himself intend the specific allegory I am herein going to claim to discern in his text. It is, as I think about it, perhaps rather I who am in this instance working in the Eastern European tradition, the tradition of that 1968 audience at the performance of Mickiewicz, or of similar audiences at performances of Sophocles or Shakespeare or even Moliére; as Leszek Kolakowski is said to have noted around that time, "In the Polish People's

Republic today, all the world's literature has become an allusion to the Polish situation."

Sacks first encountered the patients who would become the subjects of his life's major work in 1966, when, at the age of thirty-three, he reported for part-time duty as resident neurologist at the hospital he would subsequently dub "Mount Carmel" (in fact, it was Beth Abraham, in the Bronx). At first, these particular patients seemed no different from the hundreds of other extreme cases being warehoused in that institution at the time—catatonics, autistics, schizophrenics, and other sad, pathetic cases (the place had only just recently dropped its initial designation as a "Home for the Incurable"). As Sacks made his daily rounds through the wards, however, he began to notice that some of the inmates seemed distinctly different from the others—peculiar, eerily askew, suspended, frozen, "like living statues." No one had given these particular patients much thought for more than a generation—they didn't seem to require much thought, they just sat there all day, stock still; they never *did* anything—but now Sacks began to burrow into the hospital's back records and he soon uncovered evidence of a virtually unimaginable, long-forgotten (and indeed resolutely repressed) pandemic holocaust.

In the middle of the First World War, a curious epidemic spread across the world, manifesting itself initially in a chaotic welter of differing forms—deliriums, manias, implacable insomnias, trances, anxious restlessness, comas, extreme Parkinsonism. It was only several years into the siege that the great Austrian physician Constantin von Economo was able, through painstaking observation and research, to identify the myriad seemingly disparate symptoms as manifestations of a single unified malady, which he labeled *encephalitis lethargica*.

Over the next decade, almost five million people fell victim to the disease. More than a third of them simply died outright. As for the others, many seemed to make full recoveries, simply getting on with their lives. Only, in the case of thousands of those recovered victims (particularly young people, teenagers, and men and women in their early twenties), years after their initially bout with the disease, suddenly they… simply… began… coming… to… a… halt. Typically, for example, following a brief period of extreme agitation, they'd fall into a fathomless sleep, entirely entranced, utterly removed. Families cared for their devastated loved ones for as long as they could, fully expecting recovery at any moment. But the stupefying trance continued and continued, unabated, for months and presently years on end (families often cracked under the strain), and eventually entire hospitals had to be established to house the victims. This had in fact been the origin of Beth Abraham and countless other such "homes for the incurable." And then, in the late 1920s, the epidemic seemed to disappear as suddenly as

it had first arrived, and for no apparent reason: suddenly, there were just no new cases being reported. The world got on with its business. The parents and siblings of the various victims gradually died off (sometimes of grief itself), or else, as the years passed, tried to get on with their lives. The hospitals began taking on other sorts of patients—other instances of horrific devastation—and the original patients, seemingly lost to themselves, were presently lost into the general population as well. Time passed. They sat there, day after day, asleep and yet not exactly asleep—removed, rather: infinitely removed.

"They would be conscious and aware," Sacks subsequently surmised, "and yet not fully awake; totally lacking energy, impetus, initiative, motive, appetite, affect or desire, they registered what went on about them without active attention and with profound indifference. They neither conveyed nor felt the feeling of life; von Economo compared them to extinct volcanos. Such patients, in neurological parlance, showed 'negative' disorders of behavior, i.e., no behavior at all. They were ontologically dead, or suspended, or 'asleep'—awaiting an awakening which came (for the tiny fraction who survived) fifty years later."

So that it's here, of course, that one first

Frozen post-encephalitic

begins to sense the resonances with the situation of the body politics of Eastern Europe over the past several decades—in the Soviet Union certainly since the Stalinist terror, in the peripheral countries since their occupations by the Soviets—populations who likewise (though in a completely different sense) had fallen out of time.

Sacks painstakingly reviewed the files of all the patients in the hospital—their case histories, dates of admission, condition upon admission, and so forth—and eventually he identified all the surviving encephalitis victims and brought them together in a single ward. He'd spend hours, entire days, sitting with them, staring at them, trying to imagine the interior lives, if any, masked by such exterior desolation. And gradually he became convinced that "One thing, and one alone, was (usually) spared amid the ravages of this otherwise engulfing disease: the 'higher faculties'—intelligence, imagination, judgment, and humor. These were exempted—for better or worse. Thus these patients, some of whom had been thrust into the remotest and strangest extremities of human possibility, experienced their states with unsparing perspicacity, and retained the power to remember, to compare, to dissect, and to testify. Their fate,

so to speak, was to become unique witnesses to a unique catastrophe."

The opportunity to testify would come, uncannily, just two years later. For it was during those very years that a new treatment for Parkinsonism, a much vaunted "miracle drug" named laevodihydroxyphenylalanine—L-Dopa, for short—began to be widely prescribed. In reviewing the literature on *encephalitis lethargica,* Sacks began to sense that the illness's sequelae might in many ways be likened to an extreme form of Parkinsonism. The onset of ordinary Parkinsonism, as he knew, had, earlier in the '60s, been determined to be related in some way to a deficit of the nerve-transmitter dopamine in the affected parts of the victim's brain. Immediate efforts had been launched, soon after the discovery, to find a way to replenish the brains of such patients with dopamine's precursor, L-Dopa (dopamine itself could not pass into the brain), and by 1957, Dr. George Cotzias and his colleagues were able to report resounding therapeutic success in giving Parkinsonism patients massive amounts of L-Dopa orally. In fact, enthusiasm for the wondrous new therapy was beginning to verge on the messianic.

It was against this backdrop that Sacks weighed the option of giving the new drug to his living statues. Weary of all messianic pharmacological euphorias, he was nevertheless facing a dramatic decline in the fortunes of several of his patients, owing in part to the onset of old age. So that, with some reluctance, he decided to begin administering the drug on a carefully controlled basis. What followed was altogether astonishing.

In one patient after the next, virtually from one day to the next, the long trance suddenly lifted and they all "woke up." The case of the patient Sacks identifies as Leonard L. was typical (the heart of *Awakenings* consists in case histories of twenty individual patients, of which Leonard's is the most extensive): "Little effect was seen for two weeks and then a sudden 'conversion' took place. The rigidity vanished from all his limbs, and he felt filled with an access of energy and power; he became able to write and type once again, to rise from his chair, to walk with some assistance, and to speak in a loud and clear voice—none of which had been possible since his twenty-fifth year. [By the end of the month], Mr. L. enjoyed a mobility, a health and a happiness which he had not known in thirty years. Everything about him filled him with delight; he was like a man who had awoken from a nightmare or a serious illness, or a man released from entombment or prison, who is suddenly intoxicated with the sense and beauty of everything round him. During these two weeks, Mr. L. was drunk on reality..."

Other patients experienced similar sorts of transport, and all of them marveled at the sheer suddenness of the transformation. Several years ago, I myself had occasion to speak with one of those patients (the one Sacks identifies as Gertie C. in his book). I asked her if she remembered

what it had been like when she first came to. "Oh yes," she replied softly. How was it? "Well, suddenly I was talking." Did she remember her first words? "Oh yes," she smiled. And what were they? "Suddenly," she said, "I heard myself saying, 'Oooh, I'm *talking*.'"

Harold Pinter, the British playwright, was enormously taken with *Awakenings* and himself produced a version for the stage in 1982, an exceptionally concentrated and powerful one-act entitled *A Kind of Alaska*. (Translations of that play will no doubt soon be captivating audiences throughout Eastern Europe—"A Kind of Siberia"? The script is available as part of Pinter's collection *Other Places*.) With lapidary concision, Pinter similarly captures the wonder of that first moment with the very first words of the play—a woman in a white bed in the center of the stage, staring ahead blankly, who suddenly whispers, "Something is happening."

And, of course, that was the great archetypical moment throughout Eastern Europe last autumn, as in one capital after another—in Leipzig and Prague and Sofia and Bucharest (the moment had already occurred a bit earlier in Warsaw and Budapest)—after years and years of blockage and constriction, people suddenly discovered themselves in the midst of talking. Something, at long last, was happening.

But one doesn't need an Oliver Sacks (or a Harold Pinter) to adumbrate such a moment—

any number of fairy tales will do just as well. Where Sacks's narrative proves especially valuable is in his account of what happened next—a sequence of occurences which in many ways proved even more remarkable. For the *Awakenings* story, in its full sweep, correlates with one of the most complex aspects of the current transformation, the way in which in many of these formerly Eastern Bloc countries, the early euphoria is now beginning to give way to something decidedly more problematic—the way in which many of the initial, almost messianic expectations for the new order seem destined to be decisively smashed. I am speaking, in particular, of the horizon facing the sorts of "utopian capitalist" initiatives which initially seemed to enthrall so many of the Eastern Europeans and presently Russians, particularly the intelligentsia, who quickly became enamored of a free market model the likes of which might even have given Adam Smith pause.

Initially, at Beth Abraham, everything had seemed fine—the future wide and free. "For a brief time," Sacks reported in his final summary chapter, "the patient on L-Dopa enjoys a perfection of being, an ease of movement and feeling and thought, a harmony of relation within and without. Then his happy state—his world—starts to crack, slip, break down, and crumble; he lapses from his happy state, and moves toward perversion and decay." The first symptom of the returning disease, of things going wrong, was "the sense of things going wrong." The sense of

well-being slid inexorably from the ample to the euphoric to the manic and right on out toward the hysterical. "Paradoxically," Sacks reports, "deceptively, such exaggerations first appear as excesses of health, as exorbitant, extravagant, inordinate well-being; patients such as Leonard L. slip by degrees, almost insensibly, from supreme well-being to pathological euphorias and ominous ecstasies. They 'take off,' they exorb, beyond reasonable limits, and in so doing they sow the seeds of their subsequent breakdowns." Patients began experiencing ever-wilder reactions both to the drug itself and to any attempts to wean them from the drug. Within a few more weeks, the ward at Beth Abraham had transmogrified itself from a sort of Garden Paradise into sheer Bedlam.

Respiratory crises (sudden inhalations with the desperate inability to exhale), oculogyric crises (the eyes rolled back in the skull, the body spasmodically rigid), seizures, uncontrollable frenzies of tics and yelping, delusional manias of all sorts—Sacks tried to report the fearsome side-effects he was encountering with L-Dopa by way of the standard medical journals, but he was roundly attacked for undermining the sense of confidence in what was still adamantly believed to be a wonder drug with unlimited horizons.

At first, Sacks and his coworkers endeavored to tackle "the problem" as if it were simply one of "titration"—of finding the correct dosage of the drug for each individual. Thus, for example,

regarding a patient Sacks identifies as Frances D.: "Although the reported experience of others encouraged us to suppose that one could 'balance' or 'titrate' patients by finding exactly the right dosage of L-Dopa, our experience with Miss D.—at this time—suggested that she could no more be 'balanced' than a pin on its point. Her oculogyric crisis, which was severe, was at once followed by a second and third oculogyric crisis; with increase of the L-Dopa to 0.95 gms a day, *these* crises ceased, but respiratory crises returned; with diminution of L-Dopa to 0.925 gm a day ... the reverse switch occurred; and at 0.9375 gm a day, she experienced *both* forms of crisis, in alternation, or simultaneously."

That case seems to me particularly rich with analogues to the coming fate of several Eastern European economies. In fact, the transition to a free market will be fraught with complications, some of them ironclad contradictions. Technocrats will earnestly try to jimmy the dosages but they will be unable to avoid considerable chaos. They will not, for example, be able to fend off massive unemployment without provoking wild inflation; they may not be able to staunch a frightening polarization of wealth without dramatically hobbling growth. Their blithe self-confidence notwithstanding, there may simply not be any technocratic fixes to many of the tortuous dilemmas up ahead.

The point to understand is that these are not just unfortunate side-effects of an otherwise

effective therapy. To return again to the Beth Abraham pole of our analogy: Sacks notes how "This is very well realized by clear-minded patients, often better than by the physicians who treat them. One such patient (Lillian T.), now in Mount Carmel, when admitted to a large neurological hospital in New York, for the ninth time, for the 'treatment of side effects'—in her case, a violent head-thrusting from side to side—said to her physician. 'These are *my* head movements. They are no more a "side-effect" than my head is a "side-effect." You won't cut them out unless you cut off my head!' "

Some of Sacks's richest and in our context, most relevant—writing on this phase of the Awakenings process, which he calls Tribulation, comes, remarkably, when he hazards an economic metaphor to account for the complications he was encountering with his patients: "Unsatisfied need, insatiable greed, defines the eventual position of *all* patients on L-Dopa. This leads to the inexorable economic conclusion—that there is a lacuna somewhere, an unassuageable gap, to be found in the situation of every single patient ... a gulf which cannot be filled *and stay filled;* not at least through the agency of L-Dopa alone. A chasm develops between supply and demand, between need and capacity; an inner division of being takes place, so that there is a simultaneous suffering from surfeit and starvation—'one halfe lacks meat, and the other stamacke,' in the metaphor Donne applies to his sickness...

"These patients have needs over and above their need for L-Dopa (or brain dopamine), and beyond a certain point or period no mere *substance*—however 'miraculous'—can compensate, or indemnify, or cover up these other needs. ... They can be 'titrated' *at first,* as eroded ground can be watered, or a depressed area can be given money; but sooner or later complications occur; and they occur because there is complex trouble in the first place—not merely a parching or depletion of one substance but a defect or disorder of *organization* itself, invariably in the brain."

Elsewhere Sacks suggests—again in a formulation with direct relevance for our considerations—that the most dramatic tribulations occurred in patients with the most extreme prior histories. This leads him to hypothesize that such patients, for example, were not only lacking sufficient dopamine for forty years, but that that forty-year deficit had itself done organic damage to nerve endings, such that merely topping them off with the proper amount of L-Dopa inevitably failed to stabilize the situation. "Moreover," he writes, "a static metaphor—like stuffing a man with half a stomach—is not adequate to describe what actually occurs; the image of 'whipping up' decayed and flagging cells, and of their accelerated breakdown under this stress, is much more germane to the eventual consequences of L-Dopa." Here, in turn, we are speaking, at the other side of our analogy, of the consequences not just of an utterly dilapidated physical infrastructure, for example, but of

an entirely debauched work ethic as well. The simple, much vaunted jolt of good, stiff capitalism stands a good, stiff chance of simply overwhelming the system.

And yet, for all the horrors of Tribulation, for all the excruciating disappointments of early hopes savagely dashed, *Awakenings* is finally not by any means a despairing work. Far from it. If Tribulation inevitably followed Awakening for each of Sacks's patients, for many there was a third and final phase, which Sacks calls Accommodation. The utopian expectations had to be dashed—they were a goodly part of the problem—before more limited, more modest (sometimes almost infinitesimally modest) balances could be struck. Patients wanted to, fully expected to leave the hospital—and then never did. But nor did they necessarily return to the constriction and blockage of their earlier bondage. They came to live within their means; they *found* their means.

"It is characteristic of many neurologists (and patients)," writes Sacks (and, one might add, of many economists and technocrats as well), "that they mistake their intransigence for strength, and plant themselves like Canute before advancing seas of trouble, *defying* their advance by the strength of their will. Or, like Podsnaps, they *deny* the sea of troubles which is rising all round them: 'I don't want to know about it; I don't admit it!' Neither defiance nor denial is of the least use here; one takes arms by learning how to negotiate or navigate a sea of troubles, by becoming a mariner in the seas of one's self. 'Tribulation' dealt with trouble and storm; accommodation is concerned with weathering the storm...

"The weapons of use in the tribulations of L-Dopa are those we all use in conducting our lives: deep strengths and reserves, whose very existence is unexpected; common sense, forethought, caution, and care; special vigilance and wiles to combat special dangers; the establishment of right relations of all sorts; and of course the final acceptance of what must be accepted. A good part of the tribulations of patients (and their physicians) comes from unreal attempts to transcend the possible, to deny its limits, and to seek the impossible: accommodation is more laborious and less exalted, and consists, in effect, of painstaking exploration of the full range of the real and the possible ... *for health goes deeper than any disease.*" (final italics mine)

In the end, Sacks is profoundly suspicious of the pharmacopia—or rather, while he values its potential contribution, he only does so to the extent that it stays kept in its place. At one point he describes how Leonard L., as he saw himself beginning to break up, furiously composed a long autobiographical essay, which he concluded with the lines: "I am a living candle. I am consumed that you may learn. New things will be learned in the light of my suffering."

To which Sacks adds: "What we do see, first

and last, is the utter inadequacy of mechanical medicine, the utter inadequacy of the mechanical world view." For, as he argues earlier, "The therapeutic game cannot be played this way, whatever our wishes; but—to the extent that it can be played at all—it can be played 'by ear,' by an intuitive appreciation of what is actually going on. One must drop all presuppositions and dogmas and rules—for these only lead to stalemate and disaster; one must cease to regard all patients as replicas, and honor each one with individual attention, attention to how *he* is doing, to *his* individual reactions and propensities; and, in this way, with the patient as one's equal, one's co-explorer, not one's puppet, one may find therapeutic ways which are better than other ways, tactics which can be modified as the occasion requires."

Another way of framing matters is that Eastern Europe and the Soviet Union are rife these days with hellbent, hotshot technicians when what they truly need is a master economist, a master of *oiko nomia*—literally, the proper management of the household.[1] "The flashlike drug-awakening of summer 1969 came and went," Sacks concludes his narrative. "Its like was not seen again. But something else followed in the wake of that flash—a slower, deeper, imaginative awakening, which has gradually developed and lapped them around in a feeling, a light, a strength, which is not *pharmacological,* chimerical, false or fantastic: they have—to paraphrase

1. At the time I wrote this piece, the sort of hotshot technocratic advisor I had in mind was epitomized by Harvard's globetrotting wunderkind Jeffrey Sachs (different spelling and thus obviously no relation to the neurologist author of *Awakenings*) who, though clearly the best of his breed, still seemed to represent some of its most brashly self-assured, one-size-fits-all policy-dictating tendencies, at least as he stormed through Poland and then the Soviet Union with his so-called "shock-therapy" prescriptions (gleaned, in turn, from his own intervention, several years earlier, in Bolivia's hyperinflation). In Poland, as it happens, those prescriptions did indeed lay the groundwork for a solid transformation to a market economy (though not without considerable transitional tribulation and lingering long-term problems, such as persistent outlying unemployment). His results in the Soviet Union, on the other hand, were considerably less sanguine—the period of Tribulation considerably more ruinous, and the outcome decidedly more suspect—as he himself would be the first nowadays to admit.

The remarkable thing, however, is how much his own thinking in this regard has changed in the years since. Now the director of the Earth Institute at Columbia University and Special Advisor to UN Secretary General Kofi Annan on Millennium Development Goals, Sachs recently published *The End of Poverty: Economic Possibilities for Our Time,* a bracing call to arms (with a foreword by Bono), which, drawing on a review of many of those earlier experiences, goes on to advocate a distinctly fresh and new approach, which he characterizes as "clinical economics" (talk about convergences!).

Characterizing most contemporary development economics as "like eighteenth-century medicine, when doctors used leeches to draw blood from their patients, often killing them in the process," he instead advocates an approach not unlike that his wife deploys in her practice as a pediatrician. As he notes, the medical clinician views the human body as "a complex system," whose "complexity requires differential diagnosis," couched within an understanding of the wider social context, and then followed by careful "monitoring and evaluation" and when necessary, revision, all within the context of a profession with "strong norms, ethics, and codes of conduct." The resultant practice is far more nuanced than the sort of approach he was deploying fifteen years ago, far more collaborative and attentive to specific variation, far more, well—not to put too fine a point on the matter—Sacksian.

Browne—come to rest once again in the bosom of their causes."

As it happens, a version of *Awakenings* is currently being made into a film. Starring Robin Williams as the Oliver Sacks character and Robert De Niro as a version of Leonard L., directed by Penny Marshall (who, if you think about it, is in a certain sense fashioning a remake of her first hit, *Big*—children who go to bed one night only to wake up, absurdly, as adults), it will be out in time for this Christmas's blockbuster sweepstakes. The film was being shot last winter on location in an abandoned wing of Kingsboro Psychiatric Center, and you could have gone there anytime and seen the crew huddling around, most of them swathed in the production's uniform, an ample black lumber jacket with the word AWAKENINGS embossed on the back, in green. One of the most animated figures on the set was the cinematographer, the exiled Czech master Miroslav Ondricek. Which probably explains the item I came upon a few months afterwards in the *New York Times,* in Henry Kamm's profile of Vaclav Havel, ensconced as president in the high castle above Prague, on the eve of his visit to the United States. Following an account of the interview, the piece ended jauntily:

"The President slipped into a black lumber jacket and ran off for a lunch engagement. On the back of the jacket, in green letters, in English, it said, 'Awakenings.'"

I couldn't help wondering whether Havel had any idea what he was wearing. No doubt, he'd be finding out soon enough.

VARIATION

WAKING UNCLE TOBY (JANUARY 1990)

A few years ago, Sacks published a case study, entitled "Cold Storage," in the British quarterly *Granta,* in which he recalled a patient he identified as Uncle Toby, whom he encountered in 1957, when he was studying at Central Middlesex Hospital, in London. A doctor there had happened upon Uncle Toby during a house call to see a sick child. While treating the child, he noticed a silent, motionless figure sitting in a corner, and when he asked about the figure the family explained matter-of-factly, "That's Uncle Toby—'e's hardly moved in seven years."

Uncle Toby's initial slowing down had been so gradual as to go almost unnoticed. Later, it became so profound that it was just accepted by the family. "He was fed and watered daily," Dr. Sacks reports. "He was really no trouble ... Most people never noticed him, still, silent in the corner. He was not regarded as ill: he had just come to a stop." Uncle Toby, it turned out, was suffering

from a thyroid malfunction, and his metabolic rate had been reduced almost to zero. His temperature, which had to be measured on a special thermometer, proved to be sixty-eight degrees Fahrenheit—thirty degrees below normal. He was, in Dr. Sacks' words, "alive, but not alive; in abeyance, in cold storage." Over a period of weeks, doctors administered progressively larger doses of thyroxine to Uncle Toby, and his temperature rose steadily; soon he was walking and talking. Within a month, Dr. Sacks says, Uncle Toby had "awakened."

Most of the rest of the case study details the remarkable situations of both Uncle Toby, for whom not a moment seemed to have passed—for whom it was still 1950—and his doctors, who were still trying to decide how they might best coax their patient toward a realization of his predicament. But then the case took a darkly ironic turn. The doctors discovered that Uncle Toby had a highly malignant, rapidly proliferating "oat-cell" carcinoma. "We managed to find chest films, routine X-rays, from 1950, and there we saw, small and overlooked at the time, the cancer he now had." Such cancers ordinarily kill within a few months, but "it seemed evident that his cancer, like the rest of him, had been arrested in cold storage," Dr. Sacks writes. "Now that he was warmed up, the cancer raged furiously," and he "expired, in a fit of coughing, a matter of days later."

Uncle Toby's story has been coming to mind in recent weeks as we've been following the news percolating out of Soviet Central Asia and parts of Eastern Europe. Last year, like a lot of other people, we briefly entertained the notion that, thanks to *glasnost* and *perestroika,* history might be coming to an end. If Joyce's Stephen Dedalus described history as a nightmare from which he'd been vainly struggling to awaken—well, here we all were, awakening. The State Department's Francis Fukuyama, whose essay along these lines, "The End of History?," enjoyed an enormous vogue last summer, argued by way of Hegelian categories that all the conflicts of prior ages were, in our own time, beginning to resolve themselves into the triumph of liberal, more or less free-market, technocratic democracy. Fukuyama himself greeted this outcome with almost wistful misgivings, but his argument did seem to jibe with much of what was going on.

As the year came to an end, however, so it seemed, did "the end of history": it had had an unusually brief life. Far from having ended, history seemed to be resurging—and with a vengeance. Not only did events in Romania, Bulgaria, the Baltic States, the Caucasus, the Transcaucasus, Yugoslavia, and elsewhere plunge us deep into the bowels of history once more but the history we were deep into was, uncannily, that of 1913, 1914, 1915, involving, among other things, the legacies of the breakup of the Ottoman Empire. It suddenly began to seem as if the Soviet Communist experiment that came along a few years later had succeeded only in momentarily suspending history—thrusting

age-old enmities into an artificially induced cold storage. For years, the world went on about its business, virtually ignoring Transylvania, Armenia, Azerbaijan, Bosnia, and Uzbekistan as they moldered away silently over there in their corners. But now, with the waning of Soviet hegemony, those distant provinces have been reviving, and with them, some long-arrested cancers. Back in 1915, for example, the Turks embarked on a genocide of their Armenian minority, and now many Turkic-speaking Azerbaijanis seem intent on resuming the vendetta. Meanwhile, Bulgarian nationalists seem set on evicting their own Turkish minority. It's like 1915 all over again. And as for Yugoslavia...

Uncle Toby has awakened, but what has he awakened to?

LOVING OR LEAVING BOSNIA

One morning in 1993, in the early days of the Yugoslav Wars, I happened upon a photo in the pages of a newsmagazine which struck a chord. I sent the magazine in question to New Yorker *cartoonist Ed Koren, wondering whether it would strike a similar chord with him. It did. His account follows:*

The other day, opening *The Economist,* I was startled by an image of Bosnian refugees that struck me with a force not so much of déjà vu as of déjà fait. The photograph reminded me of a drawing I had made back in 1981, in an attempt to address an altogether different and infinitely less dreadful issue.

In 1981, the thoroughfares of the United States were flooded with mobile hearts: bumper stickers that celebrated the motorist's love for cats, scuba diving, or Yorkshire terriers, or for some geographic locale—a hometown or vacation spot. The phenomenon seemed at once naïve and a bit hopeless—another American effort to single yourself out, to differentiate yourself (and your car) from the hordes of apparently identical beings and things. At the same time, it seemed an attempt to reach out across the asphalt to signal your humanity (through what you ♥ed) to other souls, similarly atomized, and hurtling along in their vehicles with their own hearts plastered across their chrome sleeves.

The cartoonist's problem: How to address all this? Where best to project a distillation of ourselves? I mulled over a number of likely candidates—Antarctica, the Arabian peninsula, the Midlands, New Jersey. But none had the possibilities of Bosnia and Herzegovina. Historically fractious, physically rugged, economically marginal, the place seemed sleepily out of time—nestled in an earlier century within the confines of a modern nation. It seemed, in 1981, the perfect venue for a bit of American silliness—the most dormant place on earth.

Newt Gingrich, Time *cover, Jan 9, 1995*

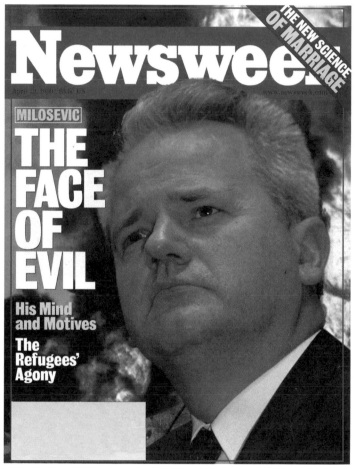

Slobodan Milosevic, Newsweek *cover, April 10, 1999*

PILLSBURY DOUGHBOY MESSIAHS

GINGRICH / MILOSEVIC

1996

It wasn't the first time I'd noticed the astonishing physical similarity, nor, I suspect, am I the first or only one ever to have noticed it. But the other day, watching the initial installment of Brian Lapping's superb five-part documentary on the fall of Yugoslavia, airing on the Discovery Channel, I was once again struck by how very much Newt Gingrich resembles that other Pillsbury Doughboy Messiah, his twin-in-the-news, the Serbian strongman Slobodan Milosevic: the same jowly countenance, the bouffant gray mantle of hair, that identical out-thrust, righteously aggrieved little button of a chin. Nor, as I gradually came to realize, continuing to monitor the weeklong documentary series, is the resemblance merely physical. For one thing, Milosevic, too,

turns out to command a seemingly effortless facility in the insouciantly glib cadences of (virtually unaccented) American-English political rhetoric.

But more to the point, the origins of the two men's respective political vocations suddenly seemed remarkably similar. A decade ago, Milosevic was a mid-level apparatchik with no particular political convictions beyond an evident craving for power itself. Various exposés over the last few years—including Connie Bruck's in *The New Yorker*—have documented Gingrich's own lack of ideological convictions at the outset of his career (or, anyway, a remarkable pliability in whatever convictions he claimed to hold); but they likewise highlighted how he, too, was animated by a fierce and burning drive for power,

almost for its own sake, and from the very outset. In Milosevic's case, the transformative moment came in 1987, when, visiting the autonomous region of Kosovo, a seedbed of Serbian national historical identity in which the local Albanian population had grown to outnumber their Serb counterparts by a factor of ten-to-one (much to the latter's consternation), he almost seemed to stumble upon the incandescent potential of greater Serbian nationalism as a ferociously effective rallying cry. (There's a moment early in the Lapping documentary

where we actually get to watch the awareness of that rhetorical gambit's potential effectiveness dawning across Milosevic's face, and he seems as startled as anyone.) In America, politicians tend not to address rallies anymore, or, anyway, such rallies seldom seem to matter—instead, they convene focus groups. Gingrich is known to have spent his years in the wilderness closeted with such groups, intently calibrating and recalibrating the slogans and appeals that might carry his side to victory, famously emerging just prior to the 1994 Congressional campaign with his

"Contract with America."

From that point forward the analogies become somewhat more striking. Because if both Gingrich and Milosevic might have been considered canny political opportunists, the legions of followers their rhetoric quickly summoned forth were, on the contrary, True Believers. In Bosnia in particular, the local Serb nationalists tended to be puritanical-fundamentalist outsiders appalled by tendencies toward inter-ethnic intermingling and cosmopolitan tolerance which had become more pronounced (for various historical reasons) in that region than anywhere else in the former Yugoslavia and were most vividly represented by the capital, Sarajevo, itself. Their campaign of ethnic cleansing quickly took on the trappings of a crusade; and, with the collusion and benediction, initially at any rate, of their maximum leader in Belgrade, that crusade soon coalesced into a strangulating siege of the Bosnian capital.

Gingrich's "Contract with America" had several components but the one that his True Believing followers—famously personified by the

self-styled "Freshman Class" of first-term Congressional representatives—most passionately seemed to champion was the call for the quickest possible convergence on a balanced federal budget. We can bracket for our purposes here whether the balanced budget was being pursued as a sound fiscal initiative in its own right or rather as a simple means toward gutting an entire range of New Deal and Great Society programs which the True Believers despised for other, variously extraneous reasons. In any case, this glorious band of outsiders, once again with

Photograph by E.J. Camp/Edge

the initial collusion if not under the direct instigation of their own Maximum Leader, likewise hit upon the tactic of laying (albeit symbolic) siege to the capital whose liberal, profligate ways symbolized everything about the country's prior governance which they so vocally and expansively despised: hence, the famous government shutdown of late fall 1995.

One of the first targets of the Bosnian Serb zealots ensconced in their mountain redoubts above Sarajevo was the city's magnificent library with its irreplaceable historical archives (containing, as it happened, vivid and irrefutable testimony as to the long traditions of inter-ethnic toler-ance and cross-fertilization which for centuries had characterized Bosnia's remarkable cultural life, right alongside the various counter-tendencies toward tension and intolerance). They blew the place to smithereens. There were countless, countless other outrages during the Bosnian frenzy of ethnic purification (mass murders, mass rapes, forced evictions, the demolitions of other cultural monuments, and so forth)—but few seemed to epitomize the tenor of the Bosnian Serb crusaders so emphatically as the destruction of that library.

Now, of course, nothing in the U.S. federal government shutdown remotely resembled the sheer physical gruesomeness of what transpired in Bosnia (unless you want to consider, as a sort of anticipation, the devastation of the Federal Building in Oklahoma City, a disaster arguably fostered by the same climate of rampant antigovernment self-righteousness which has characterized much of what has been passing, under the sway of the Freshman Class and their cheerleaders in the mass media, for national political discourse this past year—but that's another story). On the other hand, it is striking how, what with all the other inconveniences and hardships occasioned by the federal

163

shutdown, one of the main foci of public consternation became the irredeemable on-again, off-again suspension of the unprecedented, once-in-a-lifetime (hell, once in a millennium!) Vermeer retrospective at Washington's National Gallery. As Robert Hughes parsed the matter in the January 8 issue of *Time* magazine, "Nothing in the budget blackmail epitomizes the Republicans' folly as well as Vermeer. He's the canary in our ideological coalmine. This, one realizes, is part of what Congress's cultural ignorami mean by renewing American civilization. It is done by humiliating cultural institutions and depriving Americans of what the institutions contain."

Now, as both Milosevic and Gingrich came to realize in their separate ways, sieges are tricky things: they can be damnably effective, but unless they succeed outright, they can also begin to be damnably counter-effective. They stiffen the opposition's resolve, and the manifestly visible sufferings they entail can gradually turn public opinion (whether the world's or the nation's) against those doing the besieging. There was a wonderful sequence in Lapping's documentary where Milosevic, realizing this paradox, at last acceded to the celebrated Vance-Owen plan at an emergency convocation held in Athens in May 1993. After a good deal of arm-twisting, he

even got his onetime surrogate, the Bosnian Serb True Believer Radovan Karadzic, to go along with the proposal. But Karadzic cleverly insisted on bringing the pact back to his Pale headquarters for a final vote by his self-styled Bosnian Serb parliament. Lapping managed to find incredible footage of Milosevic's vain pleadings with these True Believers, his desperate argument that this was the best deal they could ever hope to get, and so forth—another great moment of gradual revelation playing across his brow as it began to dawn on him that he'd lost control of these, his True Believing onetime instruments. For, of course, defiant to the end, they voted the pact down.

A similar moment must have occurred several weeks into the U.S. government shutdown—if only Lapping's cameras could have been there!—when Gingrich, realizing the growing futility of the tactic, finessed a deal with the White House to reopen the government before Christmas (in large part, simply to be able to grant millions of federal workers their otherwise frozen paychecks in advance of the coming holiday), only to have the deal shot down by his Freshman troops, who then exultantly branched off on their own lavishly paid vacations. "We will never, never, *never* give in!" Rep. Bob Livingston (R-LA) exulted, in a would-be Churchillian ecstasy, to the wild

cheers of his cohorts. "We will stay here until doomsday—and Merry Christmas!"

Observing this entire cavalcade, particularly in the context of the happenstance of the roughly simultaneously airing of Lapping's documentary, and marveling in both instances at the whole phenomenon of True Believership, I found myself recalling a lecture I once attended, years ago—I don't even remember the professor's name. But he was talking about the concept of heresy as it gradually took shape in the early Christian church. Heresies, the professor explained, generally consisted (or came to be seen as consisting) in long-suppressed aspects of the truth which were then raised to the level of The Whole Truth and idolatrized as such. It wasn't that the sense of grievance animating these movements was wholly without validity. No: the trouble with heresies was never so much one of verity or even proper occasion so much as one of proportion.

I don't even know if that formulation (or, at any rate, my memory of it) is exactly true of the early Christian church, but in the years since, I've often found myself recalling it as I considered a whole range of more contemporary cultural and political phenomena. Thus, one might speak of a feminist heresy, or a black nationalist heresy, or a gay heresy—the whole panoply of identity-political heresies that have so

riven what once passed for a united progressive movement. (More recently, one might speak of an Embattled White Male heresy.) Internationally, one might speak of an IRA heresy (or conversely an Irish Protestant one), of a PLO heresy or a Zionist one. In most of these cases, the aggrieved party has every right to its sense of grievance and indeed every right to challenge a dominant historical paradigm that for years has managed to occlude not only the validity of that grievance but sometimes even the existence of the group itself (think of the Kurds). We enter the terrain of heresy, however, when that sense of grievance, that demand for recognition and reparation and rectification, becomes the Only Grievance, the Sole Demand.

Of course, the Serbians had cause for concern as Yugoslavia began to break up—beyond that, through their legacy of defiance to the Nazis and other earlier tyrannies, they could lay claim to a tremendous, majestic history as one of the most noble and heroic peoples in the region. But they weren't the only people in the region with legitimate concerns, and Milosevic and his followers blackened their cause and their name (perhaps for generations to come) when he began acting, heretically, as if they were. I would argue, similarly, that many of the issues raised by Gingrich and his Freshman Class—for starters, that hemorrhaging federal budget—are

valid (who could possibly argue otherwise?). Of course the huge federal deficit is a problem—although how much of one is open to honest debate (it's worth noting that on a per capita basis, America's national debt is lower than that of fourteen of our European allies) and how it is to be addressed (at what pace, under what strictures, to whose benefit and at whose expense) is likewise open to honest dispute. This is the stuff of democratic contest and governance. To fetishize the balanced budget, on the other hand, to hold governance hostage to the fulfillment of that Sole Demand, is, in the terms we have been considering here, a Heresy.

Returning to the Yugoslav analogy, one finds occasion for both hope and despair. Because, to begin with, True Believers usually go too far: untempered by all sense of proportion and right relation, they overplay their hands and usually end up having to settle for substantially less than they might have achieved at an earlier moment, in the high, full tide of their influence. This certainly happened in Bosnia: many of the Bosnian Serb True Believers, at any rate, have been decisively discredited, even in the eyes of their own people, and Milosevic himself may yet be facing a problematic future.

But the damage has been calamitous—not only the hundreds of thousands dead and mangled but the communities destroyed, the refugees relegated to pitiable existences for years to come, and so forth—and it may not be readily reparable. It is simply not true that Bosnians have been at each other's throats continuously for centuries. On the contrary, for the vast majority of those many years, they lived among one another in their various ethnic communities, with varying degrees of commingling amity or edgy wariness. The conflagrations were decidedly the exception, though it is difficult to see how anything remotely like the prior Bosnia will be salvageable after this most recent one.

Again, flipping the analogy: obviously no one is suggesting that the True Believers in Congress are guilty of genocidal ambition or anything of the kind. I have been speaking, rather, of a certain tenor of political rhetoric and behavior, one which I would call heretical. It is fundamentalist, peremptory, and intolerant. It lays waste and it glories in laying waste. It has origins (often quite cynical and manipulative), it often overwhelms those origins, and it has consequences.

In another context, the leaders of Poland's Solidarity movement used to talk about how it was so much easier to turn an aquarium into fish soup than the other way around.

A FIELD OF BLACKBIRDS

THE ABCS OF GENOCIDE

October 2000

Several years ago, while reporting from war-socked Belgrade, I happened to have a conversation with a Serb oppositionist journalist, of whom there were in those days still dismayingly few, and she recalled for me her own experience of the late 1980s and early 1990s in Yugoslavia. For some reason, she said—and she couldn't really explain why—she hadn't at the time succumbed to the ex-communist leader Slobodan Milosevic's raging propaganda campaign to recast himself as the leader of an urgent Serbian nationalist revival.

(At the time, her bewilderment reminded me of that of an old Danish woman with whom I also once happened to have a conversation—a veteran, years earlier during the Nazi times, of her country's famously successful effort to rescue its Jews.

When I asked her why little Denmark, couched there amid such hotbeds of anti-Semitism as Germany and Poland, had itself never seemed to succumb, she at first gazed upon me authentically baffled and noncomprehending. "What kind of question is that?" she finally responded, "Why did we never succumb? I mean, isn't the only valid question why Germany and Poland ever *did?*" In so saying, of course, she'd answered my original question perfectly.)

Anyway, my Serbian journalist friend continued, recalling those eerie days in the late 1980s, she'd kept herself almost studiously oblivious to the burgeoning surge of nationalist hysteria sweeping over her fellow countrymen in the Serbian capital—the swelling rallies, the

thronged marches, the midnight masses of lusty, near-Messianic patriotism.

"It was all so stupid, so beneath contempt," she said, "this transparent gambit of Milosevic's to cast himself as some kind of savior of the Serbs, when of course he'd never been the slightest kind of nationalist before. The response he managed to evoke was mystifying, to be sure, but really, it was just too *stupid* to spend time thinking about. Surely it was going to pass, and in the meantime I felt justified in ignoring it."

She paused. "Then, one night," she recalled, "I was watching the evening news, and they had footage out of Zagreb, the Croatian capital—a huge nationalist rally *there*, a shouting throng chanting these blood-curdling Croatian nationalist slogans—and I remember thinking, all at once, 'Oh my God, *we're driving them crazy!*' And suddenly I saw it all clearly, how it wasn't just going to pass. From one moment to the next that evening, I saw all the

Craig Reynolds's flocking digital birds

horrors that were going to come: war with Croatia, followed by war in Bosnia, followed by war for Kosovo, until finally it would all end, most ghastly and gruesome of all, in a civil war among the Serbs themselves. And so far, alas, we're right on schedule."

A few weeks later, while traveling in Bosnia, I happened to be reading (in Steven Levy's book *Artificial Life*) an account of flocking behavior in birds, specifically about a computer scientist named Craig Reynolds who used to gaze out over the cemetery grounds outside his office at a group of blackbirds that tended to congregate there. He'd been struck by the way the group seemed to consist, say, of one hundred individuals, each with its own little brain, but then of a one hundred and first presence as well, which was the flock as a whole. The flock seemed to have a mind of its own, one that almost seemed to control the brains of all its

members. How did they all know to rise and swoop and veer like that, as if as one?

Reynolds decided to try to model flocking behavior on his computer, that is to establish, say, one hundred points on a screen, each one animated by a simple algorithm or set of rules (but *simple* rules: so easy that even a bird brain could grasp them), such that if all one hundred such points began moving about in relation to one another in keeping with those rules, as a group they'd end up replicating the elegant, consistent, and seemingly auto-volitional patterns of a flock. And, indeed, he succeeded in doing so. He boiled it all down to three easy injunctions—I forget the particulars (something along the lines of "If another point comes within distance x to your right, veer left," and so forth)—and the resultant screen spectacle was indeed uncannily flocklike.

This in turn set me to thinking about whether the bloody surges of Balkan (and other) nationalisms might not be similarly framed. It occurs to me that my mind must have taken that particular turn that day because of the way that the fount of so much Serbian nationalism, as it happens, is said to have come welling out of the great Serbian defeat at the hands of the Turks in 1389 at the Battle of Kosovo, which famously took place on, of all places, the *Field of Blackbirds,* the very field in fact to which Milosevic himself repaired, on the six-hundredth anniversary of the defeat, in 1989, to unleash the speech which

many consider responsible for having launched this whole current round of hostilities.

Anyway, turning the riddle over in my head, after a while, I did manage to get things down to a simple three-step progression, to wit: A) Fear (of the Other) trumps hope; B) it apes hate (which is partly a projection of the disappointed self-loathing occasioned by seeing oneself giving up on hope and surrendering to that fear); which in turn, C) provokes more fear (in this case in the Other, who now launches into his own A-B-C progression). I subsequently tried that formulation out on that Belgrade friend of mine, and she managed to distill things even further, citing an ancient Persian proverb: "Fear those who fear you."

The point of all this is that the same mass psychology that animated the descent toward war in the Balkans in the late 1980s continued to predominate all through the 1990s, even after the hostilities themselves had seemingly petered out: corrupt gangland-style leaders on all sides were able to intone how if you think you had cause to fear/hate the Other before this war, just think of all the cause you have now. At which point, axiomatically, the life-and-death necessity of falling in line behind those same leaders was meant to become self-evident.

And up until this year, it had continued to do so. But in what may be the single most heartening development in the region so far in the brief new millennium, voters in parliamentary elections in Croatia this past January upended that psychology, decisively turning out the corrupt,

inept and blood-curdlingly nationalistic HDZ (Croation Democratic Committee) party of the late demagogue Franjo Tudjman that had ruled the country since its inception. (Maybe the fear/hope polarities were at last in the process of reversing, such that hope, for instance, for a greater Croatia was finally getting trumped by fear of being left utterly behind in the wider region's slow reintegration into greater Europe.)

It was hard, at any rate, to exaggerate the hopeful implications of that vote. Suffice it to say that in a beneficent obverse of the cascading developments at the beginning of the last decade, Zagreb suddenly seemed on the verge of driving the rest of the region *sane,* a prospect that has now been further reinforced by developments in Belgrade this fall (where the same sort of fear/hope polarities reversal may also at last be beginning to come into play in what may yet prove the imminent, long-delayed overthrow of Milosevic).

Maybe, maybe. On the other hand, my Belgrade journalist friend's comments from several years ago continue to haunt me as well, and a principal question for the coming months and years will remain whether that longed-for transition will be possible without that one final wrenching civil war among the Serbs themselves.

LIFE AGAINST DEATH

A PAIR OF MEDITATIONS AT THE HAGUE

AN ANATOMY LESSON (1997)

During my first few months covering the ongoing Yugoslav war-crimes tribunal in The Hague, faced day after day with the appalling sorts of testimony that have become that court's standard fare, I took to repairing as often as possible to the nearby Mauritshuis, so as to commune with the museum's three Vermeers. *Diana and Her Companions,* the *Girl With a Pearl Earring,* the *View of Delft:* astonishing, their capacity to lavish such a centered serenity upon any who come into their purview.

More recently, however, I've increasingly found myself being drawn toward the next room over, the one that houses Rembrandt's *The Anatomy Lesson of Dr. Nicholaes Tulp.* A work from the generation immediately prior to Vermeer's, it was painted in 1632, the very year of Vermeer's birth (the year, for that matter, of John Locke's birth, and Spinoza's as well), when Rembrandt, newly arrived in Amsterdam, was only twenty-six years old. With this astonishing canvas, he was brashly hanging out his shingle as an accomplished portraitist. The year 1632 was likewise just about the midpoint of the Thirty Years' War, an incredibly vicious religious struggle that savaged Northern Europe with carnage every bit as harrowing as anything being described nowadays at the tribunal—mayhem that regularly slashed into the Netherlands, until the conflict was finally brought to a (provisional) end with the Treaty of

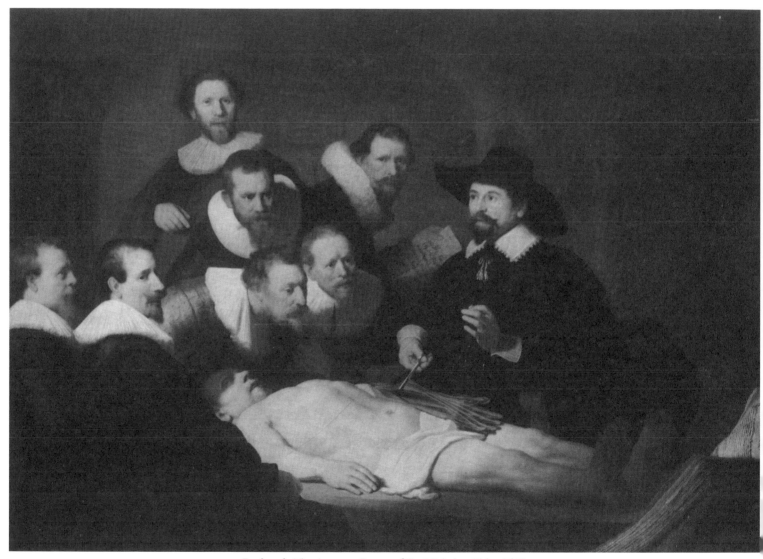

Rembrandt, The Anatomy Lesson of Dr. Nicholaes Tulp, *1632*

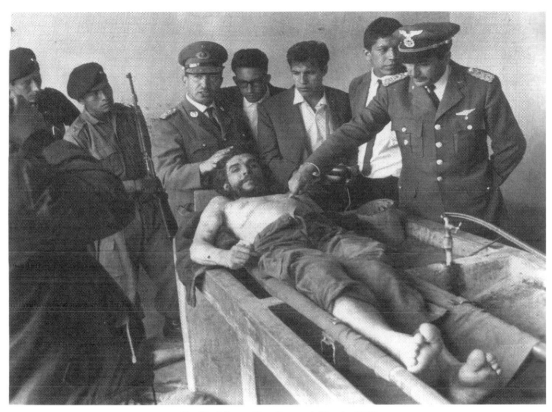

Freddy Alborta, Che Guevara's Death, *1967*

Westphalia, in 1648. The war had provided the occasion for the publication, in 1625, of the seminal work by an earlier son of Vermeer's Delft, Hugo Grotius, *On the Law of War and Peace,* a text often considered to be the foundation of all modern international law, and in particular that of these Hague tribunals. And that war's dark imperatives can likewise be seen impinging on Rembrandt's great painting.

The Anatomy Lesson is so famously overex-posed, so crusted over with conventional regard, as to be almost impossible to see afresh. And indeed, when I recently came upon the painting once again, rather than seeing it I found myself recalling that essay I'd first encountered almost thirty years ago—the English critic John Berger's 1967 rumination on the occasion of Che Guevara's death. Responding to the simultaneous appearance seemingly all over the world of that ghastly photo of Che's felled body, stretched out

half naked across a bare surface and surrounded by the proud Bolivian officers and soldiers who had succeeded in bagging the revolutionary leader, Berger made a startling connection to Rembrandt's *Anatomy Lesson.* And surely he was right. One could even say that Rembrandt's was the image, almost hardwired into the photographer's mind and the

Mantegna, Lamentation over the Dead Christ, *1490*

soldiers' very bodies, that had taught them all where to stand in relation to one another and to the grim object of their smug display.

And yet now, standing before the painting itself, I realized that for all my conventional acquaintance with its image, I'd never really seen it correctly—or, anyway, my memory was wrong in one crucial respect. The professor is poised in mid-lecture beside a cadaver, its left forearm splayed open to reveal all the sinewy musculature just beneath the skin. There is a mountain of onlookers: some gaze out strangely toward us while the rest—and this is the part I remembered most vividly—lean forward, gawking (like us) at all that gore. (Come to think of it, maybe the ones gazing toward us are staring precisely at our own queasy awkwardness in the face of such morbidity.)

Only, as I now could plainly see, that's not what was actually happening in Rembrandt's canvas at all. Of course, the theme of mortality and morbidity is there—rendered all the more unsettling by the conspicuous resemblance between the cadaver's face and those of many of the onlookers.

For that matter, it cannot be coincidence that the cadaver's face—that, after all, of a common criminal, which is to say the kind of person whose corpse was regularly given over in those days for this sort of dissective display—bears a striking resemblance to the conventional iconography of Christ's own, as in Andrea Mantagna's 1490 depiction of *Lamentation over the Dead Christ,* a possible source for Rembrandt, and for that matter another powerful echo summoned forth by that Che photograph.

But that's not what the onlookers *are* focusing on; death (their own or anybody else's) hardly seems to be on their minds at all. On the contrary, the innermost trio is gazing at the professor's *living hand,* the one with which he has been demonstrating the grips and gestures made possible by this, and this, and this other newly exposed muscle or tendon.

According to most traditional academic

iconographic readings of the painting, the trio is not looking at the professor's hand but rather gazing right past it, at the opened book beyond, in the painting's lower right-hand corner—a thick anatomical tome, supposedly representative in this context of authoritative education and the passing down of specialized knowledge. Nonsense—though, admittedly, a peculiarly self-referential art-academic, specialized-tome-generating sort of nonsense. Just look at the picture. They're looking at the professor's hand, and, indeed, they're looking at it

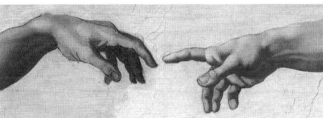

Michaelangelo's Sistine hands, 1511

wonderstruck, spellbound, as if they've never before seen anything like it.[1]

For what a marvel of motility it is—with its capacity for compression and extension, for flex and repose, grip and rotation. The hand in itself is a veritable miracle. One is momentarily reminded by the living hand hovering over the recumbent, lifeless body of that other great painterly trope of creative dexterity: God's own hand extended toward the recumbent Adam's, in Michelangelo's Sistine Chapel (an image that was surely known to Rembrandt from the countless etchings then circulating throughout the Netherlands). More to the point, a flexing hand—the focus of all this awed attention—is a painter's own foremost implement, the one with which he wields his brush. You can just imagine Rembrandt painting the picture, his own actual hand burnishing the professor's painted one as the painted class gazes on in hushed astonishment. (At that moment, the ones now gazing out at us would of course have been gazing at *him*.) This is a painting, then, about looking at hands, about vision and manipulability —about the fundamentals of painting itself.

Or, more generally, about living. It's not, as we are sometimes given to recalling, a morbid dwelling upon death but rather a celebration, a defiant affirmation of life and liveliness and vitality generated, as it happens, at a moment when the world was choking with death and dying.

All of which brought me back to the tribunal, and to those hours I'd been spending hunched in the visitors' gallery, taking in the endless tales of horror and grisly death. I thought about the judges and the lawyers, the investigators and the

1. Actually, two of them are clearly looking at the professor's hand and nothing else, though the third, the one leaning most fully across the cadaver's own head (and the one who, for that matter, most resembles the cadaver) is looking at both the cadaver's arm (with his eye closest to us) and at the professor's (with his other eye). Cover up one eye and then the other and you will see what I mean. It's like a movie: he's looking from one arm to the other, comparing them, spellbound, fully absorbing the lesson.

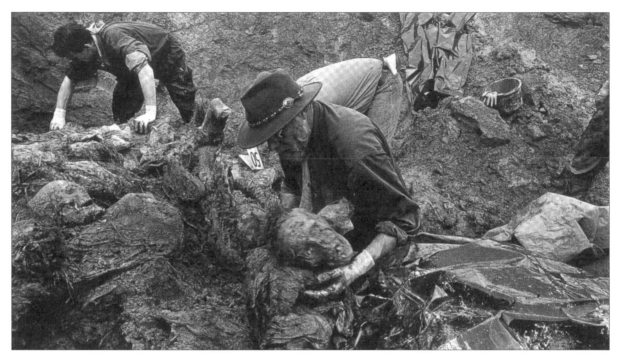

Gilles Peress, William Haglund at Pilica farm, *1996*

forensic anthropologists. I remembered, for instance, Gilles Peress's remarkable photograph of the forensic anthropologist William Haglund ever so carefully extracting a decaying body from a mass grave on a farm outside Srebrenica (another image of Death and the Professor)—the tender, almost loving way he reaches to cradle and recover the rotting corpse. Almost a Pietà image. And then as well Sara Terry's image of another forensic anthropologist, Dr. Ewa Klonowski, herself reaching out (Tulplike, Sistinelike) to grasp the very hand of death.

And I realized how, appearances to the contrary, all these labors aren't about death at all but rather about life and the living. They are about the living witness owed to every one of the once-living victims. "In these matters," the Polish poet Zbigniew Herbert (writing in the shadow of his own country's genocide-saturated history) insisted, "we must not be wrong / even by a single one / we are despite everything / the guardians of our brothers." They are about securing the possibility of an ongoing life for the survivors (the widows of Srebrenica, for instance, still stranded in limbo, straining for justice, or at least for confirmation of the fate of their loved ones). They are about

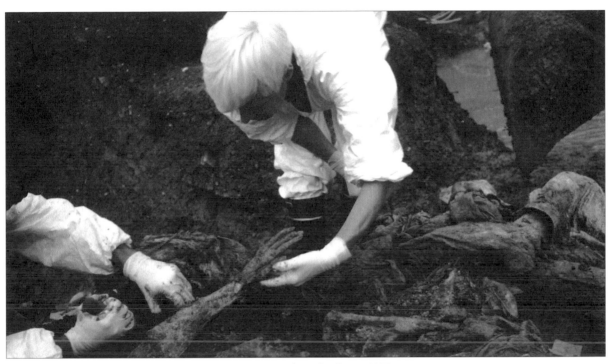

Sara Terry, Hands in the Grave, *2002*

healing a community once ravaged by war, so that liveliness can come flowing back over an otherwise blighted terrain. They are about the lives of generations yet to come, about breaking that cycle of atrocity followed by impunity which plays such a large role in provoking atrocious communal retribution decades down the line.

And, finally, they are about restoring the equilibrium of the living world itself, the world we all share. For, as Herbert concluded in his history-laden poem, "ignorance about those who have disappeared / undermines the reality of the world." It's a lesson that Rembrandt, too, was busy teaching.

THE DIKES OF HOLLAND (1999)

Justice may be many things these days at the Yugoslav War Crimes Tribunal in The Hague, but one thing it decidedly is not is swift. At times the pace of the proceedings in the court's main hearing chamber—a gleaming, light-filled, technologically almost futuristic cubicle encapsulated behind a wall of bulletproof glass—can get to seeming positively Dickensian. The proceedings tend to lurch forward and then become bogged down in a thicket of minute-seeming legalistic distinctions, and there are mornings when even the most attentive mind can wander.

One such morning a while back, I found my own attention wandering into a book of history I'd brought along just in case—though of Holland, as it happened, not of Yugoslavia. I was reading about the earliest stages of human habitation of the Netherlands in the lowland marshes and swampfields north of the Rhine River delta, terrain much of whose elevation is pitched so low that it was regularly subject to catastrophic flooding. It was not all that surprising, therefore, to learn that through many centuries this muddy floodplain went largely uninhabited and that it wasn't until around the year 800 that the first tentative forays at serious colonization were undertaken as tiny communities pitched precarious

Dirck Lons, The Grist Mill, *1622*

clusters of hovels atop artificially piled mounds known as terps.

With the passing generations, some of these terps were in turn joined together by painstakingly raised landbridges, which served both as connecting paths and as protective dikes. Any given triangle, say, of such dikes, joining together three outlying terps, incidentally proved capable of shielding the terrain it enclosed from outside flooding. But that only led to a new problem: what to do with all the rain and groundwater trapped and festering within the enclosure. Initial attempts at draining these patches of pestilential marshland, the so-called polders, have been documented as early as 1150, but the real breakthrough came with the introduction of windmills in the fifteenth and especially the sixteenth centuries. Eventually "gangs" of dozens of coordinated windmills were being deployed, each in turn raising the stagnant marshwaters a few inches up and up and finally over the dikes and into a surrounding network of irrigation and navigation canals. Polder after polder was thus reclaimed—hundreds, thousands, and presently hundreds of thousands of acres of uncommonly fertile land—in a process that continues to this day.

Half-listening to the drone of the ongoing

trial, I suddenly realized how in a sense the judges and prosecutors and investigators there in The Hague had set themselves a remarkably similar sort of reclamatory challenge. The tribunal's founding judges and officers have all repeatedly cast their work in terms of an attempt to stem the historic cycle of floodtides of ethnic bloodletting that recurrently afflict places like the former Yugloslava, or Rwanda, the other principal locus of the tribunal's mandate. And in this context, it occurred to me that each of these individual prosecutions was like a single mound, a terp cast out upon the moral swampland of the war's aftermath—and the entire tribunal enterprise a system of interconnected dikes and sluices and pumps and windmills and canals designed to reclaim for each of the regions the possibility of a fertile regeneration.

Modern Dutch windmill

But the tribunals weren't merely attempting to reclaim such a possibility for Yugoslavia and Rwanda alone. Sitting there in the spectator's gallery at the tribunal, I recalled that old jurists' saw to the effect that if international law exists at the vanishing point of law, the law of war exists, even more emphatically, at the vanishing point of international law; and it occurred to me how there, on the infinite marshy borderland, these jurists and lawyers and investigators, and the diplomats who'd carved out the immediate occasion for their labors, and the human rights monitors and journalists who'd painstakingly (and often at great risk) gathered up the initial shards and planks required for their effort, were all engaged—fact by fact, testimony by testimony, case by case—in the latest instance of a centuries-long, at times maddeningly halting, vexed, and compromised effort to expand the territory of law itself.

An effort by no means guaranteed to succeed. Indeed, one of the most fascinating aspects of their labors was the way that in plunging their foundations into the swampy borderland, they kept coming upon planks and girders left over from earlier efforts (the rules of chivalry, the samurai codes, and so forth) and earlier masters (Augustine, Aquinas, Montesquieu, Grotius), structures that had once contained the floodtide for a time and then themselves collapsed before the onslaught of further depredations. Indeed, one of the most fascinating aspects of all was the way that the current workers would come upon these earlier ruined efforts and dust them off, tighten them up, sand them down, and then reinsert them right back into the rapidly expanding structure.

Some people tilt at windmills; others, drawing on whatever is at hand, get down and build things.

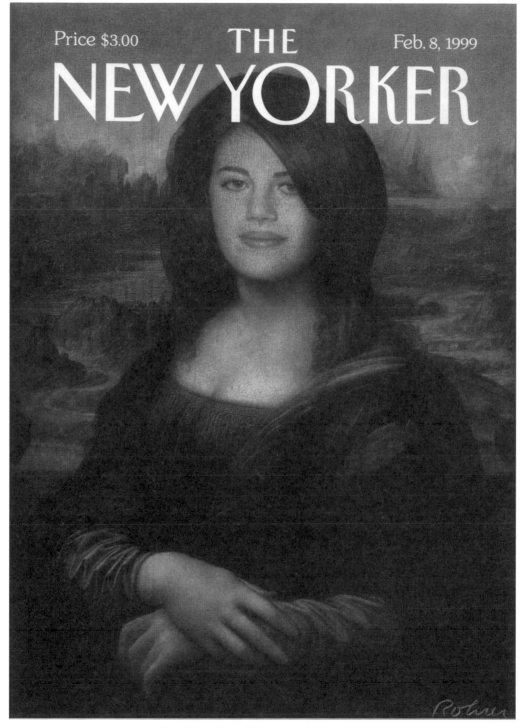

Dean Rohrer, New Yorker cover, *Feb. 8, 1999*

MONA LEWINSKY

MONICA LEWINSKY / MONA LISA / BARBARA WALTERS

March 1999

After the *New Yorker* ran Dean Rohrer's melded image of Monica Lisa (or the Mona Lewinsky) on its February 8, 1999, cover, there sprang up a fierce little boomlet in letters to the editor from, and feature stories about, other artists who claimed to have harbored virtually the same idea considerably earlier on. Richard Alden, a professor at Pennsylvania State University, claimed to have assigned precisely such a blended image as a project for the eighteen students in his visual communications class last October and had consistently been selling out T-shirt versions of the most successful rendition (by a sophomore named Alysia DeAntonio) at a local bagel shop ever since. John Cuneo, who had indeed published an ink-sketch cartoon of a mustachioed Monica as Mona Lisa a

month prior in the *Wall Street Journal,* faxed a friend in the *New Yorker*'s art department, "If this was my concept, and if she didn't have a mustache, and if you could copyright ideas, you people would be hearing from my lawyer (if I had a lawyer)."

Rohrer, for his part, insisted, entirely credibly, that the idea had occurred to him independently (sparked, he explained, by the naggingly familiar smile plastered across the face of a single particular news photo of Ms. Lewinsky). "It's one of those ideas," he assured a reporter for the *Philadelphia Inquirer,* so obvious "that, when you think of it, you say, 'Why didn't I think of it before?'" Evidently many people had, though David Remnick, the *New Yorker*'s editor, insisted this was the first version he'd ever encountered.

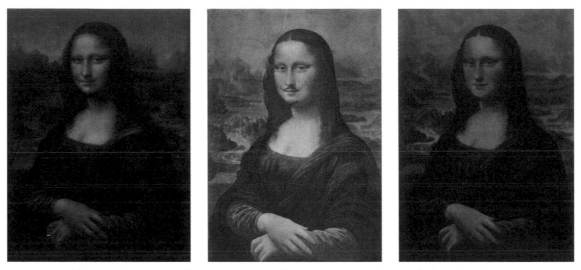

And anyway, as Remnick noted, "The only artist with any claim here is Marcel Duchamp, who started the whole joke of messing around with the Mona Lisa a long time ago."

Remnick's comment reminded me of a recent spate of research by the artist Rhonda Roland Shearer (detailed in the February 1999 *Art News*). Shearer has fairly conclusively shown that Duchamp's infamous gesture in affixing a mustache to the Mona Lisa was never as simple as it first appeared; that in fact Duchamp had subtly superimposed a photo of his own strangely feminine face onto Da Vinci's portrait, before penciling in the wicked little mustache and goatee. Shearer's intuition in turn dovetails neatly with decades of prior academic speculation to the effect that Da Vinci had superimposed a version of his own face (minus the beard and mustache) onto that of his mysterious female sitter.

All of which is kind of neat. But here's where things get really weird. Because the *New Yorker*'s cover had already been on the stands for almost a month when the real Monica Lewinsky, the actual person, was required to sit for a sort of official portrait, alongside Barbara Walters, as advance publicity for their celebrated televised interview of March 3. That photo in turn ran in newspapers and newsweeklies around the country. And look at the part in her hair, look at the slope of her shoulders, the dark dress, the conspicuously Monaesque smile. Look at those hands!

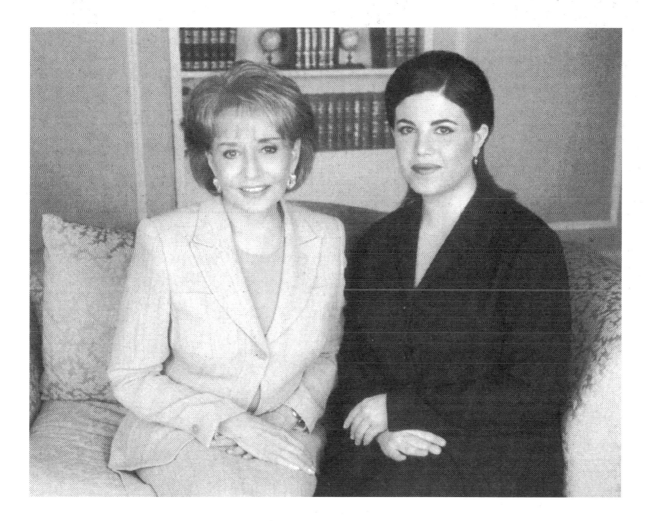

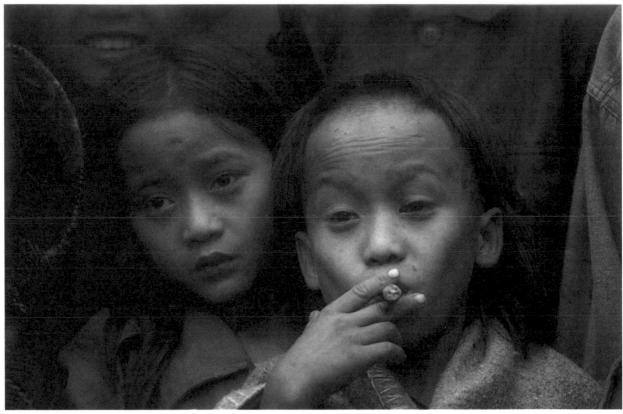

Myanmar insurgents Johnny and Luther Htoo, Dec. 6, 1999

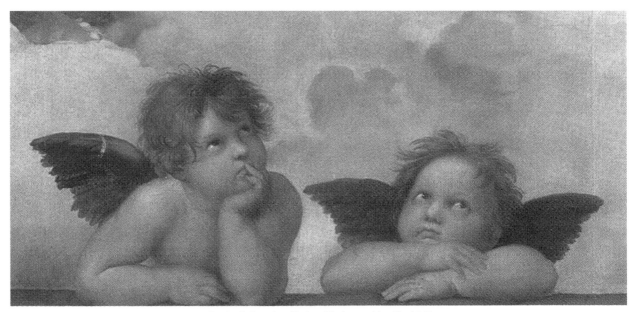

Raphael, Dresden Sistine Madonna *(detail), 1513*

THOSE WACKY HTOO TWINS

Htoo Twins / Raphael Cherubs

2000

The image itself (splayed across virtually every newspaper in the world) was uncanny, the caption more unsettling yet: Dec. 6, 1999, a pair of twelve-year-old ethnic Karen twin brothers, the Htoos, Johnny on the left (that's a boy?) and Luther (Luther!?) on the right, leaders of a beleaguered Myanmar insurgent group known as God's Army, whose members credit them with mystical godlike powers that "render them invulnerable during battle."

In the photo, they look like Renaissance cherubs gone badly wrong (specifically like those two clichéd angels propped at the foot of Raphael's Dresden Sistine Madonna): toxic putti. Raphael's cherubs, that is, gone upriver, deep, way too deep into Conradland—miniature Brandos bestriding their own demented cargo cult. Their aura is all the more unsettling in that, in this photo anyway, they actually look, if you'll pardon the expression, like Siamese twins. Johnny seems to grow right out of Luther's back, his tremulous innocence hitched helplessly to the latter's age-old, gimlet-eyed world-weariness: seen it all (toke), seen it all (toke), should never have seen any of it.

The inhaled stogie lends the image a certain sulfurous air, as does word that their followers have now gone and attacked a hospital, of all things, and are holding hundreds of hostages. Is there no bottom to the world's demented evil?

Of course, this is all so much Orientalist claptrap: feverish white Western fantasies about the

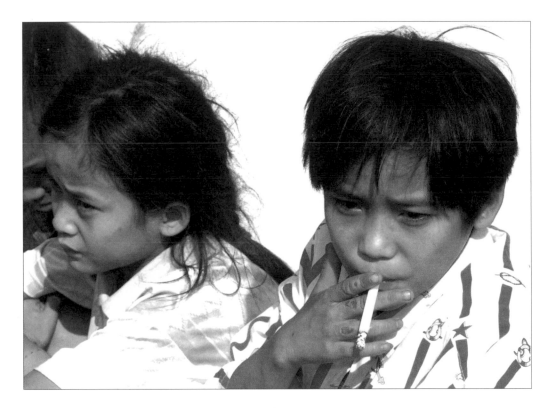

metaphysical debauch of endlessly inscrutable colored folk, the convenient Other. In fact, the attack on the hospital itself undercuts such smug and easy projections: they've raided the hospital and are holding all those hostages to advance their demands that the Thai army stop shelling their positions and that the doctors there treat their own ragtag wounded. There is no Primordial Evil here, only all-too-human desperation.

But the fantasy of the first allows us to screen out the palpable reality of the second—no need any longer to trouble ourselves over the plight of Karen minorities wedged in a tightening vise between those Burmese and Thai generals. No call to keep paying attention.

And so we don't (pay attention). Time passes, and then suddenly, last week, here they are again, those wacky Htoo boys, come in out of the cold (or rather the jungle dank). After turning themselves in to Thai border guards alongside a clutch of their followers, they are whisked to a police compound in the nearby town of Suan Phung,

where (according to the dispatch by *Time*'s Robert Horn) they soon find themselves exchanging bewildered stares with the Thai prime minister and several of his top generals. The prime minister "gently stroked the boys' lice ridden locks. 'He totally demystified them,' says Sunai Phasuk of Forum Asia, a human rights group. In Thailand, where people still crawl before royalty, 'you don't pat a god on the head.'"

So that, see: they're just ordinary kids after all. (Another comforting dodge, an obverse reassuring fantasy.) Decked out there in their fresh soccer frocks, straddling nothing more fearsome than everyday puberty, they're just like the boys next door (though it would be nice if somebody could get that Luther kid to stop smoking[1]).

This too, of course, is all wrong. Thirteen years old, they look like they can't be more than seven or eight. And that's not charming mumbo jumbo, that's severe extended malnutrition. These aren't just ordinary kids. They've seen things, they've lived through things that the world (which is to say the rest of us, swaddled in our comforting illusions) had no business allowing.

1. It turns out that, as with the Monica Lisa blur, the stogie-toting toxic Raphael putti is a trope with, shall we say, wings. Note, to take just three examples, this Van Halen album cover, Ian Falconer's Valentine's Day 1999 offering for the cover of the *New Yorker*, and a classic dorm-room poster.

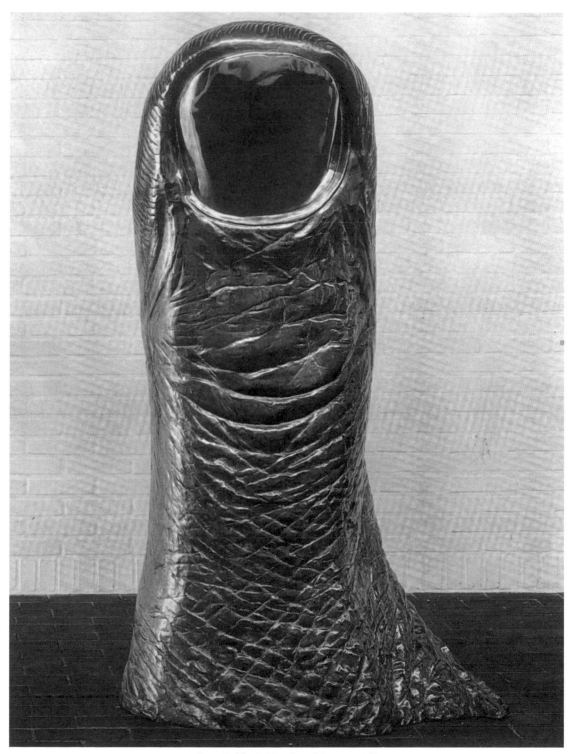

Cesar Baldaccini, Le Grand Pouce, *1968*

THUMB IN EYE

CESAR'S THUMB / SADDAM'S ARM / WEIHAI'S FRAME

2004

You can be coming round the corner there at the world's loveliest and most beloved museum (Louisiana, of course, in Humlebaek, Denmark—but then that's a whole other story), and suddenly find yourself face-to-face with it— or rather face-to-nail, or rather face-to-face-in-nail. Your own face, that is, as presently becomes evident, reflected back at you with funhouse distortion, slightly abashed, in the broad shiny fingernail of a massive, exuberantly erect, meticulously realized bronze thumb. An exact replica, as it turns out, of its creator Cesar Baldaccini's own thumb, pantagraphically blown up to the size of that full-standing, gallery-trawling human, yourself—just under six feet in height. Obtruding there in the midst of your gallery walk, the thumb's a decidedly aggressive presence—it seems, as it were, to be giving the entire world the finger—but then, on second glance, it seems to be offering forth a decidedly more playfully benign and affirming gesture: a simple thumbs-up, after all. The perfect token, in other words, of the larkish place and time of its conception: Paris in 1968. (And indeed, back in Paris, to this day, you'll find the piece's big brother, an equally meticulously rendered monolith rising up stupendously out of a tree-lined plaza in the La Defense quartier, to a height of almost forty feet!)

But in fact the piece's associations go well beyond the timebound political. For at another level, Cesar's *Grand Pouce* is simply playing off that hoary old art-historical cliché—the master

189

painter (or sculptor) pausing in the midst of his labors, extending his arm straight out toward his subject, cocking his thumb skyward, taking the measure of his quarry, getting everything into perspective. Only, for this artist, or so we are invited to surmise, his own thumb has become endlessly more absorbing as a subject of contemplation than anything that might be transpiring in the backdrop beyond. My God, it's as if he's suddenly exclaiming, look at that—that structure, those folds, those whorls, those lines upon lines! What could possibly be more amazing? When I point my finger at the moon, the zen teaching instructs, don't mistake my finger for the moon. To which the ecstatic Cesar would seem to be responding, *Oh yeah, why not?!*

1968: Same year: another city. And a whole other kind of Caesar.

For that was the year, too, that the Baath party, in anything but a lark, came hacking its way back to power in Baghdad, with the thirty-two-year-old Saddam Hussein already lurking serpentine in the wings, putatively in charge of internal security. Within ten years, through a murderous series of purges, he would consolidate absolute power, and within a few years of that he would launch out on a horrifying war against neighboring Iran, a blitzkrieg that presently bogged down terribly into what was arguably the most devastating siege of trench warfare since

Stalingrad, poison gas wafting over the wasted dunes night after night after night.

Several years into that debacle, with thousands and thousands of dead on both sides and no end remotely in sight, the Dictator hit upon the idea of commissioning a gargantuan celebratory monument, a wide parade ground flanked on either side by huge scimitar-wielding arms, with the bronze arms erupting sixty feet out of the ground and the clenched steel swords converging into an arch over the middle of the parade ground a further eighty feet above that. And here was the genius of the scheme: no artist was going to be required to realize the Dictator's exalted vision, for the arms and fists would be pantagraphically extrapolated from out of plaster casts of the Dictator's very own, exact down to the slightest pimple or follicle.

And while the French Cesar's gesture, twenty years earlier, came welling up, positively pickled in irony, even the slightest tincture of the ironic had been squeezed out of every last pore of the Iraqi master's conception. Hussein's entire regime, after all, consisted in a veritable paroxysm of the literal-minded, and anybody else's arm, let alone anybody else's exercise of imaginative interpretation, would have undermined the entire conception. (Indeed, in a similar seizure of literal-mindedness, no matter how awkward the resultant effect, it was decreed that the arms on both sides of the parade ground would have to be right arms, since how could His Exalted Majesty

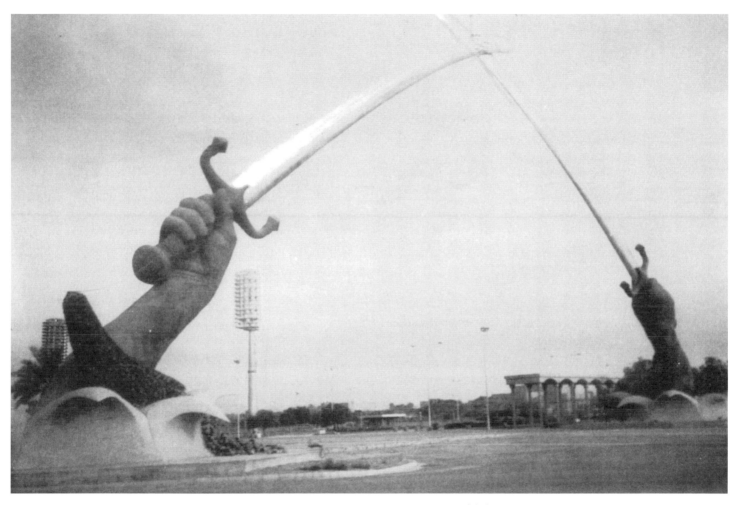

The Monument Otherwise Known as The Victory Arch *(Baghdad, Iraq, 1989)*

be seen to be wielding such incomparable power, on either side, from his left?)

It took four years to realize Saddam's vision, and indeed the work had to be farmed out, no Iraqi metalworks proving up to the task. But the Morris Singer Foundry in Basingstoke, England—one of the art world's largest and most distinguished proved only too willing to lend itself to the Dictator's grotesque vision (just as in those days American administration emissaries, such as Defense Secretary Donald Rumsfeld, were all too willing to pay sycophantic calls on Baghdad to extend their support for the Dictator's wider war aims).

It was through the happenstance of that Basingstoke connection, however, that one of the Saddam regime's most fervent critics in exile, the London-based Kanan Makiya (pseudonymous author of that seminal chronicle of the Dictator's deprivations, *Republic of Fear*) first caught wind of the whole scheme, presently becoming almost as obsessed, in his way, with the monument as was its patron, and eventually penning an entire trea-

Saddam's thumbs in Basingstoke

tise on the subject, under his regular pseudonym of Samir al Khalil.

The meatgrinder of a war dragged on and on, finally expiring in an inconclusive cease-fire in the summer of 1988: no one had won, nothing had been resolved, hundreds of thousands had perished and thousands beyond that were left severely injured. Notwithstanding which, in a splendidly triumphant ceremony the following summer, the Dictator inaugurated his Victory Arch, as he had taken to calling it. And in a final fit of ghoulish inspiration, he scattered about the bases of the erupting arms thousands of literally actual Iranian helmets, many of them pierced by the holes of the very bullets that had felled their onetime wearers.

Time moved on, and vaulting from triumph to triumph, the Dictator invaded Kuwait, was pushed back, savagely suppressed the ensuing rebellion that his internal opponents (egged on and then abandoned by the first President Bush) attempted to mount, hardened his regime yet further, only to be removed from power, a decade later, when he became the collateral object of the

second President Bush's post-9/11 fixations. Throughout the bombings of that decade, however, the Americans made a point of steering clear of the Victory Arch, and it survived the Allied capture of Baghdad unscathed. At which point, in a sublimely opportune volte-face, the folks over at the Singer Foundry patriotically volunteered up the thumbprints from their original Plasticine cast, preserved lo these many years in the company vault, to the Coalition Forces, as a potentially useful aide in someday ID-ing the suddenly fugitive Dictator. Turned out not to be needed: a swab of saliva from the mouth of the eventually captured, decidedly bedraggled malefactor having done the trick.

But here's a piece of post–Iraq War trivia for you: Who today owns the Dictator's erstwhile Victory Arch? Why, Kanan Makiya, who has in the meantime returned to Baghdad, the city of his birth, and taken out a lease on the whole hideous thing. He wanted to see it preserved as testament to the Dictator's entire terrible tenure, and he is currently raising the funds necessary to slot a museum documenting the horrors of that tenure into the base of the Arch.

One morning, a few months after the World Trade Center disaster, in the period building up to the eventual invasion of Iraq, I happened to open my hometown paper to an entirely different though equally startling image of monumental hands—a Reuters news-service photo, as its caption explained, of Chinese tourists in the seaside city of Weihai standing at a bronze sculpture measuring thirty feet by sixty feet. There was no further elucidation of the structure, and nor have I been terribly successful in the months since in scaring up much more by way of explication.

Weihai, at the easternmost tip of the Shandong peninsula, facing Korea across a relatively narrow strait (and beyond Korea, Japan), turns out to have seen some fairly dramatic history of its own, having been the site where the Japanese Navy completely scuttled an entire Chinese imperial fleet during the Sino-Japanese War of 1894–95. Though it doesn't appear that this shameful episode is what the framed perspective of the monument in question is intended to be honoring. Rather, or so I was able to glean from a series of Google forays, the past several years have seen a decided intensification of efforts to increase tourism in Shandong in general and Weihai in particular. Among other kudos, or so its website boasts, Weihai was recently proclaimed a National Sanitation City, and in 1999, approved by the Ministry of Construction, it became a State-Level Civilized Scenic Spot.

There are apparently all sorts of lovely vistas in the coves and islands scattered about the Weihai region, and a celebration of the scenic itself is clearly what this sculpture intends: You want scenery, we'll give you scenery: Look! See! Presto! *Scenery!*

Scenery Framed, *Weihai, China, 2000*

Which is odd, since it's a peculiarly Western sense of the scenic. After all, Chinese art, in its whole magnificent sweep over many thousands of years, is famous for having eschewed the crimped and cramped aesthetic of the framed (Chinese art having historically reveled by contrast in scrolls, in their endless unspooling) or the trope of the window (as David Hockney has pointed out, Chinese art historically evaded that model entirely, having reveled instead in doorlike screens)—or, not to put too fine a point on it, the very fantasy of one-point perspective embodied, in the West, by the pervasive suggestion of the artist's outstretched thumb.

A thumb. A fist. A frame. The moving finger writes, and having writ...[1]

1. But wait! Before moving on, what of this? I've always longed someday to be able to work the Prussian painter Adolphe Menzel's humbly triumphant self-portrait into a piece somewhere, and where better, it suddenly occurs to me, than here as a footnote to a piece that began with its formal twin and anatomically extended opposite? For almost a century before Cesar's thumb we had, for all intents and purposes, been offered Tom Thumb's toe.

Adolphe Menzel was a realist—indeed, according to the fervently enthusiastic Michael Fried, who has recently taken to celebrating his long-occluded genius, one of the three great realists of the nineteenth century. What Courbet was to France and Eakins to America, Fried has quite convincingly argued in his latest monograph, Menzel was to Germany. In particular, Fried contends, a genius of palpable embodiment, of the incarnated vision, the eye in a body, the body in the world—the body in question, as it happens, having been that of a virtual dwarf. Menzel was all of four foot six.

Hence the added poignancy and authority of this particular image. Menzel is perhaps most renowned for his retrospectively yearning historic paintings and in particular those limning the pomp and pageantry surrounding the court of Frederick the Great. And yet for all that, no image of his surpasses for sheer sovereign majesty this rendering of his own stunted member, veritably pulsing, as it so evidently is, with vitality and presence, the toe itself tautened, imperiously gazing back up at the viewer. Just a foot, and a foreshortened one at that, but the foot of a master.

TREES, NEURONS, NETWORKS

Rodney Graham's model for his Millennial Project for an Urban Plaza, *1986*

TREES AND EYEBALLS

R. GRAHAM / CAMERAS OBSCURA / D. HOCKNEY / CARAVAGGIO

Several years ago at the DIA Center for the Arts in New York City, the Canadian artist Rodney Graham quietly advanced a proposal—in the form of a maquette model and an accompanying suite of oversized photographs—for a marvelous, long-term, large-scale, outdoor site-based piece, a so-called "Millennial Project for an Urban Plaza." The DIA show was up for about a year; the Millennial Project itself, were it ever actually mounted, would take much longer to realize. But it was a great idea, and somebody somewhere ought to take Graham up on it.

In essence, Graham was proposing the erection of a three-story modernist utopian structure —its open, transparent struts and eaves revealing a double-helix stairwell within, leading up to a viewing platform on the third-floor roof. That platform would in turn nest a mammoth, megaphone-like camera obscura, aiming outward and casting the exterior view, inverted, onto a wide vertical screen on the opposite wall.

It's long been known—it was indeed common knowledge as far back as Aristotle and Euclid— that light passing through a small hole into a darkened chamber casts an inverted image of the exterior world onto the far facing wall. (Indeed, I've sometimes wondered whether it wasn't precisely such an image, rather than a succession of cast "shadows," that Plato was referring to in his Allegory of the Cave.) By the sixteenth and seventeenth centuries, at the latest, this phenomenon was being conventionalized through a series of cameras obscura, room-sized and presently smaller transportable boxes designed to occasion the uncanny effect. As Columbia University Professor Jonathan Crary pointed out in his thrilling 1990 book, *Techniques of the Observer,* by the seventeenth century, "the camera obscura was without question

Rodney Graham, Welsh Oaks (5), *1998*

the most widely used model for explaining human vision, and for representing the relation of a perceiver and the position of a knowing subject to an external world… For two centuries, it stood as a model, in both rationalist and empiricist thought, of how observation leads to truthful inferences about the world." (Consider, in this context, John Locke's formulation of a blank slate, the tabula rasa, onto which the world casts its myriad impressions across a person's life.) "At the same time," Crary continues, "the physical incarnation of that model was a widely used means of observing the visible world, an instrument of popular entertainment, of scientific inquiry, and aesthetic practice." Think of Canaletto's meticulously precise Venetian cityscapes, and Vermeer's luminous interiors, and the Dutch art patron Constantijn Huyghens's famously rapturous claim, in 1622, to the effect that "It is impossible to express the beauty [of the camera obscura image] in words. All painting is dead by comparison, for this is life itself, or something more elevated, if only one could articulate it."

As vivid as life itself. And unfolding life, as it happens, is precisely what Graham proposes to train his camera obscura upon—or, more specifically, a single oak sapling as, ever so slowly, over a period of years and years, it unfurls itself to its

Athanaius Kircher, camera obscura, *1649*

full height and reach. Of course, as viewed upon the camera obscura's screen atop Graham's utopian tower—as he himself reminds us with his suite of mammoth wall-sized photographs—the sapling would appear to be burrowing downward, from the ground plane at the top of the screen into the sky below. Indeed, as Graham's photos suggest, it will be as if we were watching the tree take root in the sky (its invisible roots, in turn, reading subliminally as the tree itself, stretching into the loam above).

Graham's conceit is redolent with art-historical allusions—as Lynne Cooke, the show's curator, pointed out in her accompanying essay—to Joseph Beuys's 1982 *7000 Eichen* ("7000 Oaks") project at Dokumenta 7 in Kassel, Germany, for example (a project that "motivated by ecological aspirations—that is, by the desire to green the city—aimed to plant individual trees paired with stone steles throughout the metropolitan context"), which in turn hearkened straight back to the hoary motif of the solitary oak as a heroic protagonist in the Romantic Pantheon (for more on which see "Part One: Wood" of Simon Schama's 1995 book *Landscape and Memory*).

But my own associations to Graham's proposal ran more toward the early imagery of the camera obscura itself. Consider the relevant dia-

gram from the great Jesuit cabinetman Athanasius Kircher's *Ars Magna Lucis et Umbrae* (Rome, 1649), or the early eighteenth-century comparison of the workings of the eye and the camera obscura included in Crary's book. In both cases (as in how many countless other more contemporaneous renditions), what else is the camera or the eyeball conceived as having been trained upon other than a solitary tree! A tree whose own subliminal resonances are in turn manifest in the workings of the visual process itself. Take the horizontal Figure 2 in that early eighteenth-century plate—the display of how rays converging on the eye's cornea and through its pupil get flipped and cast back onto the eyeball's far retinal wall, such that ADB becomes bda. Now, rotate that figure 90 degrees counterclockwise to vertical and compare it with the standard rendering of an entire tree (roots and all) from any children's textbook. It's as if the eye's curved corneal surface now reads as a horizon line, the ground plane, with the rays converging from outside becoming a tree's trunk

Comparisons of eye and camera obscura

and branches, and the rays receding back inside becoming its roots.

"May I use a simile," Paul Klee proposed at a lecture in Jena in 1924 (included in the 1945 collection *Paul Klee on Modern Art*), "the simile of the tree. The artist has studied the world of variety and has, we may suppose, unobtrusively found his way in it. His sense of direction has brought order into the passing stream of image and experience. This sense of direction in nature and life, this branching and spreading array, I shall compare with the root of the tree.

"From the root the sap flows to the artist, flows through him, flows to his eye. Thus he stands as the trunk of the tree.

"Battered and stirred by the strength of the flow, he molds his vision into his work.

"As, in full view of the world, the crown of the tree unfolds and spreads in time and space, so with his work…

"Standing at his appointed place, the trunk of the tree, the artist" [and here I myself can't help but think of Rodney Graham himself]

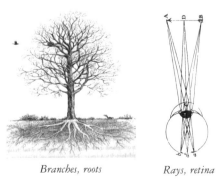

Branches, roots　　*Rays, retina*

"does nothing other than gather and pass on what comes to him from the depths. He neither serves nor rules—he transmits.

"His position is humble. And the beauty at the crown is not his own. He is merely a channel."

A while back, the British artist David Hockney, now living in California, became convinced that artists long before Canaletto and Vermeer were already deploying camera obscura–type technologies to achieve the sort of optical (as opposed to merely mathematically perspectival) look that seems to have become rampant throughout Europe during the sixteenth century (but may have been evident even before then, as far back as Van Eyck in 1430). (See my elaboration of Hockney's then-evolving explorations, "The Looking Glass," in the January 31, 2000, *New Yorker,* and his own subsequent explication of same in his book of the following year's *Secret Knowledge*.)

Caravaggio's work proved of particular interest to Hockney in this regard, and after having adduced various signs of optical procedures in the paintings themselves, Hockney one evening proceeded to theorize on how precisely Caravaggio might have achieved those effects. "He traveled a lot," he pointed out in a fax to several others of us who were following his investigations,

> so the equipment had to be portable, not really very big. So I suggest a lens that is not much bigger than two cans of beans ... The lenses

were all hand-made, hand-ground, etc. Caravaggio's would never have left his person, unless he was using it. In the highly competitive world of painters, no wonder he carried a sharp sword in those violent times.

He worked in dark rooms—cellars... He used artificial lighting, usually from the top left. He would use models from the street—who else would sit still for him very long?—and was known to work very fast. How long can you hold your arm outstretched even resting on a stand? Try it: you begin to ache under the arms.

So the "Supper at Emmaus," say, was set up carefully in a cellar, lit carefully, and then he put his lens in the middle on a stand and hung a curtain (thick material in those days) around it. The room is now divided into a light part and a dark part. He is "in the camera" and the tableau is projected clearly with telescopic effect (notice how the rear hand is almost bigger than the front hand nearer to you).

He covers the canvas with a rich dark undercoat that, being wet, reflects light back. He takes a brush and with the wrong end draws guidelines for the figures in the composition, to enable him to get the models back in position after [breaks for] resting, eating, pissing, etc.

He rapidly paints on the wet canvas, skillfully and with thin paint, knocking in the difficult bits, and then with his virtuosity he can finish by taking down the curtain, turning the canvas round and looking at the scene in reality.

All this sounds perfectly plausible to me. So, say there's no lens; then give a reasonable

Caravaggio, Doubting Thomas, *1602–1603*

explanation. Remember: there are no draw-ings, no notes.

Goodnight, D. Hockney

Goodnight indeed: the fax had been sent at 2:30 in the morning.

I subsequently had occasion to talk with another of the fax's targets, one of the Met's sen-ior curators of European painting, Gary Tinterow, and he pointed out that when you look at Caravaggio's paintings from below in a raking light, you can indeed often make out the marks made upon the canvas by the blunt end of the sty-lus as it traced out the contours of the various forms, and that those indentations had long puz-zled Caravaggio scholars. So, go figure.

At any rate, leafing through a monograph on Caravaggio's work, I happened to come upon a reproduction of his astonishing rendition of *Doubting Thomas*, now at the Staatlich Schlösser in Potsdam. Christ stands to one side, gingerly pulling aside the cloth draping his torso so that a manifestly peasant Thomas, backed by two other grungy street types, can literally poke his finger into the gash in the risen Messiah's flank. And for a fanciful moment I found myself wondering whether Caravaggio's composition might not contain a subliminal allusion to the dumbfound-ing hole-in-the-curtain methodology of the painting's very creation.

If so, the painting opens out onto a whole new interpretation as the earthbound, mundane con-cerns of the terrestrial poke and prod their way, convergent, into and through the looking glass of the Messiah's wound, splaying out, on the far side, transformed and transcendent.

Mike and Doug Starn, first panel of Blot Out the Sun #1, *1999-2004*

Cerebellum neurons from Restak's The Brain *One of Tom Eisner's leaf details*

BRANCHING OUT YET FURTHER

Trees / Branchings / Brains / Templates / The Internet

Let's go back and take another look at one of Rodney Graham's majestic winter oaks (this time right-side up), or, for that matter, the astonishing trees at the center of the roughly contemporaneous diptych, *Blot Out the Sun,* by the Starn brothers. For, of course, such images lend themselves to all sorts of other associations as well. For example, to the vascular structure of the human brain, as envisioned, for instance, early on, by the great sixteenth-century Flemish anatomist Andreas Vesalius in the third book of his *De Humani Corporis Fabrica*—the central trunk and its spreading branches. For that matter, the neural structure of the brain at the microscopic level evinces similar trunk-and-branchings-type patterning, as captured a century ago by Henry Gray in his standard *Gray's*

Anatomy, in this instance a Purkinje cell from the cerebellum with its axon and dendrons gloriously rampant—or as captured even more gloriously, recently, in the photograph of a cajal stain of neurons from the cerebellum which Richard Restak included in his book *The Brain.* The latter two, in turn, rhyme uncannily with an early sixth-century Byzantine rendering, paint on parchment, of a medicinal coral (Dioskorides, *De Matera Medica*).

Which is to say what, exactly? Maybe nothing more than that organic processes, unfurling across time, repeat—or maybe the word is reinvent, or rediscover, at any rate fall into—the same essential structural template, time and again: this recurrent motif of trunks and branchings. Think of the veins in an oak tree's leaves, as in Tom

208

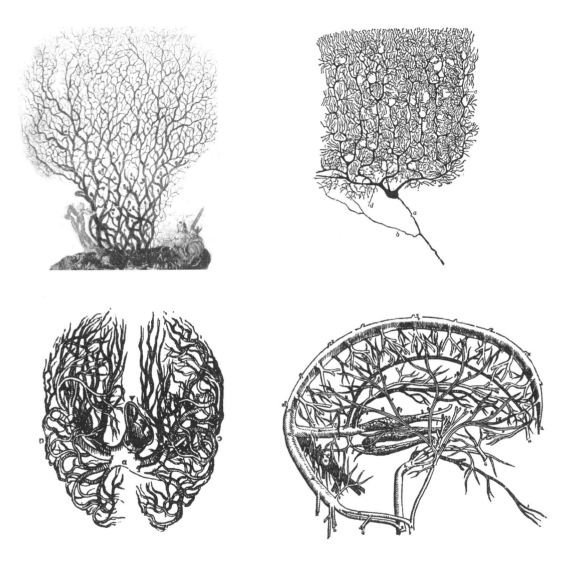

Clockwise from upper left: from De Matera Medica, *Dioskorides; Cell from the cerebellum,* Gray's Anatomy;
Andreas Vesalius, De Humani Corporis Fabrica

R.W. Powell, C.Y. Ho, and P.E. Liley, "Thermal Conductivity of Copper" (detail)

Eisner's haunting microscopic image. For that matter, the motif reasserts itself all over nature, inorganically as well. Consider, for example, the watershed of a river, the rivulets feeding the tributaries which in turn gradually merge into the main stream. (Of course, with a river, the temporal flow is the reverse of a tree's, starting from the farthest extremities and converging at length on the central trunk which in turn finally spreads out again into the delta's root system.)

Which, still, is to say exactly what? Maybe nothing. The convergence so far verges on the tautological. But things get more interesting, perhaps, when we start thinking about how human brains in turn conceptualize the world's workings, for, time and again, they deploy treelike branchings as a way of visualizing complex processes, and especially processes across time. Family trees, for instance (as in Athanasius Kircher's seventeenth-

century rendering of the line from Adam and Eve, through Noah, to Abraham) or the splay of artistic influence (as rendered by Ad Reinhardt in the June 2, 1946, issue of *PM*), or the reputed progress of evolution. (The metaphor of a tree provokes a curious misprision in such instances, for they get used both to indicate the confluence of ancestors converging on the birth of a given particular individual and, separately, the mesh of progeny verging out from that same individual. By thus focusing on the individual as trunk, such imagery tends to occlude the way that the individual's position in the flow of time is actually more like that of a nexus in a thicket.)

The template of trunk-and-branchings likewise regularly gets deployed, for example, in flow charts and decision trees and management charts, and even, scientifically, in the display of inorganic data, as in the remarkable chart on "Thermal

Athanasius Kircher, Geneological Tree, from Adam to Abraham, *1633*

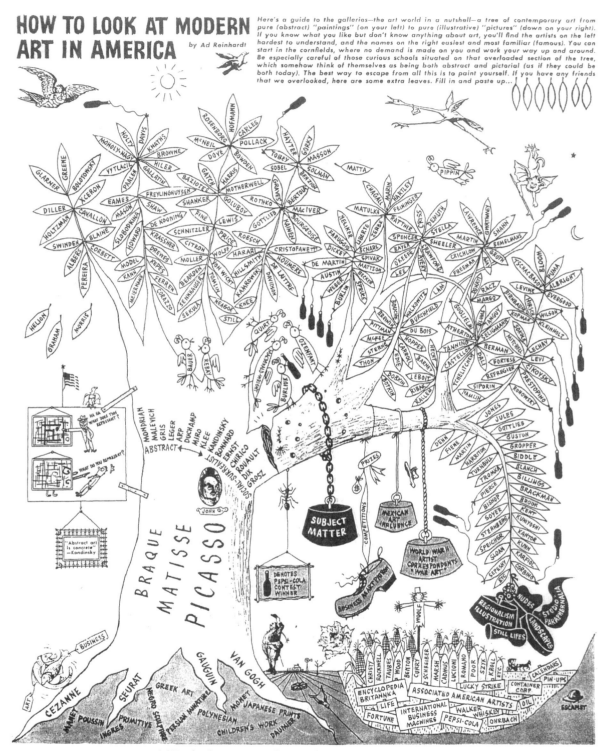

Ad Reinhardt, How to Look at Modern Art in America, *1946*

Conductivity of Copper" which Edward Tufte highlights in the chapter on "Graphical Excellence" in his *Visual Display of Quantitative Information*.

It's not as though one couldn't envision an alternative metaphorical motif for processes across time: geological layering, for example, or the way circular waves well out from a pebble dropped into a pond. And I just find myself wondering whether we instead see trunk-and-branch-type patterning so pervasively everywhere, and can't help but see them, because that's how our brains themselves, as it were, are wired. Or is it rather that our brain's wiring partakes of the principal universal pattern, a state of affairs that in turn makes it easier for it to maneuver in a world of like wirings?

For me, the germ of this whole meditation—its seed: the acorn—was a dumbfounding graphic I happened upon a while back in *National Geographic* (January 2000), a "mapping" of the internet performed by Bill Cheswick and Hal Burch of Bell Laboratories. For, of course, what else does the internet, latest product of human consciousness, end up most resembling other than a mammoth human brain? But is that, once more, a sort of conceptual illusion, an outward projection onto the world of our own cerebral wiring? Or, quite the opposite, is the human brain in fact now starting to write itself large, as it were, as big as the whole wide virtual world?

Bill Cheswick and Hal Burch, Bell Laboratories, A Mapping of the Internet, *2000*

Mike and Doug Starn, second panel of Blot Out the Sun #1, *1999-2004*

COMPOUNDING UNSCIENTIFIC POSTSCRIPT

TOWARD A UNIFIED FIELD THEORY OF MASTER-PATTERN METAPHORS

Of course, once you see them, you start seeing them everywhere: that's the crazy thing with these pattern convergences. Uh-oh, my by-now-resigned daughter still finds herself sighing, There goes Daddy again with another one of his loose-synapsed moments. It's only natural, I suppose, that the speculations on synapses and branchings that I broached in the previous two chapters should have proved especially compounding; but some of the rhymes in this instance have been feeling particularly uncanny.

To recapitulate the capillary mesh of associations: cameras obscura; eyes, pupils, and the hourglass converging of lines of sight; trees, leaves, branchings, and the hourglass convergings of roots and crowns; dendrites, brains, branching templates (family trees, decision trees, etc.) on out into the capillary mesh of the internet itself. As it happens, no sooner had I sent my own lines off to

McSweeney's 5 (2000) than I came upon the following bit of speculation near the conclusion of neurologist Elkhonen Goldberg's magisterial new volume, *The Executive Brain: Frontal Lobes and the Civilized Mind* (p. 224):

> With this demonstration in place, the following intriguing questions arise: Do the invariant laws of evolution, shared by the brain, society, and digital computing devices reflect the only intrinsically possible or optimal path of development? Or do human beings recapitulate, consciously or unconsciously, their own internal organization in man-made devices and social structures? Each possibility is intriguing in its own right. In the first case, our analysis will point to some general rules of development of complex systems. In the second case, we encounter a puzzling process of unconscious recapitulation, since neither the evolution of

society nor the evolution of the digital world has been explicitly guided by the knowledge of neuroscience.

Likewise, a few weeks later, this extended passage from Deborah Treisman's marvelously moving contribution to a symposium on art and science in the *Threepenny Review* (Summer 2000):

> The term "naturalist" could apply equally to Galileo or Augustine, Rembrandt or Wordsworth. Some thinkers have combined the facets of naturalism: William Carlos Williams, for example, a doctor who could as easily diagnose illness as write,
>
> > On a wet pavement the white sky recedes
> > mottled black by the inverted
> > pillars of the red elms,
> > in perspective, that lift the tangled
> >
> > net of their desires hard into
> > the falling rain.
>
> … What are we observing when we observe nature? What are the priests, poets, and scientists drawn to with such force and conviction? … Nature is a world of patterns—from the symmetrical almost yin-yang of a tadpole embryo to the geometric fan of veins on a leaf once described by William Carlos Williams:
>
> > Upon each leaf it is
> > a pattern more
> > of logic than a purpose
> > links each part to the rest,
> >
> > playfully following
> > centripetal
> > devices, as of pure thought—
> > the edge tying by
> > convergent, crazy rays
> > with the center
>
> Nature is the bonding of cells into unexpected shapes, the layering of pupil upon pupil in a fly's eye, the splay of brain cells or of branches against a winter sky that combine in another poem, by August Kleinzahler:
>
> > A section of cortex
> > stained dark and frozen on a field
> > of gray
> > axons, dendrites
> > probe and reticulate
> > layered
> > as the frigid river's gray no
> > one sings of
> > mighty
> > almighty oak
> > & maple

Nor were the resonances confined to the written word. Again, consider that uncanny Starn twin diptych: what sort of branchings are those? For that matter, had not a brain much like the one anatomized over a century ago in the cerebellum diagram from *Gray's Anatomy* I'd included in that earlier piece—indeed perhaps that very brain!—conceived of the amazing graphic I subsequently came upon in Edward Tufte's *Envisioning Information*, Joshua Hutchings Colton's 1864

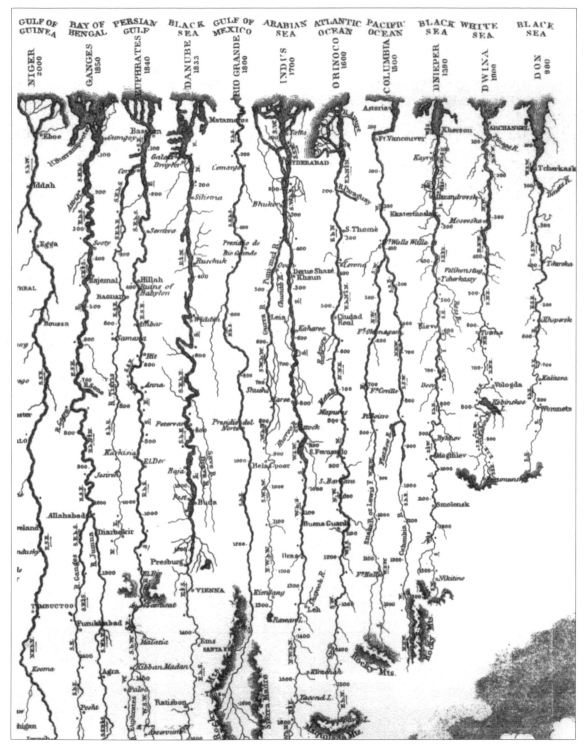

Colton's river lineup (detail)

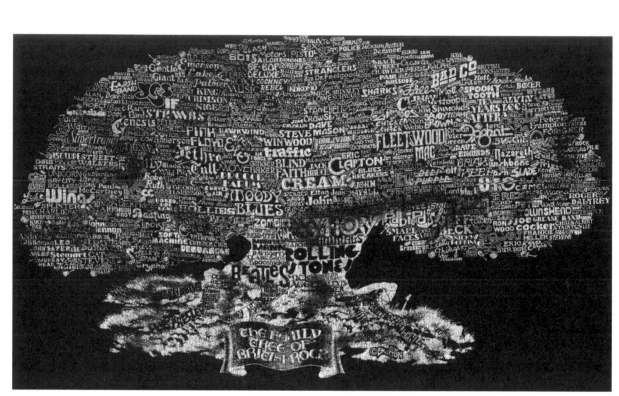

Tree of Rock T-shirt

comparative lineup of the drainages of the world's great rivers? One afternoon, out on the streets of the city, I happened upon a more contemporary tree genealogy emblazoned across the front of the T-shirt of an especially hip passerby. And then someone else alerted me to the current heroic-absurd efforts of a benightedly inspired artist named Beth Campbell, who's taken to covering over entire gallery spaces with ever-more-detailed decision trees, painstakingly anatomizing the possible implications of her almost every choice: talk about Compounding!

Somewhere in there, *Science* magazine offered up an astonishing supplement to their vol. 291, no. 5507 issue: J. C. Venter et al.'s poster-size "Annotation of the Human Genome Assembly" —the whole infernal celestial shebang!—and damn if that in turn didn't end up reminding me of a 1980 poster affording a precise grammatical splay of "The Longest Sentence: 958 Words from Marcel Proust's *Cities of the Plain*," which I'd taken to keeping above my desk (as some sort of cautionary warning, I suppose).

But the thing is, it wasn't just trees and

A Beth Campbell decision tree (detail)

Annotation of the human genome assembly (detail)

Proust's sentence (detail)

branchings. In my original piece, I'd noted how one could just as easily have envisioned an alternative metaphorical motif for processes unfurling across time: geological layering, for example, or the way circular waves well out from a pebble dropped into a pond. Why, I'd wondered, was it always trees and branchings? (Because, I—like Elkhonen Goldberg—had speculated, of the tree-and-branching make-up of the brain?) But now I indeed did begin noticing all sorts of other motifs.

The first page of the January 2, 2001, Science section of *The New York Times,* for example, featured an awe-inspiring color photo of Mexico's Popocatepetl volcano in full-throttle eruption. Page three of the same issue featured an ad for an upcoming lecture series at the 92nd Street Y— "Cracking the Code of Life: The Impact of the Human Genome Project"—whose backdrop 3-D model of the structure of spiraling DNA molecule made it seem the spewing volcano's diminuitive twin. And two weeks later, reversing scale, the same Science section featured on its front page "A New View of a Nursery of Stars," with photos of entire nebulae in turbulent eruption.

This serendipitous progression of images in turn reminded me of an (admittedly somewhat overwrought) passage from *Clea,* the final volume (1960) of Lawrence Durrell's *Alexandria Quartet:*

> I thought of some words of Arnauti, written about another woman, in another context. "You tell yourself that it is a woman you hold in your arms, but watching the sleeper you see

all her growth in time, the unerring unfolding of cells which group and dispose themselves into the beloved face which remains always and for ever mysterious—repeating to infinity the soft boss of the human nose, an ear borrowed from a sea-shell's helix, an eyebrow thought-patterned from ferns, or lips invented by bivalves in their dreaming union. All this process is human, bears a name which pierces your heart, and offers the mad dream of an eternity which time disproves in every drawn breath. And if human personality is an illusion? And if, as biology tells us, every single cell in our bodies is replaced every seven years by another? At the most I hold in my arms something like a fountain of flesh, continuously playing, and in my mind a rainbow of dust."

And then, a few days later, at a bookstore I happened upon a book which just may be the ur-text for this particular sort of metaphorical speculation, Sidney Perkowitz's *Universal Foam: From Cappuccino to the Cosmos.*

Meanwhile, in a different, or maybe not all that different, vein entirely, an email pal of mine, Michael Benson, a passionate stargazer based in Ljubljana, Slovenia, of all places, took off on my throwaway pebbles-in-a-pond reference. It was clear he'd already been obsessing on the implications of that sort of metaphor for some time. To wit:

> That comment of yours about waves rippling out from a pebble dropped in a pond resonated

Watchful Eyes On a Violent Giant

Scientists Devise New Ways to Monitor Rumblings
Of Mexico's Biggest and Most Treacherous Volcano

New View of a Nursery of Stars

Unfurling scenes from The New York Times

Cracking the Code of Life

**Genes, DNA and You:
The Impact of the Human
Genome Project**

Learn the latest on genetics in a unique series
presented by the 92nd Street Y and The
Rockefeller University, which is celebrating
100 years of science for the benefit of
humankind. We'll explain the science behind
the headlines and show how our genetic
information will change the way diseases
are diagnosed, treated and prevented.

After the Genome: Tailor-made Drugs
Tue, January 9, 7 pm
Stephen K. Burley, Richard M. and Isabel P. Furlaud
Professor, Head of the Laboratory of Molecular
Biophysics and Investigator for the Howard Hughes
Medical Institute

Keeping Time with Biology
Tue, February 27, 7 pm
Michael Young, Professor and Head of the Laboratory
of Genetics

Senses and Sensitivity
Tue, April 10, 7 pm
A. James Hudspeth, F.M. Kirby Professor, Head of the
Laboratory of Sensory Neuroscience and Investigator
for the Howard Hughes Medical Institute

Don't miss this informative series.
Call 212.415.5500
for registration and information.
Subscriptions $55/Tickets $20

Lectures are held at The Rockefeller University's
Caspary Auditorium, York Avenue & 66th Street.

92Y St

THE ROCKEFELLER UNIVERSITY

92nd Street Y
Charles Simon Center for Adult Life & Learning
www.92ndsty.org
An agency of UJA-Federation

with me, because, well, maybe it's just my ongoing space obsession, where one enters a field in which all things larger than a certain size are molded into a sphere or flat disc due to gravity, but I've been concentrating a bit on spheres and discs, as well as the "inside" and "outside" of things. (Again, a tree's fascinating to me partly because it's suspended equidistant between those two.)

Benson: Orange, sun. Sun, orange.

There must be some ineffable circular connection between the infinitely large and macrocosmic and the infinitely small and microscopic, as best represented in the perfect circles/ spheres of outwardly directed energy (raindrops on a lake, lunar craters, the sun blazing away in space) and the perfect circles/spheres created by inwardly directed energy (i.e., gravity pulling blobs of matter into spheres, black holes pulling entire galaxies into razor-thin spinning discs). Inwards, outwards: note also that "artificial" gravity can be "made" by spinning a wheel—a direction out and away from a center—and "real" gravity is directed towards the center of a massive spherical object. But is there really a difference between them, or are they the same? Even if the forces would seem to be directed in opposite directions? Maybe there's a time component, or time-mirror, in there somewhere:

and instead of forward/ backward, we have in/out?

I ask those who have peeled a mandarin orange, and looked down in amazement to see an exact 3-D scale model replica of a solar observatory picture of the sun in vivid diagrammatic detail: how do you explain the linked inner-outer directions of nature? The uncanny linkages, vividly detailed, right under our very noses? What is that? The peeled mandarin sits, right now, beside my keyboard, radiating the energy it got from the sun. It's palpable. And it looks exactly like the sun. Could this be how energy zaps between the dimensions? Maybe our ability to perceive it in this way is already evidence of energy transfers. And then you take a bite, and something "blooms" in your sensorium. Why? Where's it from? It blooms, and expands outwards, like rays of light and energy.

Or, as I say, like the waves welling out from a pebble dropped in a pond. Obviously, neither Benson nor I had been the first to have thought along these lines. Viz., the following, from Leonardo da Vinci's *Codex Atlanticus*, fol. 9 v., which I happened upon not long after I received Benson's email:

Just as a stone thrown into water becomes the center and cause of various circles, sound

222

spreads circles in the air. Thus every body placed in the luminous air spreads out in circles and fills the surrounding space with infinite likenesses of itself and appears all in all and all in every part.

And I just find myself wondering, might there be some sort of Grand Unified Field Metaphor that unites all of these metaphors, such that eruptions, for example, simultaneously evince a branching and a pebble-welling characteristic? And indeed, don't they already? Think of the branching tubes and ducts of rising magma in those cross-section diagrams of the interiors of imminently explosive volcanoes (again from that *Times* article), and then of the maps of concentric zones of fallout and damage following any given event. No doubt at some sub-submicroscopic level, the furthermost neural dendrites in the brain are in fact exuding spasms of chemical foam, whose electrical consequences well out in concentric waves across the synaptic gap and toward the furthermost extensions of neighboring neurons. And— genius to genes, cerebellums to

cereal, concepts to conception—what else, what other, is procreation itself?

Exhausted, spent, I pick up W. G. Sebald's magnificent historico-metaphysical walkabout volume *The Rings of Saturn,* my newest favorite book, and come upon the following passage (pp. 19–20), in which Sebald in turn evokes Sir Thomas Browne, that seventeenth-century Father of Us All:

> The greater the distance, the clearer the view: one sees the tiniest of details with the utmost clarity. It is as if one were looking through a reversed opera glass and through a microscope at the same time. And yet, says Browne, all knowledge is enveloped in darkness. What we perceive are no more than isolated lights in the abyss of ignorance, in the shadow-filled edifice of the world. We study the order of things, says Browne, but we cannot grasp their innermost essence. And because it is so, it befits our philosophy to be writ small, using the shorthand and contracted forms of transient Nature, which alone are a reflection of eternity. True to his own prescription, Browne records the patterns which recur in the seemingly infinite diversity of forms; in *The Garden of Cyrus,* for instance, he draws the quincunx, which is composed by using the corners of a regular quadrilateral and the point

at which its diagonals intersect. Browne identified this structure everywhere, in animate and inanimate matter: in certain crystalline forms; in starfish and sea urchins; in the vertebrae of mammals and the backbones of birds and fish; in the skins of various species of snake; in the crosswise prints left by quadrupeds; in the physical shapes of caterpillars, butterflies, silkworms and moths; in the root of the water fern; in the seed tusks of the sunflower and the Caledonian pine; within young oak shoots or the stem of the horsetail; and in the creations of mankind, in the pyramids of Egypt and the mausoleum of Augustus as in the garden of

Quid Quincunce speciosius, qui, in quamcunqz partem spectaueris, rectus est. Quintilian: 1

The quincunx

King Solomon, which was planted with mathematical precision with pomegranate trees and white lilies. Examples might be multiplied without end, says Browne, and one might demonstrate ad infinitum the elegant geometrical designs of Nature; however—thus, with a fine turn of phrase and image, he concludes his treatise—the constellation of the Hyades, the Quincunx of Heaven, is already sinking beneath the horizon, and so 'tis time to close the five ports of knowledge. We are unwilling to spin out our waking thoughts into the phantasmes of sleep; making cables of cobwebs and wildernesses of handsome groves.

And so, indeed, to bed.

The Hyades, with cacti

CODA / CREDO

The crash of two gold nuclei traveling at nearly the speed of light

WE JOIN SPOKES TOGETHER IN A WHEEL

NICHOLAS OF CUSA / SAGAN / CIRCLES AND HOLES

Somehow I keep coming back to Nicholas of Cusa, that late medieval Renaissance man (1401–1464), a devout church leader and mathematical mystic who was at the same time one of the founders of modern experimental science, propagator, for example, of some of the first formal experiments in biology (proving that trees somehow absorb nourishment from the air, and that air, for that matter, has weight) and advocate, among other things, of the notion that the earth, far from being the center of the universe, might itself be in motion around the sun (this a good two generations before Copernicus)—and yet, for all that, a cautionary skeptic as to the limits of that kind of quantifiable knowledge and thus, likewise, a critic of the then-reigning Aristotelian/Thomistic worldview. No, he would regularly insist, one could never achieve knowl-edge of God, or, for that matter, of the wholeness of existence, through the systematic accretion of more and more factual knowledge. Picture, he would suggest, an *n*-sided equilateral polygon nested inside a circle, and now keep adding to the number of its sides: triangle, square, pentagon, hexagon, and so forth. The more sides you add, the closer it might seem that you will be getting to the bounding circle—and yet, he insisted, in another sense, the farther away you will in fact be becoming. Because a million-sided regular polygon, say, has, *precisely,* a million sides and a million angles, whereas a circle has none, or maybe at most one. No matter how many sides you add to your polygon (ten million, a hundred million), if you are ever going to achieve any true sense of the whole, at some point you will have to make the leap from the chord to the

arc, a leap of faith as it were, a leap which in turn can only be accomplished in or through grace, which is to say in some significant way *gratis,* for free—beyond, that is, the *n*-sided language of mere cause and effect.

And all of that rings true to me (the ring of truth, indeed, it seems to me, being one of the ways you might know you had popped past the *n*-sided polygon and into the realm of the circle).

And yet I also find myself holding with the late Carl Sagan, who in his 1994 book *Pale Blue Dot,* insisted that

> In some respects, science has far surpassed religion in delivering awe. How is it that hardly any major religion has looked at science and concluded, "This is better than we thought! The universe is much bigger than our prophets said—grander, more subtle, more elegant. God must be even greater than we dreamed"? Instead they say, "No, no, no! My god is a little god, and I want him to stay that way." A religion, old or new, that stressed the magnificence of the universe as revealed by modern science

Nicholas and Carl

might be able to draw forth reserves of reverence and awe hardly tapped by conventional faiths. Sooner or later, such a religion will emerge.

That, too, seems profoundly true to me, evinces the ring of truth. But can Nicholas of Cusa and Carl of Cornell both be right? Phrased another way, I suppose, is it possible to imagine a science that, while remaining true to its own principles and methods, nevertheless manages to break free of the n-sided polygon and toward the circle whole?

One morning, a while back, over NPR's *Morning Edition,* somebody was reporting how scientists have determined some of the mechanisms whereby staph bacilli mutate (evolve) with astonishing rapidity so as to outwit antibiotics, sharing DNA ("information") across the entire process in ever more novel ways.

It sounds almost as if staph as such is thinking, or rather maybe daydreaming, or anyway

musing—letting its thoughts (all that genetic information) meander into whatever available channels present themselves (that the attempt to counter this tendency in effect is an effort "to keep" nature's "mind from wandering, where it will go—ooh—ooh—ooohhh… oh oh oh oh oh.")

The mind/body split may constitute a misguided formulation, as for that matter in a sense may the split between the in-itself and the for-itself, between the world and consciousness.

It may not be a matter of *cogito ergo sum*—in fact, in a sense, perhaps it's that formulation's very opposite: *sum ergo cogito*. Or better yet: *esse est cogitare.*

Being is itself thinking: the world is daydreaming.

Hence the German word: *Glaube*. Faith, belief, as in *das glaube ich* (I believe this; This is what I believe). But also, *der globus:* the globe.

The globe glaubes.

All that is, wonders—and just goes on marveling.

And then, just the other day, there was this startling image staring up at me from the pages of the science section of my morning paper and spearing me in its gaze (I momentarily felt the way I imagine some microbe might, gazing back up the barrel of a microscope—or, then again, the way Szymborska's "darling little being with its tiny beating heart inside" must have, plastered that day across the giant screen). "The crash of two gold nuclei traveling at nearly the speed of light," the picture's caption explained, "produces a shower of debris that is detected by a house-sized detector that is part of the Relativistic Heavy Ion Collider at the Brookhaven National Laboratory on Long Island." The article itself went on to note how, "According to one theoretical physicist, the collisions have even been creating a sort of tiny, short-lived black hole" (granted, "very, very tiny and very, very short-lived," lasting "less than one-10,000,000,000,000,-000,000,000th of a second").

By now I suppose you know me well enough that you won't be surprised to hear how all that got me to thinking about black holes and vision, or more precisely about what comes in and what goes out when we see. The history of thinking about vision is in fact a history of a continual rejiggering of the relative importance of those two vectors: is it that light rays enter the eye through the corneal lens (whereupon they get sprayed onto a sort of tabula rasa screen at the back of the eye)—or rather, in some sense, that the brain's, or the mind's, or anyway the self's attention courses out to the world through that lens (actively grasping and even shaping what it sees, or rather looks at, or rather chooses to tend to)?

To the extent that something is going in, what is it going in *to*? Recall how Sartre characterized voracious consciousness as Being's very obverse, which is to say, Nothingness—in that sense a (perhaps not merely conceptual) mirror of the sorts of actual physical black holes cosmolo-

gists posit out there in the actual physical universe. Consider, in this context, Rilke's melancholy Panther at Paris's Jardin des Plantes, padding in his cramped circles behind those perpetual bars, its will by now almost completely paralysed, how (in Stephen Mitchell's marvelous translation),

> Only at times, the curtain of the pupils
> lifts, quietly—. An image enters in,
> rushes down through the tensed, arrested muscles,
> plunges into the heart and is gone.

Then again, as I say, maybe the vectors go the other way around, and mind is more like the black hole's physical obverse, the extravagantly spewing supernova, with wave-particles gushing forth at the speed of light. Which in turn raises the question of whether the outgoing attending gaze moves at the same speed as the incoming light, which is to say, the speed of light? Or faster? Or slower?

Beats me. Maybe it's some combination of all of the above. After all, as the great sixth-century B.C. Chinese master Lao-Tzu parsed things in the eleventh of the poems that make up the *Tao te Ching* (again this time in Stephen Mitchell's superb translation, with a slight tweak of my own there at the very end):

> We join spokes together in a wheel,
> but it is the center hole
> that makes the wagon move.
>
> We shape clay into a pot,
> but it is the emptiness inside
> that holds whatever we want.
>
> We hammer wood for a house,
> but it is the inner space
> that makes it livable.
>
> We work with being,
> but non-being is where we live.

Maybe it just takes a circle to know a circle.

Supernova remnant, forty light years across, photographed by the orbiting Chandra X-ray Observatory

ACKNOWLEDGMENTS

For starters, of course, first and last, as ever, to my bride of over two decades, and to my daughter of coming on almost as many, Joasia and Sara: somehow, resurfacing from my distractedly preoccupied, loose-synapsed mind-wanderings, there they always were—steady, forgiving, and true. How lucky can a guy be? And then as well, to my siblings, to whom I have dedicated this volume, in the increasing awareness that the leapfrogging, fast-darting, improbably connecting turns of mind that it evinces had their origin around the mad, slapdash table of our childhood dinners (much to the forlorn mystification, often, of our poor, beleaguered mother).

If this book has been about anything, it has been about the uncanny web of influence, and the confluence of indebtedness, that stand behind any human project. In my own case, I have tried to be as transparent as possible throughout with regard to the taproots of the various intellectual currents that make themselves felt across these pages. But here I would especially like to acknowledge the seminal force, in my own thinking, of the profound insights (and in some instances verbatim contributions) of John Berger, Edward Snow, Wyslawa Szymborska, Stewart Brand, Ryszard Kapuscinski, Oliver Sacks, Michael Fried, David Hockney, Elkonen Goldberg, Deborah Treisman, Michael Benson, the late W.G. Sebald, Annie Druyan (and her late husband Carl Sagan), and Stephen Mitchell—and of the formative role, as well, of several of my teachers, including Donald Nicholl, Harry Berger, Robert Goff, Sheldon Wolin, Peter Euben, Maurice Natanson, Todd Newberry, Norman O. Brown, Page Smith, and Mary Holmes.

Who knew what this particular turn in my writing was going to portend, and whether it ought in any sense to be encouraged? Well, in my own case, two decades worth of agents—Flip Brophy, Deborah Karl, and now Chris Calhoun—were unfailingly forebearant (that word again) and even enthusiastic. The editors at the various venues where earlier versions of these pieces found successive homes—notably Wendy Lesser at *The Threepenny Review*; Martin Pedersen at *Metropolis*; William Shawn, Robert Gottlieb and Tina Brown at *The New Yorker*; Ingrid Sischy at *Artforum*; James Weinstein at *In These Times*; and Laura Miller at Salon—all sharpened my thinking and then harbored my prose.

But my most generous patrons this time out were the gentle folk over at *McSweeney's*, in whose pages (as readers will discern from the list that follows) a preponderance of these pieces first appeared—and of course, in particular, the dazzling impresario of that merry band, that veritable Niagara of happy confluences, Dave Eggers. The look of this book, the pace of its unfurling, and whatever coherence it has managed to retain through to the end, owe everything to that magazine's managing editor, and this book's at times beleaguered shepherd (ah, the soft loggerheads, the soft loggerheads!): my impertinently youthful *miglior fabbro*, Eli Horowitz. Assisted by endlessly resourceful image-mavens Karan Mahajan, Astrid Stavros, Alex Carp, and Christopher Ying, and publisher Barb Bersche, Horowitz really deserves all the credit: lunkminded, loggerheaded me, alas, I retain the considerable blame for whatever infelicities remain.

ORIGINAL PUBLICATION

Introduction
McSweeney's #3, Summer 1999

EXEMPLARY INSTANCES

Echoes at Ground Zero
Omnivore, prototype issue,
Autumn 2003

The View from the Prow of the Getty
Metropolis, August/September 2002

Cuneiform Chicago
McSweeney's #8, Summer 2002

Helen Levitt: Ilium off the Bowery
Threepenny Review, Winter 2001

Ziggurats of Perception
McSweeney's #4, Spring 2000

Expressions of an Absolute
McSweeney's #3, Summer 1999

Gazing Out Toward
McSweeney's #6, Winter 2001

Magritte Standard Time
The New Yorker, November 16, 1992

WOMEN'S BODIES

Found Triptych
McSweeney's #3, Summer 1999

Girls in Their Turning
McSweeney's #6, Winter 2001

Languorous Landscapes
Omnivore prototype issue,
Autumn 2003

Olbinski/Bruno Schulz postscript
Olbinski's Women: Motif and Variations
(Hudson Hills Press, 2005)

Torso as Face, Face as Torso
McSweeney's #14, Early Fall 2004

Fathers and Daughters
McSweeney's #8, Summer 2002

The Darling Little Being
McSweeney's #4, Spring 2000

POLITICAL OCCASIONS

The Graphics of Solidarity
Artforum, February 1982

The Contras and the Battle of Algiers
The New Yorker, August 25, 1986

How Suddenly It Can All Just End
In These Times, March 12, 1986

Tetris/Gorbachev
The New Yorker, March 26, 1990

Modern Times
Threepenny Review, Spring 1991

Allegories of Eastern Europe
Threepenny Review, Fall 1990

Uncle Toby
The New Yorker, January 29, 1990

Loving or Leaving Bosnia
The New Yorker, January 11, 1993

Pillsbury Doughboy Messiahs
McSweeney's #3, Summer 1999

A Field of Blackbirds
Salon, October 5, 2000

An Anatomy Lesson
The Atlantic, October 1997

The Dikes of Holland
Introduction to *Crimes of War*
(W.W. Norton, 1999)

Mona Lewinsky
Slate, March 11, 1999

Those Wacky Htoo Twins
Salon, January 29, 2001

Thumb in Eye
McSweeney's #14, Early Fall 2004

TREES, NEURONS, NETWORKS

Trees and Eyeballs
McSweeney's #5, Fall 2000

Branching Out Yet Further
McSweeney's #5, Fall 2000

Compounding Unscientific Postscript
McSweeney's #11, Summer/Fall 2003

CODA / CREDO

We Join Spokes Together in a Wheel
McSweeney's #18, Late 2005

IMAGE CREDITS

Readers can perhaps imagine the convergent hive of indebted gratitude a daft project like this one quickly builds up on the part of its progenitors, especially with regard to imagery. In this instance, I am especially appreciative of the generous, open-spirited (if sometimes bemused) forebearance of Joel Meyerowitz (and the Ariel Meyerowitz Gallery in New York); Jim McBride; Matt Stolper; Breyten Bretyenbach; Helen Levitt; Alfredo Jarr; the Polish stencil artist Kret (and Piotr Bikont who turned me onto him); Len Jenshel and Diane Cook; Bella Meyer (representing the estate of Marc Chagall); Lloyd Ziff (and his posse of cloud image wranglers at the late lamented *New West*); Rafal Olbinski; Tina Barney; Jeff Barbee; Ed Koren; Gilles Peress; Sara Terry; Kanan Makiya; USGS; Rodney Graham; Tom Eisner; Rita Reinhardt; Mishka Shubaly (for the tee-shirt literally off his back); Michael Benson (for the orange on his computer); David Wilson at the Museum of Jurassic Technology (always good for the pertinent Athanasius Kircher reference); and Carrie Weiss (for the endpaper imagery). Jackson Pollack, *Autumn Rhythm* ©1999 Pollack-Krasner Foundation/ Artists Rights Society; Mark Rothko, *Untitled* ©1998 Kate Rothko Prizel & Christopher Rothko/ Artists Rights Society; NASA; Richard Deibenkorn, *Untitled*, courtesy of Knoedler Galleries; *Battleship Potemkin* still. The Museum of Modern Art, NY; "Hannah Wilke" ©Estate of Hannah Wilke; Jan Vermeer, *Head of a Girl (Wearing Pearl Earring)*, Erich Lessing/Art Resource, NY; Diego Rodriguez Velazquez, Venus and Cupid, National Gallery, London. Erich Lessing/Art Resource, NY; Tina Barney photographs courtesy of Janet Borden, Inc., New York; Mushroom cloud photo courtesy U.S. Department of Energy; Challenger photo courtesy NASA; earthquake damage photo by C.E. Meyer, U.S. Geological Survey; Htoo photos courtesy AP Photo/Apichart Weerawong; Gorbachev and Reagan photo courtesy AP Photo/Ira Schwartz; Rodney Graham, *Welsh Oaks (5)*, courtesy the artist; *Eyewitness Explorer's Trees*, courtesy Doris Kindersly; Ad Reinhardt, *How to Look at Modern Art in America*, courtesy of Reinhardt Estate; *Blot Out the Sun* ©2005, Doug and Mike Starn and Artists Rights Society (NYC); Relativistic Heavy Ion Collider photo courtesy Brookhaven National Laboratory–STAR Collaboration; circle diagram by Aran Baker; golf course photo courtesy Carl E. Swanson III. We kept trying to track down Sigfrido Geyer, the photographer who captured that marvelous Rokeby-Venuslike hillscape in Venezuela, but were never able to; if he ever comes upon these lines, we'd love to hear from him.

Institutionally, we are also grateful for the generous cooperation of the relevant parties at the Louisiana Museum in Humlebaek, Denmark; the Getty in L.A.; the DIA Center for the Arts in New York; the Ronald Feldman Gallery; *The New York Times Magazine; Time; Newsweek; The Economist*; AP; UPI; Reuters; and Bell Laboratories.

A NOTE ON THE ENDPAPERS

Of course, it never ends: you start thinking this way and it just goes on and on.

For instance, take these endpapers. Pretty amazing, hunh? Want one for yourself? They're surprisingly easy to produce. Here's what you do: Take a slab of clear acrylic Plexiglas and find your way to your nearest linear beam accelerator. The one we happen to have in mind consists in a four-story hangerlike structure with, for all intents and purposes, a huge downfacing television picture-tube lodged inside (albeit one with its filament encased in a ten-foot diameter steel pressure vessel surrounded by 200 psi of sulfur hexafluoride gas, for insulation, evincing an acceleration voltage of 5,000,000 V in lieu of the 20,000 you'd find in an ordinary picture tube).

Now, get the guys to remove all the stuff they're ordinarily stiffening up in there (the plastic industrial pipes, tubing, that sort of thing), and slot your acrylic slab down at the bottom. Get well out of the way, and now give the thing a good stiff zap with all that humongous energy. When you pull the slab out, it may betray a mild yellowish tint, but otherwise it will seem unaltered: just as transparent and unblemished as before. In fact, however, the thing has become supersaturated with stray electrons, gazillions of them momentarily trapped inside (acrylic is an excellent insulator) and just itching to escape (feel the huge charge of static electricity as you brush the back of your hand against the block).

Now, set the slab on its side, take a sharp pointed metal rod and give the thing a good solid whack. Suddenly, in the flash of an instant, all those stray electrons will come racing from all about the slab in a headlong dash toward the site of the disturbance: Kaboom, a blinding discharge! Exactly, for that matter, as happens inside a stormcloud as all its stray electrons come madly converging just before it unleashes its lightning bolt. Although in this instance, unlike with the cloud, the hellbent electrons will have left traces of their escape routes embedded in the encasing plastic (capillaries into tributaries into branches into surging trunks)—a perfect instance of a classic Lichtenberg figure, named for the eighteenth century German humorist and physicist, Georg Cristoph Lichtenberg, who first noted their appearance when he discharged static electricity onto a dust-laden plane. Really cool.

So, go try it, or else pay a visit on Bert Hickman and his cohorts over at www.teslamania.com. They do this sort of thing all the time, and even sell the results of their little science projects: flat electric trees embedded in plastic rectangular slabs, or, even more amazing, three-dimensional trees embedded in rectangular cubes, which looked at from above, look for all the world like spokes converging on a wheel hole.

And here's the thing of it: In a cloud, those spokes of static electricity converge exactly like that, like the roots, as it were of an upside down tree; the bolt in turn is like an upside down trunk; and the site where the thing hits the ground—want to see what that looks like? Well, just look—in this case, the Lichtenberg figure spreading out, spokelike, from the point of contact across a patch of lawn, everyone of whose grassblades in turn evinces precisely the same structure, only in reverse.

Makes your wonder: Thinking trees, indeed.